Imaginary Dreamscapes

Imaginary Dreamscapes

Television Fiction in Europe

Eurofiction First Report 1997

Milly Buonanno (editor)

UNIVERSITY of JL
LUTON PRESS

British Library Cataloguing in Publication Data

A catalogue record for this book is available from the British Library

ISBN: 1 86020 557 7

Cover photographs

Front: *Terre Indigo* (TF1, France)

Back (from top to bottom): *Hostal Royal Manzanares* (TVE1, Spain)
Verbotene Liebe (ARD, Germany)
Il Maresciallo Rocca (Raidue, Italy)

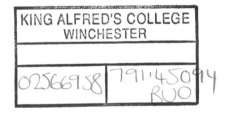
Published by
ULP/John Libbey Media
University of Luton
75 Castle Street
Luton
Bedfordshire LU1 3AJ
United Kingdom

Tel: +44 (0)1582 743297; Fax: +44 (0)1582 743298
e-mail: ulp@luton.ac.uk

in association with
Fondazione Hypercampo Osservatorio sulla Fiction Italiana (OFI)
50122 Firenze
20 Via dei Servi
Tel/fax +39/55/213602
e-mail: hypercampo@mega.it

Cover design by Keith Marr
Typeset in Times and Tekton
Printed in United Kingdom by Redwood/Bookcraft/Whitstable

Contents

Project Team

Italy	Fondazione Hypercampo – Osservatorio sulla Fiction Italiana (OFI)
France	Institut National de l'Audiovisuel (INA)
Germany	Universität Siegen
Spain	Universitat Autónoma de Barcelona (UAB)
United Kingdom	British Film Institute (BFI)
Promoters	Fondazione Hypercampo – Osservatorio sulla Fiction Italiana (OFI)
Head of the project	Giovanni Bechelloni (Università di Firenze)
Project coordinator	Milly Buonanno (Università di Salerno)

National Teams

Italy	Milly Buonanno (Università di Salerno. Coordinator)
	Giovanni Bechelloni (Università di Firenze)
	Fabrizio Lucherini (Università di Firenze)
	Anna Lucia Natale (Università di Campobasso)
	Tiziana Russo (Osservatorio sulla Fiction Italiana)
France	Régine Chaniac (Institut National de l'Audiovisuel. Coordinator)
	Maria Cajueiro (Conseil Supérieur de l'Audiovisuel)
	Jean-Pierre Jézéquel (Institut National de l'Audiovisuel)
Germany	Gerd Hallenberger (Universität Siegen. Coordinator)
	Lars Behrens (Universität Siegen)
	Matthias Leidig (Universität Siegen)
	Stefan Nickel (Universität Siegen)
Spain	Lorenzo Vilches (Universitat Autónoma de Barcelona. Coordinator)
	Rosa A. Berciano (Universitat Autónoma de Barcelona)
	Charo Lacalle (Universitat Autónoma de Barcelona)
United Kingdom	Richard Paterson (British Film Institute. Coordinator)
	Ilja Gregory (British Film Institute)
	Nick Pettigrew (British Film Institute)

Contributors

Giovanni Bechelloni is Professor of Sociology of Culture and Director of the Master in Communication and Media at Università di Firenze, Faculty of Political Sciences 'Cesare Alfieri'. President of Fondazione Hypercampo.

Rosa A. Berciano is Researcher at Universitat Autónoma de Barcelona (UAB).

Milly Buonanno is Associate Professor in the Department of Sciences of Communication at Università di Salerno and Lecturer in Media Theory for the Master in Communication and Media at Università di Firenze. Director of «Osservatorio sulla Fiction Italia» (OFI).

Régine Chaniac is a Researcher at Institut National de l'Audiovisuel (INA).

Gerd Hallenberger works for the Special Research Programme Screen Media of the German Research Council DFG at Universität Siegen.

Jean-Pierre Jézéquel is a Researcher at Institut National de l'Audiovisuel (INA).

Charo Lacalle is Associate Professor of 'Semiotics' at Universitat Autónoma de Barcelona (UAB).

Richard Paterson is Honorary Professor of Media Management at the University of Stirling. Head of Information and Education at the British Film Institute (BFI).

Lorenzo Vilches is Professor of Visual Communications Theory at Universitat Autónoma de Barcelona (UAB). Director of the Master Program in TV Scriptwriting.

Preface

The publication of the first *Eurofiction* report on domestic television fiction in five European countries marks an important step in the process of understanding Europe's broadcasting industry. Fiction figures prominently in programmes broadcast by European networks. Its importance is therefore undeniable, from both an economic and socio-cultural point of view. It is paradoxical however, that no permanent framework existed previously for monitoring fiction throughout Europe on the basis of a common set of criteria.

Eurofiction is promoted by the Fondazione Hypercampo. Its founding resolutions include interactive research and the adoption of a common methodology for analysing domestic fiction. To this extent, it is a pioneer in its field. The project is carried out by a network of five specialist research bodies, each of which is recognised in its home country as an authority in the field of broadcasting research, particularly for television fiction. This project is clearly a landmark in the study of broadcasting on a European scale.

The European Audiovisual Observatory, which is dedicated to gathering and distributing information regarding the European audiovisual industry, welcomes the creation of this *Eurofiction* network. Hence the Observatory's support in releasing the first issue of the *Eurofiction* report.

Lending support for the *Eurofiction* network is part of a global strategy adopted by the Observatory in its mission to gather data pertaining to the audiovisual sector. The Observatory's efforts to promote the collecting and disseminating information include:

– a Statistical Yearbook containing vital statistics regarding the sector: turnover ratings for the major companies in the industry, European television channels, an overview of fiction programmes and broadcasting rights, fiction imports, the current state of television in the 34 member countries of the Observatory, market shares, financial performance and programming on the major broadcasting stations. This yearbook is produced by the Observatory in collaboration with its partners (BIPE Conseil, IDATE, Screen Digest), and specialised organisations (notably ACT, ECCA and EUR), along with numerous other information providers (particularly ETS and the Eurodata-TV service offered by Médiamétrie.

– *Iris*, a legal review offering summaries of the most important legislation and case-law rulings pertaining to radio and television broadcasting.

- a website (http://www.obs.coe.int) providing links to television channel sites and a guide to information sources. During the course of 1998, this site will be enhanced with monographic studies giving comprehensive overviews of radio and television broadcasting in the different countries, in addition to a database covering European television networks.

The Observatory considers the approach chosen for the *Eurofiction* with respect to domestic fiction (assessment of volume of domestic fiction broadcast, critical analyses of fiction themes, and a filmography of the most important programmes) in keeping with its overall strategy. It is the perfect complement for gathering information concerning one of the key genres in television production and broadcasting.

Since the publication of the first *Eurofiction* report, under the patronage of the Observatory, several Northern European and Russian organisations have applied for membership to the network. For researchers from the various founding organisations of *Eurofiction*, this desire to collaborate expressed by colleagues from other countries reaffirms the validity of their work. Pan-European in make-up and vocation, the Observatory can only look with a favourable eye upon the gradual enlargement of the *Eurofiction* project to include the entire European area.

Moreover, it is also satisfying to note that this publication has stimulated the interests of the European and national institutions working together with the European Audiovisual Observatory, as well as many major European companies from the industry.

The European Audiovisual Observatory is pleased to play a vital role in helping specialist organisations and professional European and national broadcasting institutions – which all too often know little or nothing about what the other is doing – to find converging goals and guidelines.

André Lange
European Audiovisual Observatory
Expert in Market Information

Introduction

Giovanni Bechelloni

1. This is the first *Eurofiction* Report. As it goes to press, the research teams of the five major European countries (France, Germany, Italy, Spain and the United Kingdom) are in the process of preparing the second Report. At the same time, steps are being taken to extend the monitoring and geographical area of the Report to other European countries not yet under observation.

The monitoring process, carried out by the five country teams using a standardised set of methodological tools (see 'Methodology'), constitutes the competitive edge of this Report, whose aim is to provide a source of data and original information unavailable elsewhere. Thanks to this monitoring, it has been possible to give a global picture of first-run TV fiction broadcast over national networks in five countries during 1996, following the guidelines laid down by a similar nine-year study carried out in Italy by the Osservatorio sulla Fiction Italiana (OFI).

In the course of the study, in addition to viewing the programmes directly, the five research teams analysed a series of other primary sources: audience surveys, programme grids, TV reviews, press coverage, promotion and marketing for networks, channels and programmes, investments and costs. Hence, national observatories have been set up within the framework of the project and are co-ordinated by *Eurofiction*, the European observatory.

This Report, which presents the findings of a one-year study, is to be considered *experimental* in all respects. The groundwork for the *Eurofiction* project was laid during a series of preparatory meetings held in Florence (June and October 1995), under the initiative of: the Master in Communication and the Media of the Faculty of Political Science 'Cesare Alfieri'; the Hypercampo Foundation; the RAI department Verifica Qualitativa Programmi Trasmessi (VQPT); the Osservatorio sulla Fiction Italiana (OFI). The project was then presented for discussion during the course of two International Conferences held in Florence in April 1996 and 1997, with the participation of scholars, specialists and professionals in the field from eight European countries, the United States and Canada.[1]

1 As a follow-up to the first *Eurofiction* conference on *The New Frontiers of the Audiovisual Industry* (12–13 April, 1996), the volume: *Television Fiction and Identities: America, Europe, Nations*, edited by Giovanni Bechelloni and Milly Buonanno was published by Ipermedium, Naples and Los Angeles, 1997, pp. 171. The second

This first Report is *experimental* in many respects, but first and foremost, in terms of harmonisation of methodology. It is no simple feat, when considering a group of countries which, despite their common European tradition, present such diverse characteristics, to account for the myriad of differences which are apt to arise in lexicon, cognitive styles, production and consumption practices.

The scope of monitoring was limited for this reason, and also to remain within the constraints of the start-up budget. *Eurofiction* per se does not dispose of a general budget. Instead, it is the task of each individual country team to procure its own financing. To take part in the co-ordinated effort, the Italian team had to rely on funding from a combination of sources: RAI, MEDIASET, Sacis, the University of Florence, the Italian Bureau of the European Commission, the National Council of Research.

Eurofiction is experimental from another point of view as well. Its intention from the start has been to open its doors not only to contributions from its European counterparts, but also to the knowledge and experience of non-European countries. This is why the International Conferences held in Florence invited scholars and specialists from countries other than the five currently involved in the project to participate in the sharing of opinions.

The 1996 Report – and to some extent the 1997 Report which is currently being elaborated and will surely see each section grow – is not a Report made by scholars for scholars, even if its academic contribution has already proven to be valuable for researchers studying cultural processes and the role television plays in shaping their outline, form and content. This Report has been elaborated by a group of researchers with a finely-tuned ability to describe and interpret fiction television programmes, as well as the methods of production, marketing and exploitation, in direct link with the professional circles of the television industry. Well-versed in the television history of the various countries, during the course of monitoring these researchers have developed a comparative approach which allows them to appreciate the national peculiarities of their own culture by analysing the similarities and differences compared with other national contexts.

This is a fundamental aspect which makes *Eurofiction* a valuable source of information for anyone operating in the television industry. It is also indispensable for formulating policies in this sector both at national and European level. Future Reports promise to be even more useful since they will allow for the sharing and exchange of technical and professional expertise in marketing and production which is partially obstructed today. An entire sequence of chronological Reports will provide a higher concentration of information and expertise which, scattered as it is today among various sources with different constructs, is somewhat socially unproductive.

The *Eurofiction* project represents a phase of experimentation with the aim of exploring new and innovative ways of achieving European integration, of developing industrial strategies aimed at producing television fiction programmes for both European and international circuits. It is hoped that the data and analyses proposed by *Eurofiction* will be useful in elaborating public policies at state and European level, aimed at elaborating a competitive advantage for the European

conference dealt with the issue of *National Television Across Cultural Boundaries* (15–17 April, 1997). Both conferences received the patronage and support of the Italian Bureau of the European Commission.

broadcasting industry. It is in the interests of this industry operating in the various different countries to produce and market programmes whose appeal goes beyond national borders.

2. This Report is divided into two sections which present the results of a monitoring study carried out according to homogeneous guidelines by the five country teams which met regularly to co-ordinate their work. In addition to the 1995 preparatory meetings in Florence, and the work groups held during the two International Conferences of April 1996 and 1997, two more recent encounters took place. The first was held at the Institut National de l'Audiovisuel in July 1996, and the second in London at the BBC and British Film Institute in January 1997.

Part One of this Report comprises six chapters, one for each of the five countries included in the project, preceded by an introductory chapter which gives a comparative overview of the results. Two different surveys were carried out within each country to form the common data base used in all six chapters. Information was gathered and classified regarding:

(a) 4120 hours of first-run domestic fiction programmes broadcast during the course of the entire year;

(b) all fiction programmes (including reruns and imports from European and non-European countries) during the course of the sample week running from 2 to 8 March, 1996.

Part Two contains an Index with the profiles of 100 programmes, 20 entries per country, which were selected on the basis of popularity. In certain cases, the Index also includes trendy or niche programmes, hits with the critics and even 'interesting' flops. Once again, the sheets provided for each programme, which include technical specifications and credits followed by a brief synopsis, are based on data collected during the monitoring study, and hence constitute an invaluable primary source.

The data gathered and classified during the sample week provide the interpretative groundwork necessary for a better understanding of the space occupied and role played by domestic fiction in each country. It also sheds light on the national markets and their potential, and the volume of domestic supply as compared to imports from Europe, the US, Latin America and Australia.

The 4120 hours of fiction produced domestically in European countries are highly inadequate in comparison to an overall offer which exceeds 50,000 hours. Furthermore, the data collected during the sample week reveals two similarly worrisome tendencies, which confirm what had been observed previously: (1) the very limited distribution of the European products (ranking highest in France with 22 per cent, compared to Italy's 6 per cent and Germany's 4 per cent); (2) the overwhelming presence of US products (which during the sample week accounted for 70 per cent in Italy, 69 per cent in Germany and 67 per cent in Spain).

In addition, the single country-Reports provide a context for the data by describing the main characteristics of the national television system and the most recent trends in production and marketing. This brings forth the similarities and differences of major interest to those operating inside or on the periphery of the broadcasting industry.

It is the differences which are most likely to strike the reader who, bombarded by the pervasive anti-television campaign rampant in recent years, has come to

believe that all television is alike. However, this Report is unique in that it underlines the country-specific features of national broadcasting, which in terms of marketing policies, network grids, programme format and content, is heavily influenced by national culture and tradition.

In light of these characteristics, it is possible to explain both the failure of past *Europudding*, and the recent trend toward co-productions with a dominant partner from one country. In these projects, the programme is heavily rooted in the culture of the dominant country, which is also the main market. The secondary partner or partners, on the other hand have low expectations from the start as to the performance of the programme in their own markets.

Though some cases are more evident than others, changes and transformations throughout Europe are affecting individual markets. These include demographic and socio-cultural changes in terms of family size, cross-generation relationships and identity in general. Even transformations in the domestic sphere have occurred in terms of number of television sets and where they are situated in the household, the number of video recorders, computers, and satellite or cable links. Markets are becoming progressively more complex and fragmented. Germany is one of the most striking examples of this trend. Nevertheless, compared to ten years ago, no European market, not even the English or Italian markets which appear to be relatively stable, albeit for fundamentally different reasons, presents the same characteristics, in terms of structure or potential.

Several additional observations can be made: (a) certain televised programmes like game-shows or reality shows, which seemed to have acquired a steady foothold in terms of popularity, have not withstood the test of time and have failed find successful new formulas and formats; (b) fiction programmes from the US and Latin America, apart from no longer being at an advantage in terms of cost, are consistently losing favour with audiences, and are used more and more as a second resort to domestic programmes; (c) the US industrial machine produces very few films or TV shows with general appeal which nonetheless continue to be costly in terms of broadcasting rights.

In other words, the combination of a multiplicity of networks, the obsolescence of non-fiction formats, the fading appeal of non-European programmes, and the high costs of broadcasting Hollywood hits, all make it necessary that the European broadcasting industry and public policy makers for the audio-visual sector take a fresh approach to defining strategies in order to find the most effective ways to boost production. This can only be done by creating and marketing programmes which are suitable for Europe-wide distribution.

The first chapter of Part One, which presents a comparative analysis of data from the five national broadcasting systems, provides stimulating insight into current trends and directions in production, and indicates which genres and formats, stories and characters are most apt to arouse public interest. As a valuable follow-up to this first chapter, 100 synopses compiled in Part Two should prove particularly useful for identifying the most effective industrial, marketing and political strategies to ensure a solid future for the European broadcasting industry.

In compiling data and analyses regarding the domestic production of televised fiction in five leading European countries, this Report proposes to provide the preliminary groundwork for meeting a challenge which it then intends to pass on. It illustrates that throughout Europe, in each of the five countries observed, there

exists a broadcasting industry which produces thousands of hours per year, broken down into hundreds of programmes telling stories, some longer than others, some more dramatic or humorous, stories which attract, captivate and entertain diverse types of public, stories which offer viewers the chance to amuse themselves, to laugh and cry, to broach problems related to everyday contemporary life, to get involved in an affair, to identify with one character or another. Millions of Europeans, whether German, French, English, spanish or Italian, watch television on a daily basis, and through television they come into contact with fiction stories which are still the best of what television offers today. What would become of television, whether terrestrial, cable or satellite, without the stories told by cinema and televised fiction? What would become of the publishing industry if it no longer published novels, short stories or tales? The peoples of Europe, who make up an important part of Western Civilisation, are fond of reading, listening to, and watching stories where new situations and characters either alternate or blend together with old, familiar elements.

The need for story-telling appears to be deeply rooted in European cultures. This is in line with Richard Rorty's claim that the novel is the most typical and distinctive creation of Western Civilisation. According to Rorty, if any element can be considered emblematic of the Western story, it is 'the novelist's predilection for the narrative, for details, variety and the accident'.[2] It is therefore impossible to ignore the deeply-rooted anthropological factor underlying the European public's fondness for narratives, which should be recognised as a symbolic meeting ground giving substance and foundation to the general tendency on the part of all European peoples to strive for liberty, democracy and solidarity. Producing stories, providing broadcasters with the means to fill their network grids with a wide range of televised stories could also imply offering the peoples of Europe a better opportunity to develop that 'taste for detail' which gives colour to a story, which gives it a life of its own, thereby contributing to the development of the history of each individual as well as the collective history of the peoples and nations of Europe.

Fiction is more than merely the core business of television. Contrary to what many critics of television, in their abstract projections of an improbable future claim, it provides important input for the cultures and nations of Europe. It will also play a key role in building a European culture.

For this Report also demonstrates that there is still a lack of continuity in television programming capable of telling stories attracting and captivating the various audiences scattered over the European continent, in order to go beyond the boundaries of the nation-states and of Europe itself.

The challenge therefore is two-fold. By providing analytical documentation of what is being produced on a frequent and regular basis, it is possible to work more effectively in each European country, in the writing, producing and marketing of televised stories. It is possible to stimulate more competent performance in the professional spheres which keep the television industry alive: authors, script-writers, producers and marketing experts, network managers and training programme directors. Furthermore, this conveys the concept that the broadcasting industry and the culture of the people are closely interconnected in a two-way relationship of mutual give-and take which is all too often underestimated.

2 Essay by R. Rorty, *Heidegger, Kundera e Dickens*, in *Scritti filosofici* II, Laterza, Bari 1993, p. 101.

This enhanced competence and more thorough knowledge of televised stories would trigger the convergence of industry and culture, of national and community policies, giving birth to a cross-national television industry capable of producing European fiction with world-wide potential.

Part One

Methodology

1. Preliminary Remarks

The graphs and tables appearing in the first chapter, as well as those in the single country-reports, present the results of a study carried out by five research teams in the *Eurofiction* member countries: France, Germany, Italy, Spain, the United Kingdom. Monitoring was conducted according to a set of pre-established, homogeneous criteria. In light of the overall lack of harmonisation in gathering and processing information which currently hampers research in the field of television industry and programming, this homogeneity in methodology is one of the primary strong points of the *Eurofiction* project.

The datasheet presented here below was used to analyse all domestic fiction pro-grammes, including co-productions, broadcast as first runs during the year 1996 by the national broadcasting networks[1] of five major European countries. The basic unit of analysis was the single episode or instalment.

The major networks monitored in each country are as follows:

France	Germany	Italy	Spain	Great Britain
F1	ARD	Raiuno	TVE1	BBC1
France2	ZDF	Raidue	La2	BBC2
France3	RTL	Raitre	T5	ITV
M6	SAT.1	Canale5	A3	Channel 4
	Pro7	Rete4	TV3	
	(others)[2]	Italia1		

It is important to specify that reruns of domestic fiction and imports from European or non-European countries are *not* included in the study. These two groups were excluded for both pragmatic and programmatic reasons.

With regard to these latter, *Eurofiction* has focused primarily on the productive activity and capacity of European broadcasters. The most obvious indicator of this is without a doubt the volume of first runs domestic fiction programmes each network is able to offer per year.

1 Spain is the only exception here. The regional Catalan channel was included in the study because of the important contribution it makes in producing and programming domestic fiction.

2 See the country-report for Germany for more detailed information.

From a pragmatic point of view, given the experimental nature and limited start-up budget of *Eurofiction*, the tendency has been to proceed gradually, and thus wait till next years to extend the study to peripheral areas of interest surrounding the core research.

Reruns and imports have been included, on the other hand, in the data gathered during the *sample week* (2-8 March 1996). Monitoring, for this week only, included the totality of fiction programmes without exception, in order to situate the results within a broader range of contextual factors.

Fiction is a product both of industry *and* television culture. This dual approach, which is the cornerstone of the *Eurofiction* research project, is reflected, from a methodological point of view, in the datasheet, which has been divided into two sections.

In the first section, fiction programmes are classified according to key variables attributed to certain production types in conjunction with their position in the programme grids and ratings.

The second section looks at four *cultural indicators*, time, place, environment and main character, in an attempt to give an overview of the dimensions and components characteristic of the more specifically cultural aspect of the stories told. It is clear that the definition and breakdown of *cultural indicators* will need further fine-tuning as the research project progresses.[3] Nevertheless, this has already proven its worth as one of the merits of *Eurofiction* for two reasons:

- first, because it adopts an approach which is both qualitative and interpretative, and not merely statistical. This approach, which is introduced at an early stage in producing quantitative data, gives *Eurofiction* a competitive advantage in the research field of European television industry and culture.

- second, it entails and implies a working method requiring first-hand knowledge of the fiction programmes. Without this, the classification of *cultural indicators* would be impossible.

This first-hand knowledge is the starting point for a thorough and comprehensive analysis of the state of domestic fiction and its major trends in the individual countries observed.

2. Datasheet

(Unit of analysis: broadcast unit, i.e. single episode)

A. Basic classification

1. Retrieval information	*2. Type of production*
Title:	1. Domestic productions
Day:	2. European co-productions (with partners from other European countries); Europe is meant within conventional geographical borders)
Date:	
Channel:	
Starting time:	3. Other co-productions*
Length in minutes (advertising not included):	* where applicable, co-productions with same-language countries can be introduced separately

3 The cultural indicators *place* and *environment* have already undergone modification in
 the 1997 monitoring.

3. Format

1. TV movie (one-off)
2. Miniseries (up to six episodes)
3. Series
4. Open serial
5. Closed serial

4. Genre

1. General drama
2. Action/crime

3. Comedy
4. Other

5. Subgenre

(the establishing of subgenres is left to each national research team)

6. Audience data

Audience average
Ratings
Share

B. Cultural indicators

1. Time

1. Present (the present decade)
2. Past
3. Future

2. Place

1. National – i.e. if the story is set *mainly* in the country of production

2. International – if the story is set in other countries *as well*

3. Abroad – if the story is set *totally* in other countries

3. (Main) Environment

1. Big town
2. Small town
3. Other

4. Main character*

1. Male
2. Female
3. Male group
4. Female group
5. Mixed/choric

* any elements implying that one character holds a special position (e.g. programme title) are to be considered indicators of non-group/choric status.

1. A Comparative Overview

Milly Buonanno

1. European Television Fiction in 1996

It is becoming more and more evident with time that visions of the European television space as a homogeneous and unitary ensemble are based more on an *imaginary dreamscape* than on a real landscape. Empirically speaking, the underlying structure of this landscape is formed by a dense network of unique and diverse national peculiarities, which come together only partially on the basis of few cross-national guidelines and tendencies.

It is not surprising, therefore, that a comparative analysis of the results of the EUROFICTION monitoring reveals that significant differences exist in terms of production capacity between the broadcasting industries in the five major European countries. During 1996, almost 4120 hours of first-run domestic fiction programmes were broadcast over the major television networks in France, Germany, Italy, Spain and the United Kingdom. The overall annual fiction programming for each single country can be estimated at an average volume of at least 10 thousand hours. Thus, it becomes evident how seriously lacking the European[1] broadcasting industry is in offering more consistent programming for national network grids, provided that full autonomy, or autarchy, in offering this type of product would be realistically unfeasible, and even less desirable.

Aside from the wide gap which exists between domestically produced European fiction and imports, as shown more ahead by the results of the sample weeks, it can be seen from Graph 1.1 that the most significant disparities (and perhaps in the most unexpected proportions) arise *within* the European field itself.

Germany, the leading fiction producer, registered a peak of 1689 hours, followed by the UK (1058), France (690), Spain (459) and finally at the bottom end of the scale, Italy (221). These figures show that the European broadcasting industry of the mid-nineties has developed production capacities which vary greatly from one country to another. To mention only the extremes, German television produces an average of four hours of new fiction per day, compared to Italy which produces just over 30 minutes.

1 Unless differently specified, 'European' in the context of this chapter is usually referred to the five European countries involved in the EUROFICTION project.

Graph 1.1: Domestic TV fiction broadcast in 1996
(first run in hours)

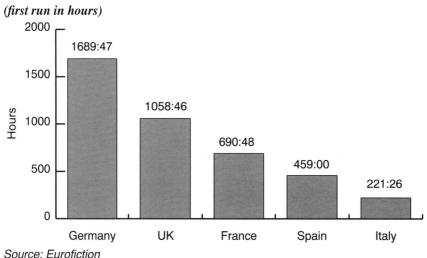

Source: Eurofiction

A dividing line of 1000 hours per year of new fiction broadcasts can be used as a watershed in an attempt to extract general trends from this maze of diverging results. The northern countries, Germany and the United Kingdom, are situated above this threshold while the southern countries, France, Spain and Italy, fall below. Two thirds of the overall supply of European fiction in 1996 as monitored by EUROFICTION were broadcast by Germany and the United Kingdom.

Given that this first Report comes out when the monitoring process for 1997 is already well underway, it is safe to predict that southern-produced fiction will increase to both in terms of volume and importance, thanks in particular to

Graph 1.2: Countries' share

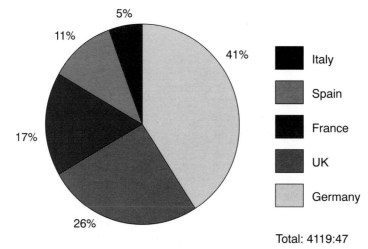

Total: 4119:47

Source: Eurofiction

renewed investments in Spanish and Italian production. It is not uncommon to hear it said in the professional milieus of these two countries – previously known as the 'tail-lights' of European broadcasting industry – that 1996 marks a turning point, thanks to the adoption of innovative processes and overall increases in the production of domestic fiction.

Taking all countries into account, a total of 760 new European listings or new productions were broadcast in 1996. Here, if the dividing line is drawn in terms of number of productions rather than hourly volume, the breakdown of the five countries differs considerably. On the one hand, Germany, the UK and in this case France as well, are able to provide a remarkable menu of new listings, somewhere between 200 and 300. Lagging far behind, Italy and Spain, on the other hand, are under the threshold of 50 productions.

Graph 1.3: Number of productions and episodes

Source: Eurofiction

Seriality Index (n. episodes./n. productions)

Spain	UK	Germany	Italy	France
25.7	9.2	8.5	5.4	4.6

Source: Eurofiction

The two ends of the spectrum – Germany with 297 new productions and Spain with just barely 27 – give a clear picture of the degree to which the productive systems in the different countries vary in terms of quantity and strength. Behind the 200 to 300 programmes produced in France, the UK and Germany, there is clearly a well-oiled industrial machine which in Italy and Spain is either totally lacking or just beginning to take shape.

Using number of listings as a yardstick to measure how much of the national network grids are taken up by domestic production could be misleading, since it establishes a fictitious equivalence between a one-off TV movie, for example, and a serialised programme of dozens and dozens of episodes. Instead, it would be

more representative to consider the number of episodes linked to the type of production format.

Germany's comes out on top regardless of the parameters or indexes used: the weekly average of new fiction episodes (2532 in all) broadcast by German networks in 1996 is close to 50 units. With nearly the same number of listings, British and French production vary significantly in their ability to provide fiction programmes: thanks in particular to segmented productions like soap-operas, the British networks boast an average production capacity of 35 new episodes per week. In the case of French production, this same average drops sharply to 17 units. Spain provides the most striking example. In last place with regard to number of productions, the Spanish broadcasting system distributes 13 weekly episodes of newly released domestic fiction programmes over its own networks. This average is slightly under that of France, and a whole three times as much as Italy's four weekly episodes – though Italy accounts for a greater number of productions than Spain.

The differences pointed out here refer for the most part to the dimension of seriality, a crucial factor for fiction products, (which will be discussed further on in relation to format). In terms of seriality index – the ratio between number of episodes and number of listings – Spanish fiction rates highest (27.7) today. This is because the meagre production is compensated for in a sense by the large number of episodes or instalments per serial programme. At the opposite end of the scale, and in spite of their different production potentials, France and Italy are similar in that they tend to favour 'short-winded' fiction programmes.

One final feature characterising production can be observed in both these countries, though more so for Italy: programmes are broken up into long episodes. There is a clear preference for formats lasting over 60 minutes, and in fact, the standard hour-and-a-half feature film format is adopted most often. The breakdown of episodes according to length reveals three different production patterns or approaches:

– the first model conforms closely in terms of length with international standards. Here scheduling is generally broken into the short half-hour formats typical of soap operas and sitcoms, as well as the medium hour-long formats typically used for series. British and German fiction programmes follow this pattern.

Graph 1.4: Episodes by length

Source: Eurofiction

10

Longer episodes are rare, accounting for a scant 5 per cent in the UK and 12 per cent in Germany.

– the second model, in a sense an exaggeration the first, features exclusively short and medium formats. The latter are often cut into 45 minute segments. Spain is the only country to follow this pattern, which responds in part to its need to speed up production and reduce the costs.

– the third model is characterised by a dual tendency: medium-length episodes play an extremely marginal role, while episodes following feature film standards are much more common than in the other models. This pattern is typical of France and Italy, where long episodes account for 44 per cent and 28 per cent of the total respectively. As will be seen shortly, in the case of French and Italian production, the formats for TV movies and miniseries, which are generally broken into long episodes, dominate to a much greater extent than elsewhere. In these countries, however, the series – at least those scheduled in prime time – are produced in 90 minute episodes, so as to cover as much of this highly competitive time slot as possible. As a result, and in direct contrast to what occurs in Spain, production costs and times are expanded. Moreover, the length of schedule slots is one of the obstacles, though not the only one, to exporting fiction products to countries where programme grids are broken into 30 and 60 minute standards.

Of the 6185 episodes of new domestic fiction productions broadcast in 1996 in the five countries, a total of 2905 – or 47 per cent – were scheduled for prime time slots. Here again, however, striking differences can be noted from one country to the next. These are due not only to diversity in production units and types, but also to differences in the social breakdown of time. This has resulted in a certain degree of variation in the definition of prime time itself. While variations in the positioning and overall length of these time bands are relatively small, four distinct prime time slots can be discerned in the five countries (only France and Italy share the

Graph 1.5: Episodes by time slots

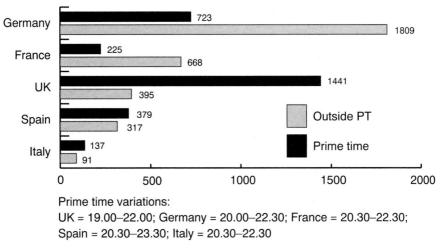

Prime time variations:
UK = 19.00–22.00; Germany = 20.00–22.30; France = 20.30–22.30;
Spain = 20.30–23.30; Italy = 20.30–22.30

Source: Eurofiction

same slot). These span a period from 7.00 p.m., when prime time programming begins in Great Britain, to 11.30 p.m., when prime time comes to a close in Spain.

On the whole, it can be affirmed that countries characterised by a lower production capacity tend to invest proportionately more in prime time slots. This is true for both Spain and Italy, where 54 per cent and 60 per cent respectively of newly produced domestic fiction episodes are concentrated in the evening hours boasting the highest number of viewers. In contrast, both in the case of Germany, the largest European producer, and France, a steady, medium-sized producer, the lion's share of programmes offered (over 70 per cent of episodes) is distributed over slots outside prime time. This for the most part coincides with a relatively low budget serialized production, more suited for stripping.

With 78 per cent of its episodes of new domestic fiction broadcast in prime time, Great Britain would at a first glance appear to go against this tendency. The contradiction however lies primarily in the early start (7.00 p.m.) of the English prime time slot, which includes daily soap operas, the main staple of national production. These are extremely popular and provide an excellent lead-in for evening programmes. In fact, even the English scenario confirms that high production capacity and supply is founded on the basis of a large quantity of domestic fiction produced for time slots, or segments of time slots, outside prime time. This has inevitable repercussions on production typology, budgeting and aesthetics.

The novelty of the break-down of fiction programmes according to formats is that it reveals a landscape which is remarkably, though not totally, homogeneous. With the exception of Spain, the production of fiction in European countries tends to prefer the TV movie format. This European favourite accounted for just under 50 per cent of the programmes broadcast in 1996, ranging from 35 per cent for Great Britain and 58 per cent for Germany.

While TV movies understandably carry little weight in terms of overall hourly volume, the top-priority positions they enjoy on production schedules in all countries except Spain demonstrate the strategic role they play in European broadcasting. More similar to cinema models, they give television fiction a more 'noble' air and upgrade the image of the networks which commission and programme them. This

Graph 1.6: Productions by format

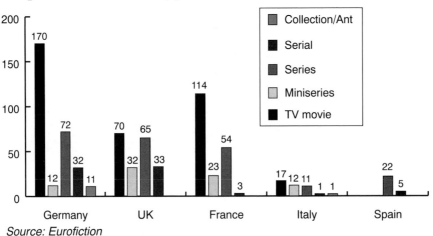

Source: Eurofiction

is also because TV movies lend themselves more easily to the current social issues which tend to be associated with 'good television.' They are also increasingly used (at times more successfully than others) in a conscious effort to dethrone American fiction and even films from prime time slots.

Ranking second in order of importance for the entire group of countries, and first for Spanish network programming, the series as a format shows the best performance in terms of popularity and success. The episodes with the highest ratings in 1996 are all series productions: from *Only Fool and Horses* (UK), to *Tatort* (Germany), from *Une femme d'honneur* (France) to *Il maresciallo Rocca* (Italy) and including *Medico de familia* (Spain).

Miniseries and serials rank last in terms of number of listings, both with a ratio of 1 to 10 compared to total European production, though for very different reasons. whether open or closed, serials are programmes with an extensive number of episodes, and although in Germany and the UK they number over 30, it is unfeasible to produce and broadcast them in large numbers. The costly miniseries format, which is also difficult to squeeze into programme grids, is usually reserved for and limited to fiction specials, international co-productions, or the odd historical remakes and literary re-adaptations belonging by tradition to 'highbrow' public European broadcasting companies.

This plurality of formats can be simplified into a dichotomy: on the one hand, distinctly non-serial formats like TV movies, together with formats containing a low degree of seriality, like the miniseries; on the other hand the bona fide serial formats like series and serials. Using the same data presented in the preceding chart, this classification sheds greater insight on the similarities and differences between countries.

With production focused almost exclusively on series and serial programmes, Spain stands in a group of its own. TV movies and miniseries have been strategically left aside as part of the policy to re-launch domestic production. Under pressure from the competition and other economic uncertainties, producers prefer to

Graph 1.7: Productions by assembled format (%)

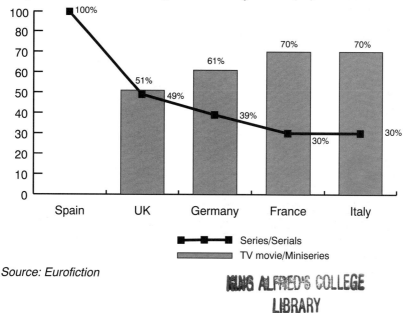

Source: Eurofiction

avoid risks linked to costly formats, and prefer long-winded projects which ensure audience loyalty and provide consistent programming for their grids.

In between Spain and the other countries, Great Britain's production in 1996 was evenly distributed between serial and non-serial types. It is important to remember that this is a question not of hourly volume offered, where series and serials obviously dominate to some extent across the board, but rather of listings and programmes, and thus production projects in which broadcasters and producers have chosen to invest. In the remaining countries, and specially in France and Italy, this choice seems to apply preferably to non serialised productions which, through the TV movies and miniseries formats, bridge the gap between television and cinema.

Finally, a break-down of the fiction supply according to narrative genres divides northern and southern countries once again. Drama is prevalent in almost all cases, with the exception of France, and is linked to a large extent with an abundance of serials in fiction programming. Therefore it does not constitute a distinguishing factor. In contrast, the watershed in this case is comedy and how it ranks on the scale of genres offered. In last place, after drama and action/crime, in Germany and Great Britain, comedy ranks second in Spain and Italy. In France, it actually comes in first, thanks to a generous spate of afternoon sitcoms geared to young audiences.

The comedy series, an original way of re-elaborating formulas and formats borrowed from the situation comedy, has been the cornerstone of Spanish fiction, the key to its most recent hits and a sure bet for its future. In the case of Italy, comedy is even more prevalent than the figures show. This is because humour tends to be a cross-genre element in fiction and 'infiltrates' both drama and crime programmes.

Table 1.1 – Genres

Genre	Germany		UK		France		Spain		Italy	
	hours	*%*	*hours*	*%*	*hours*	*%*	*hours*	*%*	*hours*	*%*
Drama	1009:34	60	632:54	60	238:51	35	242:20	53	89:20	40
Action/Crime	548:05	32	262:13	25	141:14	20	–	–	55:30	25
Comedy	110:57	7	163:39	15	297:18	43	205:20	45	63:56	29
Other	21:11	1	–	–	13:25	2	11:20	2	12:40	6
Total	1689:47	100	1058:46	100	690:48	100	459	100	221:26	100

Source: Eurofiction

Though they do not exist in Spain, crime series account for a hefty share of domestic fiction offered in the other countries. Moreover, and in particular for the detective series, they rate highest in terms of popularity on the public national networks. This genre is part of a long productive tradition in Germany and France, where of the 10 most-watched fiction episodes in 1996, police programmes accounted for seven and five respectively. Even in Italy, after long lull, this genre picked up again in the 1990s, and was used to make the biggest hit of 1996.

2. Cultural Indicators

The interpretation of cultural indicators provides results which are diametrically opposed to the above analysis. Our purpose so far has been to draw out the simi-

larities lying beneath the surface of a relatively diversified topography. It is now necessary to uncover the subtle differences filtering through a surprisingly uniform crust.

European fiction appears to take exclusive interest in stories depicting present-day life: of a total 6200 episode broadcast in 1996, a scant 4 per cent were set prior to the 1990s.

Table 1.2 – Time

	Germany		UK		France		Spain		Italy	
	eps.	%	*eps.*	%	*eps.*	%	*eps.*	%	*eps.*	%
Present	2507	99	1642	89	838	94	694	100	210	92
Past	22	1	158	9	51	6	–	–	18	8
Future	2	–	36	2	–	–	–	–	–	–
Mixed/not av.	1	–	–	–	4	–	2	–	–	–
Total	2532	100	1836	100	893	100	696	100	228	100

Source: Eurofiction

Television in general is notoriously obsessed with the present, and contemporary European fiction deviates in no way from the mainstream. To render the past attractive, particularly the more remote past of previous centuries, stories must be grandiose and sumptuous, and consequently costly. It is not surprising then that broadcasters tend in those cases to prefer co-productions like the *Bible*, *Nostromo*, or *Gulliver's Travels*.

Regardless of the causes, the disappearance of History from the stories of European fiction is in itself highly indicative of the major changes affecting the cultural orientations of television broadcasting. It should not be forgotten that these historical and historical/literary genres, the *heritage dramas*, the *sceneggiati* (as they were called in Italy), were for a long time the staple as well as the pride of public broadcasters in Europe. The most visible traces of this tradition can be found today in English fiction, with 158 episodes (roughly 1 for every 10) set in the past. At the opposite end of the spectrum, Spanish production continues to pursue its goals for re-launching the sector by cutting down on the range of formats, genres and even time dimensions.

Table 1.3 provides irrefutable proof that television is basically a 'local medium.' In the five European countries, 93 per cent of domestic fiction episodes were filmed or at any rate set somewhere within the national borders.

The 'sense of place,' the familiarity and easily recognisable elements of the setting, the scenery, the interiors and exteriors as integral parts of the story and not merely backdrop, is in itself a basic component of the 'cultural proximity' principle which comes into play in most consumer patterns, and which, in the case of television fiction, leads domestic television viewers to prefer home-grown production as a rule. Domestic fiction plays an essential role in this by focusing on the localization of the imaginary, in an overall cultural context which is open to an influx of global trends and influences.

Table 1.3 – Place

	Germany		UK		France		Spain		Italy	
	eps.	%	*eps.*	%	*eps.*	%	*eps.*	%	*eps.*	%
National	2368	93	1726	94	754	84	696	100	207	91
Internat.	22	1	110	6	87	10	_	_	5	2
Abroad	142	6	_	_	52	6	_	_	16	7
Tot.	2532	100	1836	100	893	100	696	100	228	100

Source: Eurofiction

It is nonetheless legitimate to ask whether such an inward-looking approach to production might not also prove to be a barrier to its own exportation, preventing it from being accepted beyond national borders. This is not to suggest underestimating the role of the *place* factor, which we consider in this case to be a metonymy of fiction with a strong national flavour. Nor would a kind of 'TV tourism' be desirable. It has already been put to the test in a series of well-meaning European co-productions, but the results were disappointing both in terms of artistic creation and ratings. The problem remains however, and its solution depends on our capacity to understand how at least a portion of domestic production in Europe can be instilled with a 'sense of place' in such a way that it appeals to non-domestic (and non-European) audiences as well.

With reference to the figures, as occurred in the case of time factors, the spatial dimension reveals individual variations with respect to the mean. With 16 per cent of the episodes set in countries other than France, or exclusively abroad, French fiction is a striking example of a cosmopolitan orientation.

Domestic fiction for the most part tells stories about urban and metropolitan Europe, although there is a wide range of variation between the different countries: anywhere from 50 per cent in France (one episode out of two is set in a big city or large town), to 83 per cent in Germany, where more than any other country, the reality depicted is predominantly urban.

In effect, compared to their counterparts, the cultural indicator environment presents a considerably more varied picture. In addition to urban reality, which is depicted in 72 per cent of the episodes broadcast in 1996, broadcasting time and space is given to the small world of provincial life, a speciality of French fiction, and even to rural surroundings, particularly in England (one episode out of five).

The interest of stories about provincial towns and villages goes beyond their substantial yet secondary weight in European fiction. It can be seen in the *Programme Index* presented in the second part of this report that small towns and villages often provide the setting for the most successful programmes. In France and Italy, the most popular productions by far in 1996 featured provincial settings. Even the depiction of big cities does not always correspond to the images, life styles, and types of relationships typical of large spaces and urban sprawl, to that unmistakably metropolitan flavour so prevalent in American fiction. On the contrary, urban and metropolitan *society* serves only as a backdrop for the local *community*, and is often honed down to a neighbourhood, a workplace, a network of interpersonal relationships, which plays the central role in many European fiction stories. English soap operas are an example of this.

Table 1.4 – Environment

	Germany		UK		France		Spain		Italy	
	eps.	%	eps.	%	eps.	%	eps.	%	eps.	%
Big town	2098	83	1284	70	444	50	459	66	168	74
Small town	114	4	185	10	309	35	236	34	29	13
Other	320	13	367	20	140	15	1	-	31	13
Total	2532	100	1836	100	893	100	696	100	228	100

Source: Eurofiction

This brings us directly to the fourth cultural indicator, the main character. Televised serials, most commonly in the form of soaps, are characterised among other things, by what might be called 'lead clusters'. The central feature of the story is not one main character but a group of leading characters (this feature is closely linked with the complex narrative structure of the genre).

Table 1.5 – Main Character

	Germany		UK		France		Spain		Italy	
	eps.	%	eps.	%	eps.	%	eps.	%	eps.	%
Male	412	16	250	14	122	14	112	16	69	30
Female	125	5	113	6	116	13	86	12	12	5
Male group	121	5	82	4	7	1	25	4	10	5
Female group	43	2	45	2	66	7	39	6	7	3
Choric/ Other	1831	72	1346	74	582	65	434	62	130	57
Total	2532	100	1836	100	893	100	696	100	228	100

Source: Eurofiction

It is not surprising therefore to find that Germany and Great Britain, the two countries offering the largest volume, broadcast the highest percentage (70 per cent) of episodes with lead clusters. The generous volume of programmes offered is due also to the fact that these countries produce the most serialised programmes. As a matter of fact, the use of a single lead character, traditionally the hero of classical narratives, appears to be fading on all fronts. However, southern European countries are different in this respect. Stories revolving around a single main character are more frequent, as is the case, for example, in Italian fiction.

In most cases, the main character is male. If all countries are considered, episodes featuring male leads outstrip those with female leads by more than two to one. French production is the most evenly distributed in this respect, while for German and Italian fiction, the gap between male and female characters is far above the average. On the other hand, it is possible to note that in certain countries, female characters have taken on roles and genres traditionally played by men. It is not uncommon for example to find women leads in detective or police series. This has also brought about new inflexions and shifting profiles in this narrative genre itself.

3. Co-production and imports

The term 'domestic' fiction is a particularly appropriate label for the European production monitored in 1996. Of a total 760 listings, no more than one out of 6 were the result of co-productions. The ratio is even lower if the scope is limited to co-productions with other European countries.

Graph 1.8: Types of production

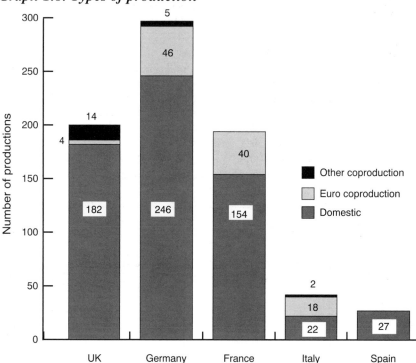

Source: Eurofiction

The chart shows once again how differently the various countries behave. At one extreme, Spain provides exclusively home-produced programmes; at the other there is Great Britain, which maintains favourite and almost exclusive co-production partnership with same-language non-European countries (Australia, New Zealand). Germany, France and Italy are the only countries to opt regularly for co-productions with other European partners, to the overall tune of one programme out of five. However, although these three countries participate reciprocally in joint-efforts, Germany and France have a clear preference for co-productions with countries from the same linguistic area (Austria and German-speaking Switzerland, on the one hand; Belgium and French-speaking Switzerland on the other). This option is obviously less feasible for a country like Italy.

Aside from the linguistic limitations, which constitute a veritable *language disadvantage* as opposed to the *language advantage* shared by English-speaking countries, the reluctance to produce fiction in partnership with other European countries is the consequence of a series of negative experiences and the ever-present fear of producing another batch of the so-called *Europudding* of some years ago. In order

to avoid this *Europudding*, the recent trend is to co-produce stories with strong local roots, whereby the stories are basically national for the major partner, but also provide broadcasters from other countries with an audience share proportionate to the sums they as secondary partners have invested. A number of Franco-Italian or Italo-German co-productions follow this pattern.

It is not to be excluded that the relatively modest ratings achieved by co-produced fiction programmes (with some exceptions), which are often cited as proof of the low profitability of co-productions, may to some extent be the fruit of a *self-fulfilling* prophecy. Because of their biases and low expectations regarding these joint efforts, broadcasters tend to relegate such programmes to marginal positions in the grids, where they are often penalised.

A final comparison looks at a broader scope of exclusively domestic fiction, although the time frame monitored is more limited. The *sample week* chosen ran from 2 to 8 March, 1996. In terms of programming, this was an extremely ordinary week in all countries, and featured no special events to make it stand out from the norm. This study monitored all programmes across the board, whether domestic or imports, first runs or reruns, broadcast between 8.00 am and 1.00 am.

The results gathered during this monitoring process, whose limits in terms of dates and times have been specified, are not to be generalised. It would be inappropriate to use them in order to calculate the yearly amount of fiction from various origins broadcast over national television networks. The purpose of this study, or rather

Graph 1.9: Origin of TV fiction (sample week 2–8 March 1996)

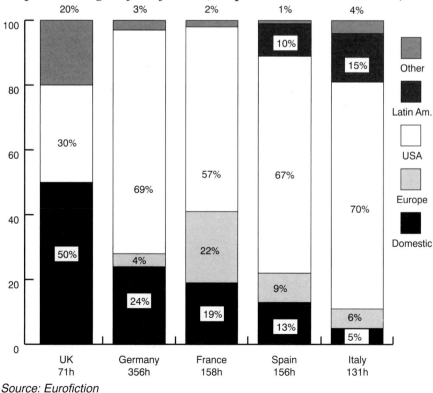

Source: Eurofiction

the answer these results intend to provide consciouly concerns a very precise issues: the distribution of fiction programmes over programme grids in the five different countries during the same week. An analytical interpretation of these figures can be carried out following the three dividing lines marked out by the different types of offer.

Domestic fiction. The amount of fiction produced domestically reaches significant proportions in Great Britain only (50 per cent), within the framework of a relatively modest weekly offer of fiction in terms of overall hourly volume (71 hours). Broadcasters in the southern countries offer twice as much, on average, while the German networks offer up to five times as much.

In Germany, France, Spain and Italy, the share of local fiction broadcast during this week peaks at a threshold of 24 per cent (Germany), decreasing gradually from there on to arrive at a scant 5 per cent (Italy). There is clearly an enormous gap between what occurs in Germany, with an impressive offer of 356 hours of fiction – 85 of which are home-produced – and the situation in the other countries. However, even in Germany, the domestic product barely reaches a ratio of one hour for every four. Given the vast and fragmented market at hand, this gives a clear idea of the dire straits in which even the largest producing countries of Europe can find itself.

European imports. Fiction imported from other European countries acts as a watershed, in this case between France and all the other countries. During the week in question, European-made programmes make a regular appearance (22 per cent), which is actually greater than domestic broadcasts, on French channels only. Totally absent from English grids for the week, the amount of European imports broadcast in the other three countries is marginal or minimal.

Non-European imports. Great Britain, thanks to the hefty amount of purely domestic fiction broadcast, and France, with its substantial portion of European fiction offerings, are the least dependant on imports from beyond Europe (50 per cent and 59 per cent respectively). In the other three countries, international imports break through the 70 per cent threshold, but nowhere do they account for such an enormous share as in Italy, where 90 per cent of the fiction broadcast for this week came from non- European countries.

Programmes from the US are, as can be expected, omnipresent. This is one of the common features unifying European programming grids, though each country follows a different pattern. In Germany and France, non-European fiction offerings are almost equal to US products (69 per cent and 57 per cent respectively). Spain and Italy, on top of the North American fare, offer a fair share of programmes from Latin America (10-15 per cent). US fiction scores lowest in Great Britain (30 per cent) in an overall offer which includes Australian productions as well (20 per cent). In the case of Great Britain recourse to imports tends to contribute to, rather than detract from, the homogeneity of a fiction supply whose countries of origin are different yet belong to the same language group.

As is the case with all results gathered by EUROFICTION, these data concerning the sample week will become even more significant when, in the years to come, they can be observed in relation to where they stand in the overall historical progression.

2. Women and Cops

French Television Fiction in 1996

Régine Chaniac and Jean-Pierre Jézéquel

1. The Television Scene

In 1996, there were seven channels providing nation-wide coverage over-the-air in France. The first three channels – TF1, France2 and France3 – came into existence on January 1 1975, following the break-up of the former French broadcasting service, ORTF. TF1 was privatised in April 1987 by virtue of an act of parliament passed on 30 September, 1986. The TF1 franchise, held by a consortium of shareholders led by the construction and civil engineering group Bouygues, was renewed for a further five-year term in March 1996.

France2 and France3 (formerly Antenne2 and FR3) are public-service channels financed through both television licence fees and advertising. Since 1989, the two stations have been under the authority of a single president, but they continue to operate as two quite separate entities.

CanalPlus, which began broadcasting in November 1984, is a scrambled channel whose mainstay is sport programmes and movies. Most of its financing comes from subscriptions. The channel served over 4 million subscriber households in 1996, roughly one-fifth of France's TV-viewing households.

M6 is a commercial channel. Established in 1986 as TV6, and initially created as a music channel, its franchise was awarded a year later to a Métropole TV group of shareholders led by CLT. It still maintains a music component (videoclips), which it broadcasts during low viewing times (daytime, night). Its broadcasting franchise was renewed this year for a five-year period.

Since September 1992, The Franco-German cultural channel Arte has been broadcasting on the 5th channel, vacated a few months earlier with the folding of La Cinq, a private company set up at the same time as M6. Arte does not start broadcasting on this channel before 7.00 pm (until 3.00 am).

Since December 1994, *La Cinquième*, the 'knowledge, training and employment' channel has been broadcasting its programmes during the unused daytime slot on this channel (from 6.00 am).

Table 1 gives the breakdown of French television shares per channel (viewers 4 years old and over) in 1996:

Table 2.1 – 1996 Market Share of French TV Channels

TF1	35.3%
France2	24.2%
France3	17.7%
M6	11.2%
Canal+	4.5%
Arte/5	3.0%
Others	3.4%

Source: Médiamétrie

France's public-service television bottomed out in 1988-91, when it held less than one-third of the market. This was a direct result of the privatisation of TF1. But in 1992, it began regaining ground, and by 1996, it accounted for 44.9 per cent of the total national audience. This comeback was made thanks to France2, and even more so to France3, which saw its share increase by over 6 per cent between 1991 and 1996.

The average amount of time French viewers four years old and over spent in front of the TV stood precisely at 3 hours a day in 1996. Average viewing times kept rising until 1991, then slackened off between 1992 and 1994, before settling at their present level.

2. Trends in the Supply of TV Fiction

For years, televised fiction accounted for only a limited part of the schedules for public channels, after news and current affairs, game shows and variety. In 1983, the three existing channels broadcast a total of 1,265 hours of TV fiction, or 12 per cent of their schedules. If movies are also included in this category, then the total fiction broadcast added up to less than 20 per cent. As the channels did not go on the air before lunchtime (FR3 began at 18:00), fiction was largely broadcast in the evening, and to a lesser extent in the afternoon. Domestically-produced programmes filled a third of the TV fiction requirements, the rest being made up of foreign, mainly North American, productions and re-runs.

TV fiction broadcasts sky-rocketed between 1983 and 1991, with the coming of the new commercial channels (La Cinq and M6) and the increased supply of the genre on the older networks – over 12,000 hours annually, almost a third of total programming time. TV fiction outstripped all other genres. In 1989, La Cinq dedicated more than half its schedule to fiction. M6 followed with 40 per cent, then TF1 with 32 per cent. Public channels increased their share of fiction in an effort to fight off the competition and fill the newly-opened time slots, first in the afternoons, then mornings. The daily volume of fiction broadcast on Antenne2 quadrupled, accounting for one-quarter of its schedule in 1991. FR3 was the only channel where TV fiction remained a secondary genre, after magazines, news & current affairs, and entertainment for teenagers and children. In 1991, it was also the only French TV channel not broadcasting round the clock. Instead, it signed off at 1.00 am and started up again at 8.00 am.

TV fiction was everywhere. It occupied a large part of the schedules in the morning, afternoon and early evening on the private networks. The new channels, La Cinq and M6, offered nothing else in the evening. As might be expected, first-run domestic fiction failed to keep up with this increase. In 1989, it accounted for roughly 1,500 hours annually. The new channels behaved largely like secondary operators, programming re-runs of old French series produced by the former ORTF, and purchasing programmes abroad.

After 1992, following the closure of La Cinq, the genre fared poorly for the first time, plunging to less than 9,000 hours. But over the next two years, TV fiction staged a recovery, increasing its volume on all channels except TF1. The table below shows the volume of TV fiction broadcast in 1996, together with its share of total programming time per channel.

Table 2.2 – Total TV Fiction Offered in 1996

	Total	TF1	France 2	France 3	Arte	La Cinquieme	M6
Hours	9411	2646	1688	1199	422	346	3110
Percentage	22.8	30.3	19.3	16.3	14.5	7.3	35.6

Source: Médiamétrie

3. Sample Week

During the sample week, the six channels offering unscrambled nation-wide coverage broadcast a total of 158 hours of fiction, accounting for 24 per cent of all programmes broadcast in this particular time slot. This weekly volume coincides with the annual total given below, given that roughly 1,000 hours of fiction were broadcast in the night.

Table 2.3 – Origins of TV Fiction Broadcast over the sample week 2-8 March, 1996

	Dom.	Euro	USA	Other	Tot. min	Tot. hrs
TF1	913	106	1458	–	2477	41:17
France 2	281	622	952	44	1899	31:39
France 3	89	116	914	–	1119	18:39
La Cinquième	–	–	123	–	123	2:03
Arte	–	190	138	178	506	8:26
M6	510	1018	1859	–	3387	56:27
Total minutes	1793	2052	5444	222	9511	158:31
Total hours	29:53	34:12	90:44	3:42	158:31	

Source: Eurofiction

M6 made its mark as the leading fiction broadcaster in terms of volume (42 per cent of its schedule), followed by TF1 (31 per cent) and France2 (24 per cent). France3 came far behind with 14 per cent. Traditionally a channel catering to regional interests, in addition to broadcasting movies, it programmed very little

fiction until the mid-1980s. Though it began a marked upward swing in 1992, it still lags behind the previously-mentioned channels. Arte and La 5ème combined broadcast only ten hours or so of TV fiction.[1]

French-made TV fiction accounted for less than a fifth of total fiction programmes broadcast. This figure might seem fairly low compared to the 29 per cent quota set by the broadcast monitoring authority CSA for the year 1995. However, the CSA classification of fiction includes programmes not considered as such in this study: animation films and children's fiction broadcast in time slots specifically designated for children. It is not clear therefore whether the week selected is actually so atypical compared with the rest of the year.

The scant volume of domestically-made fiction reveals how difficult it is for France to produce long-running TV fiction programmes to fill the daytime and early evening slots. In the week under study, TF1 was the only channel to broadcast French-made fiction in any considerable quantity (early morning and late-afternoon). More specifically, it included four 26-minute sitcoms programmed back-to-back between 17:00 and 19:00 over the five week days. M6 also succeeded in broadcasting two programmes daily between 17:00 and 18:00: a 40-episode sitcom which it produced itself, and a 52-episode co-production with Canada (*The Black Stallion*). On France2 and France3, French-made fiction appears only in prime time, with the former programming it over three evenings and the latter only one. It should be noted however that French-made fiction programmes are not missing from daytime slots all year round on France2, which occasionally broadcasts a 26-minute series for teenagers during late afternoon (*C'est cool* for a part of 1996).

Half the domestic fiction productions were new releases. Once again, TF1 was in the lead, being the only channel to schedule domestic fiction programmes in daytime slots, with a total of three of its daily sitcoms being run for the first time. In the week under study, it filled only one evening slot, Friday, with a first-runner serial (*Une famille formidable*), the Thursday slot having been pre-empted by live coverage of a football game. The three France2 programmes were first runs: a mini-series on Monday (*Les Allumettes suèdoises*), a television movie on Wednesday and a series on Friday (*Les Cinq dernières minutes*). Similarly, the only fiction programme on France3 was a newly-released TV movie shown during the regular Saturday evening slot. On Thursday evening, M6 broadcast one of its rare domestic TV movies (14 over the whole year).

European-made TV fiction fared relatively well in the week under study, accounting for 22 per cent of all the fiction broadcast. CSA statistics show that in 1996, European fiction productions accounted for only 18.6 per cent of the total fiction broadcast in France. France2 and M6 broadcast the most European-made productions. The public channel regularly broadcast two 60-minute German series (*Derrick* and *Le Renard*) every day around 14:00. The private channel scheduled reruns of several British-made series (*The Avengers*, *The Saint*, etc), including one

1 One week cannot be considered representative for these two channels. Arte tends to broadcast television movies from a wide range of horizons (in the week under study, three came from India) or short series – often British and German productions – broadcast at 19:00. In this particular week, it was an American series (*Hollywood Collection* 1950). La Cinquième regularly programmes the American series *Rintintin*, along with old French series during certain periods

every morning (*The Professionals*), and two TV-movies broadcast in two parts on Sunday afternoon and Wednesday evening. France3 concentrated its European-made broadcasts on Sunday evening, with *Derrick* and *Un cas pour deux* programmed in succession. Apart from Germany and the United Kingdom, the only other country represented here is Italy, with *Projet Atlantide*, although it is broadcast at 06:00 on Sunday on France2.

American-made TV productions met more than half the demand (57 per cent) for fiction on the six channels, which is higher than the rate set by the CSA for 1996 (46 per cent). In terms of hours, M6 resorted most to North American suppliers (31 hours a week), followed by TF1 (24 hours). But with 15 hours, France3 beat all records by importing four-fifths of its fiction programming from the United States. This particular week is not representative to the extent that the public channel usually turns to European-made productions to fill a part of its daytime slots (*Les rivaux de Sherlock Holmes*). However, this shows that it would have been impossible for this channel, like so many others, to gradually introduce extended drama slots in daytime viewing without resorting to foreign, and in most cases, American fiction.

Table 2.4 – Origin of Television Fiction offered in 1996

Total in hours	TF1	France2	France3	Arte	La 5ème	M6	Canal+	Total
Total fiction	3355:42	1978:27	2226:16	496:54	812:18	3351:01	1024:03	13244:4
France (29.7%)	1386:19	565:33	622:29	113:11	325:18	569:26	346:08	3928:24
Europe excl. France (18.6%)	279:21	580:16	442:35	261:27	140:52	508:04	247:12	2459:47
European Community (18.2%)	279:21	572:57	441:25	243:39	118:00	508:04	247:12	2410:38
United Kingdom	19:25	17:25	179:18	70:39	35:40	317:23	153:58	793:48
German	136:01	504:51	111:19	128:14	13:54	109:07	7:23	1010:49
Italy	54:46	30:25	44:09	–	0:16	65:38	35:34	230:48
Netherlands	31:55	–	25:34	2:49	1:07	–	–	61:25
Spain	–	11:41	10:53	14:54	12:01	–	10:33	60:02
Sweden	–	–	–	0:04	0:36	–	24:44	25:24
Austria	–	6:51	–	3:14	–	–	–	10:05
Portugal	–	–	–	10:03	–	–	1:52	6:05
Other European countries (0.4%)	–	7:19	1:10	17:48	22:52	–	–	49:09
Roumania	–	–	–	–	20:19	–	–	20:19
Switzerland	–	5:52	–	3:03		–	–	8:55
Non-European countries (51.8%)	1690:02	832:38	1161:12	122:16	346:08	2273:31	430:43	6856:30
USA	1492:46	674:20	1017:13	106:49	315:38	2147:35	402:32	6156:53
Japan	134:05	–	92:46	–	–	1:03	–	227:54
Australia	59:27	107:55	17:35	7:18	3:11	17:31	–	212:57
Canada	3:44	19:30	11:31	–	24:32	29:	25:08	113:25

Source: CSA

A scene from *Les allumettes suédoises*

Photo: Hamster Productions/Bernard Fau

US-made TV fiction is in fact noticeably present in daytime and early- evening programmes across the board, with French-made productions taking over in the evening. M6 is the only channel to regularly broadcast US-made fiction in the evening. In the case of the week under study, these consisted of the Friday TV movies and three *X-Files* episodes shown back-to-back on Saturday evening.

4. Domestic TV Fiction in 1996

Table 2.5 – Domestic Fiction in 1996

	France2	*France3*	*TF1*	*M6*
Total in hours	180	82	325	104

	Public channels		*Private channels*	
Total in hours	262		429	

Source: Eurofiction

The four major networks analysed in this study broadcast 690 hours of domestic fiction in 1996. It is worth pointing out that CanalPlus normally produces 40 hours of dramatic fiction a year, and Arte some 20 hours. In most cases, the productions commissioned by CanalPlus and broadcast first on its own channel appear unscrambled a few months later on another channel when they are picked up as first run works by this study. The 690 hours of French-made productions correspond to a ratio of one hour of domestic fiction for every 12 to 13 hours of fiction broadcast on these same four channels. It should be underlined that a certain number of programmes (for children) are not taken into account in our monitoring, but are part of the sum total of fiction broadcasts.

It should be pointed out that TF1 alone accounts for almost half the total of domestic fiction broadcast – 325 out of 690 hours. The two public-service channels combined, France2 and France3, do distinctly less well (262 hours) than TF1.

One 'objective' observation can be made on the basis of this analysis of fiction programmes: the fiction produced is by preference strictly home-grown. At the same time, public and private channels are clearly divided, sometimes with considerable gaps, according to their attitudes towards opening up to foreign producers. The total lack of interest in co-productions is particularly striking in the commercial channels. Co-productions accounted for only six titles out of 68 on TF1 in 1996, with the programmes concerned adding up to only 22 hours and 30 minutes of overall viewing time (out of a total of 325 hours, it should be remembered), a grand total of 7 per cent. The imbalance is slightly less marked on M6, with four productions out of 23, amounting to 26 hours and 30 minutes, out of a total 194 hours. On the other hand, for France2, twenty co-productions out of 67 accounted for 71 of the total 180 hours, a hefty one-third. France3 co-produced 10 drama programmes accounting for 34 hours (out of 82), an even better ranking than France2.

Programmers today see international co-productions as a form of fiction conveying cultural references that are less familiar or spontaneous, and therefore not easily accessible to the general public. In addition, cross-border productions do not easily lend themselves to the series format which, as shall be seen below, is at present the most popular. In the most commonly used technique, each of the co-producing countries takes turns making one (or several) episodes or seasons of a series, with the lead roles being played by the same actors. Some episodes of *Julie Lescaut*, *Maigret*, *L'Instit'* and *Docteur Sylvestre* (to name only a few) were co-produced using this formula.

In view of this widely shared bias, it is hardly surprising that international coproductions continue to be a prerogative of the major state-owned channels. This is

Gérard Klein and Catherine Wilkening in 'Demain dès l'aube', an episode of *L'Instit*

Photo: Hamster Productions/Bernard Fau

true not only for France, but for most other European countries as well. Under pressure to boost their ratings and advertising revenues, private channels opt for typically home-grown fare.

After analysing a year's worth of programmes, it can also be stated that the series is unequivocally the prevailing format with regard to domestically produced fiction. Once again, this preference is more common with the private channels than in the public sector. This prevalence given to series is particularly striking in the case of TF1, where they accounted for 244 out of 325 hours of fiction (television movies accounted for 41 hours, mini-series for 26 and a serials for 14 hours). On the other hand, the dominant genre on France2 was the television movie, with a total of 85 out of 180 hours.

But such 'static' considerations do not fully convey how firmly the series has caught on as a dominant genre in French television. A channel like France3, which still lags behind its competitors as far as the overall volume of its domestic fiction is concerned, recently produced a series with a 'recurring hero'. The encouraging audience ratings rewarding this initiative show just how successful this format is with the public. TF1, as a rule, creates spin-offs centred around the characters of successful television movies: The series *La Mondaine*, *Les boeufs carottes* and *Deux justiciers dans la ville* all started out as stand-alone television movies. *Madame le consul* can be expected to spin off its own series. This programming gambit also gives more weight to the series in programme grids, though this does not show up in our statistical tables. Programming a series makes it possible to skilfully mix old episodes together with new ones. Such a practice can be observed both in daytime viewing (when a succession of 20 to 30 new episodes and reruns are programmed), as well as in prime time slots (where reruns and first runs of stand alone episodes alternate).

The French channels have adopted this practice rather successfully: the audience shares of episodes broadcast as re-runs have in no way been affected. For example, the highest rating recorded in 1995, across the board, was a re-run from the *Julie Lescaut* series. The fact that only the best episodes are selected for repeat programming cannot be the only explanation. The success of episodes broadcast for the second and even third time shows above all that the public is unquestionably attached to its familiar heroes, even when they are reliving adventures it has already seen.

This description of the mechanisms behind the programming process helps explain why French series play a heftier role in programme grids than the statistics regarding first-run domestic fiction broadcasts would seem to reflect. Television movies and mini-series are less frequently programmed as repeats, except when they score exceptionally well in the ratings. Prime time serials are often rerun by the same channel at later dates. Most often they take the form of daytime reruns of soaps cut up into 26- or 52-minute episodes.

In terms of format, or programme length, French fiction generally assumes two forms, with programmes running 26 minutes (for daytime) and 90 minutes (for prime time). The 52-minute format, so common internationally, is almost never used in France.[2] Only three out of 68 programmes broadcast on TF1 last year lasted 52 minutes. The figures for France2, France3 and M6 were respectively none, two and one. However, as producers are also anxious to sell their programmes on the

2 For domestically produced TV drama.

Veronique Genest, Alexis Desseaux and Laurence Figoni in 'Propangande noire',
an episode of *Julie Lescaut*

Photo: TF1

international market, 90-minute episodes broadcast in France are frequently refor-
matted as two 52-minute episodes for foreign television networks. This practice,
also common in the case of co-productions, is easier to implement for mini-series
and soaps than for one-off programmes (television movies). Pierre Wiehn, one of
France's most eminent programming experts, explains the preference for the 90-
minute format in prime time:

> The television viewer invests his free time carefully, in order to ensure
> maximum pleasure. In other words, with some 90 to 120 minutes avail-
> able every evening for watching television, and all programmes being
> of equal interest, the viewer will choose the length which best suits the
> time available. In such conditions, the 45- to 50-minute episode of a
> series has little chance of prevailing over a 90-minute programme.[3]

The odd drama running 52 minutes (or thereabouts) is reserved for the late (or even
late-late) night slots, after 22:00 or 23:00, or daytime (Sunday, for example).

5. Successes and Failures

Before examining the strictly qualitative aspects of TV fiction, attention should be
drawn to an outstanding feature of French television. While domestic production
has for many years now been successfully turning out fiction programmes in great
quantity for prime time slots, actually increasing their ratings, French production
still has a hard time supplying domestic productions for daytime slots. As a result,
American-made series fill up the better part of their grids. This imbalance is
already noticeable in terms of quantity. TF1, the channel that has worked hardest

3 Pierre Wiehn in *Le prime time en Europe*, INA/Carat TV study, December 1989.

29

to promote domestic fiction on daytime television, lists not more than twelve 26-minute titles out of an annual total of 68. Even if the weight of these programmes in terms of hourly volume is proportionately far more significant, these figures show that the bulk of fiction is programmed for prime time. During the evening, in contrast, fiction is programmed no more than three times a week, whereas programme for daytime slots runs daily (i.e. five days a week). This imbalance is even more striking on the other channels.

A good part, if not most, of the up-market fiction broadcast in the evening falls into the cops-and-crime category. For many years (from the 1950s to the 1980s), it was the leading genre in French cinema. Big-name actors like Jean Gabin, Lino Ventura, Alain Delon and Jean-Paul Belmondo revelled in detective movies. This genre has always been a part of television. Incidentally, France's oldest televised drama series, *Les 5 dernières minutes*, which dates back to the early 1960s, is a detective series. Nevertheless, toward the end of the 1980s, the detective story became the leading genre in television fiction.[4] In a certain sense, television took over from cinema, where the genre was losing ground. While it would be difficult to prove that the waning of the cop movie favoured the growth of television drama, or vice versa, it is possible to state that cop movies began losing popularity in French cinema production before television entered its period of rapid expansion. Of the top ten drama programmes in 1996, eight were episodes of a detective series.

It should also be pointed out that with the boom in the cop story, certain aspects of the genre have changed. The leading character is no longer a man, but either a woman (*Julie Lescaut*), or a whole family complete with father, daughter and son (*Les Cordier, juge et flic*). Not only does the hero (or heroine) have a family life, with all its ensuing problems, but these tend to get in the way of the story's plot, when they do not actually become its central feature. Story-lines are no longer restricted to uncovering a conspiracy, or investigating a more or less intricate crime. Cop stories are used more and more as a vehicle for examining social problems like terrorism, medically-assisted death, suburban life, battered children, religious fundamentalism, drug addiction, pro-life commando groups and so on.

Perhaps the most innovative development of the cop story in recent years has been its tendency to spread beyond the confines of its original setting, the police force, and move into professions and social activities which have little to do with police precincts. Certain characters have in a way been turned into police heroes: the judge (*Le juge est une femme*, *Le JAP*), the lawyer (*L'avocate*), the amateur antique dealer (*Adrien Lesage*), the parish priest (*Le juste*) and even the school teacher in *L'Instit'*, who spends more time unravelling a tangled plot that the police should be working on than in teaching his class or keeping order in the school yard.

Two tendencies can be observed here. On the one hand, the cop is increasingly becoming part of the social fabric, even in the most trivial and intimate aspects. On the other, the recurring heroes in many dramas, in spite of any apparent police vocation, find themselves faced with the task of uncovering a relatively illicit affair. The aim here is to maintain the involvement and programme loyalty of an audience regarded (and rightly so) as increasingly fickle. These two aspects, moreover, fall into a more general pattern where the boundaries between traditional television genres such as entertainment, magazine and documentary, for

4 For prime time drama.

example, are becoming blurred. In this case, it is the distinction between the various kinds of TV fiction (detective, tragedy, family plot, comedy) which is beginning to fade.

Table 2.6 – Top 20 TV Fiction Episodes in 1996

No.	Title	Date	Channel	Genre	Share	Rating
1.	Une femme d'honner	21.11	TF1	crime	53.6	22.2
2.	Julie Lescaut	29.02	TF1	crime	51.7	23.4
3.	Navarro	9.05	TF1	crime	49.1	21.0
4.	Les Cordier juge et flic	5.09	TF1	crime	46.1	17.6
5.	Terre indigo	5.08	TF1	drama	44.3	13.5
6.	Le juste	12.04	TF1	drama	43.6	17.9
7.	Commandant Nerval	12.05	TF1	crime	43.4	17.4
8.	Une famille formidable	5.04	TF1	comedy	43.0	18.0
9.	Une femme dans mon coeur	19.04	TF1	comedy	42.6	17.0
10.	Sixième classique	31.05	TF1	comedy	42.3	16.4
11.	Le juge est une femme	18.01	TF1	crime	41.2	17.7
12.	Loin des yeux	12.01	TF1	drama	41.2	16.8
13.	Le bébé d'Elsa	20.11	France2	drama	39.9	17.0
14.	Les boeuf carottes	10.10	TF1	crime	39.5	16.0
15.	Petite soeur	2.02	TF1	drama	39.5	16.9
16.	L'Instit	28.02	France2	drama	39.1	18.6
17.	L'Orange de Noël	11.11	France2	drama	38.4	16.3
18.	Madame le Consul	26.04	TF1	action	38.0	14.4
19.	La ferme du crocodile	14.12	TF1	drama	37.6	14.5
20.	Chaudemanche père et fils	13.05	France2	comedy	37.4	16.7

Source: Médiamétrie

Given these themes of social adaptation and integration into today's reality, it is relatively easy to explain the growing importance of feminine leads in the major French television series. Heroines are now just as numerous as their male counterparts: *Imogène, Le juge est une femme, Julie Lescaut, Une femme d'honneur, Madame le consul, Madame le proviseur, L'Avocate, Anne Le Guen.* Lead roles in stand-alone television movies are also just as equally split between men and women. It is indicative that M6 chose the title *Combats de femmes* for a collection of independent television movies (*Un monde meilleur, À découvert*). Programme directors are becoming aware that more women watch television, and that the number of women entering the labour market in France has grown considerably over the last 25 years. Looking at the ten TV programmes with the highest audience ratings in the chart mentioned earlier, the main characters were male in four cases, female in five, while one featured a family.

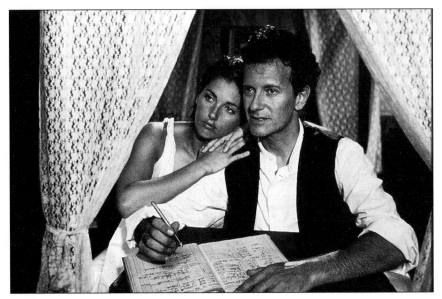

Christiana Réali and Francis Huster in *Terre Indigo*

Photo: Néria Productions-TF1-ICAIC-SOTEL/ Dominique Maestracci

French prime time televised fiction can hardly be reproached for ignoring today's social issues. Families are almost always multi-parental with children torn between two households. Aids, runaway children, juvenile delinquency, incest, violence in suburban housing estates and its reflection in schools, unemployment, racism, people over their heads in debt, couples caught up in domestic conflicts because of widely differing cultures, religions and social backgrounds, etc. These issues either serve as backdrops or provide the narrative momentum for many TV dramas.

While this involvement in such crucial social issues characterises prime time TV drama, the same cannot really be said of the fiction served up during daytime viewing. The fiction programmes of interest here come on the air in late-afternoon. They also happen to be the most numerous and have the largest audiences, for those broadcast in late-morning, night-time or late-night slots are marginal. These TV series are kind of sitcom, packed into 26-minute formats, with a few rare exceptions, and programmed in a succession of at least 20 episodes. They are above all shown on the private channels. France2 rarely carries them, and France3 never does. The overwhelming majority of these series are therefore to be found on TF1. For many years, most of them were produced for this channel by AB Productions,[5] which has turned out programmes like *Les années fac, Les filles d'à côté, Le miel et les abeilles, La philo selon Philippe* and *La croisière Foll'amour.* Last year, TF1 started cutting down on its orders to AB. This year, AB programmes have become scarce in TF1's timetable. The AB Productions series are nearly all

5 AB Productions was set up with the introduction of digital television broadcasts (AB Sat). Since December 1996, the company has been quoted in Wall Street, where it raised a capital of F1.2 billion.

constructed along the lines of *Hélène et les garçons*, one of its first productions. Highly successful at first, its popularity then waned until it was taken off the air in 1995. This series is about a group of young, rather student-type boys and girls with no easily-identifiable social characteristics living in an enclosed space (very often a cafeteria). Their sentimental adventures, which can be shuffled to offer endless combinations, provide the action. Low-budget productions based on distressingly insipid dialogues tacked on to trite situations, the series had a hard time surviving.

With *Jamais deux sans toit*, TF1 tried its hand at something new in 1996. The series was thought up, written and produced by the channel's own services. This was the first time since the break-up of ORTF in 1974 that a nation-wide channel (with the exception of France3[6]) produced a TV fiction programme all its own. The series is based on a situation just as artificial as ever. A young man and woman inherit an ordinary apartment where they discover the father of one and the mother of the other had had a secret, adulterous affair. The only find in this series was the voiced-in commentary by one of the characters who was shown superimposed on the image in certain sequences.

All too obviously short on time and money, these series are based on sloppy scripts and banal dialogues. Like American sitcom, canned laughter is used to hold the story together, emphasising punch lines and drawing the distracted viewer's attention to moments which are supposed to be funny. There is one exception to the rule. Deviating somewhat from the basic principles of the genre as it is produced in France, *C'est cool*, on France2, strives to be more serious and realistic: no canned laughter, socially recognisable young characters from the black African and North African Arab immigrant communities, situations imitating real life waxing dramatic at times, a greater variety of sets and more sophisticated shooting. Unfortunately, it is somewhat lacking in humour, and the audience share is slightly disappointing (20 per cent on average), though not totally disastrous. It remains to be seen whether France2 will persist long enough in this venture to make the necessary improvements.

The overall problem with these afternoon series is that they lack resources, imagination and effective dialogues and situations. They are bland and artificial in every way. The series run in afternoon slots, in a certain sense, are diametrically opposed to prime time drama where social realism can sometimes become so oppressive that it detracts from the natural development of the story or characters. Moreover, it is also worth noting that one characteristic is missing from French fiction programmes: there are currently no medical dramas[7] on the air. This is in sharp contrast to numerous other countries, especially the United States, where the medical profession is used as the setting for a spate of series. This exception is in keeping with the total absence of social or professional themes in the daytime series.

By comparison, competing American productions (*Madame Is Served*, *The Cosby Show*, *Roseanne*, *Beverly Hills*, *Melrose Place* and *Baywatch*) come out looking like works of art. As a result, programme directors lose interest and critics look down on French series, thereby locking them into a vicious circle of insufficient funding, lack of popularity and short shelf life. It should be remembered that the American series filling these French time slots were initially designed as weekly

6 Owing to the availability of an important regional production tool.

7 The medical profession occasionally appears in prime time drama programmes such as *Docteur Sylvestre* (France3) and *Profession infirmière* (M6).

broadcasts. This gives the production an appreciable working time, whereas the French series are turned out at a much faster pace in order to keep up with their client channel's rhythm of daily broadcasts.

In the final analysis, it is not surprising to note that the ratings for almost all day-time series are appreciably lower than the overall average of the channel broadcasting them. The opposite is true for domestic French prime time fiction, where ratings are higher than average in most cases.

3. Derrick's Children in the TV Supermarket

German Television Fiction in 1996

Gerd Hallenberger

1. Advanced Market Fragmentation

If you read about a European TV station which on the average has a market share of 15 per cent you are normally quite right to assume that this station doesn't play a leading role in its country. If it is a German station, however, it is probably the most popular broadcaster. In Germany, the introduction of commercial television in the 1980s was coupled with the implementation of new distribution technologies – in the first years of the 'Dual System', the co-existence of public-service and commercial television, the latter could only be received via cable or satellite. Aided by a massive programme for cabling Germany and ever lower prices for satellite dishes, a rapidly growing number of TV stations catered for the viewing tastes of cable and satellite households, which within a few years became the majority. Today, the average German household can choose among more than 30 channels of free television plus one domestic pay-TV-channel, Premiere. Off-air-viewing has become a minority option: this traditional technology for transmitting TV signals is only used by 18.4 per cent[1] of all German households, compared to 55.0 per cent of cabled households and 26.6 per cent of satellite dish owners. As a consequence of the federal structure of Germany, regional authorities decide which channels are supplied via cable or given access to terrestrial frequencies. Speaking of the number of German TV channels and their availability to viewers the picture is very complex – on the one hand, there are just two channels, public-service broadcasters ARD and ZDF, which can be received by all Germans, but on the other hand there are 24 stations available to more than 50 per cent of all households. Top of the list behind ARD and ZDF are the biggest commercial channels RTL and SAT.1 (95 per cent each), followed by their most important commercial rival PRO 7 (88 per cent). Close to the 50 per cent limit are VIVA, a domestic

1 The source of all data concerning the technical reach of German TV stations and of all audience figures used in this text is the GfK-Fernsehforschung.

music channel, and TM 3, a commercial broadcaster geared towards female audiences (54 per cent each).

Apart from ARD and ZDF, the public-service sector of German television offers a further 11 channels. As the ARD is a network of regional stations, each of these stations is also involved in a regional channel, formerly introduced as 'Third Channels' – of which there are 8. Today, all these channels can be viewed in a much larger area than the one they were originally intended for as nearly all of them are also transmitted via the ASTRA satellite and every cable system offers at least 3 of them. As additional offerings there are 3Sat, a joint programme for the German speaking part of Europe, produced by German (ARD and ZDF), Swiss (DRS) and Austrian television (ORF), a new children's channel of ARD and ZDF and of course ARTE, the European cultural channel, mainly taken care of by France and Germany.

Not counting Premiere and local stations in Berlin, Hamburg and Munich, the commercial sector of German television as of January 1997 consists of 15 channels. Taking ownership as a clue to whose interests are involved in these channels, there are two 'families' of stations plus a couple of – rather small – outsiders. Although there have been conflicts between the Bertelsmann Group and the CLT in recent years, now terminally solved by a merging of the two, both have usually acted jointly in German media politics, controlling RTL, RTL 2, Super RTL and VOX. The second 'family' of stations has Leo Kirch, internationally renowned buyer and seller of broadcasting rights, as the most influential force. It consists of SAT 1, PRO 7, Kabel 1 (formerly known as the Kabelkanal) and the DSF, a sports channel. The remaining 'independant' channels are a German version of Nickelodeon, the news channel N-TV, TM 3, plus four music channels – VIVA, VIVA 2, ONYX and a German VH1, the latter three catering for the musical tastes of the not-quite-young generation.

According to audience figures, Germany has developed a relatively stable 'three-tier-system'. On the first level, there are four 'big' channels, public-service stations ARD and ZDF plus the commercial broadcasters RTL and SAT 1, with monthly audience shares of about 15 per cent. To be precise, this level is made up not by four channels but rather by one plus three, as RTL quite regularly tops the ratings and the other channels only compete for second position. A separate second level of audience response is occupied by commercial broadcaster PRO 7 and the regional ARD channels, counted as one offer. Both usually get audience shares of about 10 per cent. All others channels have to live off what's left and make up a third level of 'small' stations, with audience shares below 5 per cent.

Table 3.1 – 1996 Market Share of German TV Channels

RTL	17.0%	Kabel	3.6%
ARD	14.8%	VOX	3.0%
ZDF	14.4%	Super RTL	2.1%
SAT 1	13.2%	DSF	1.1%
ARD III combined	10.1%	3Sat	0.9%
PRO7	9.5%	N-TV	0.3%
RTL 2	4.5%	ARTE	0.3%

Source: GfK-Fernsehforschung

On closer inspection, this simple picture is somewhat misleading, however, both in terms of commercial importance and audience interest. From this point of view, PRO 7 is nearly as important as market leader RTL – this channel is hugely popular among the younger age groups (up to age 49), which are especially sought after by advertisers. Some other channels like RTL 2 and Super RTL, specializing in kids' programmes, are very popular with their target group and so have to be acknowledged as a stronger market force than their overall audience figures might lead one to assume.

2. Television Audiences

Speaking of viewing habits with respect to the fundamental changes in the structure of the German television system during the last ten years, you inevitably arrive at two observations. Observation one: everything has changed, observation two: nothing has changed.

German viewers have become accustomed to a lot of forms of programming which had been unknown in this country up to the introduction of the 'Dual System' – like daily game and talk shows, daily soaps and late night comedy. Both public-service and commercial channels adopted American programming strategies, differing only in the amount of following these rules. A similar 'Americanization' occured in viewing patterns. Today, many German viewers as well tend to avoid commercials by zapping and especially younger viewers engage in channel hopping. Even station officials admit that during most of the daytime a significant part of their audiences use television simply as 'radio with pictures', as audiovisual background to whatever they do primarily.

On the other hand, viewers' general tastes show very little change. Although styles of production and presentation have become modernized in various areas of programming, basically meaning faster programmes employing hi-tech effects, as a rule of thumb you can say that what has been popular in the past is popular now, too. If you compare annual overall top 20 programme rankings of today to those of twenty or even thirty years ago, similarities are striking. Audience favourite number one is still football, followed by 90 minute plus game shows, the occasional Hollywood movie, domestic crime series and some German peculiarities like carnival shows.

A little detail illustrating the current balance between old and new, between tradition and change is the definition of prime time viewing. Although the term has no fixed meaning in Germany, most research takes 19:00–23:00 as 'Hauptsendezeit'. Traditionally, the beginning of the 'Hauptsendezeit', which is a looser concept than the American 'prime time', is marked by the main edition of a channel's news. Today, each of the five main channels presents its news at a different time – first up is SAT 1 (18:30), followed by RTL (18:45), the ZDF (19:00), PRO 7 (19:30) and the ARD (20:00). Unfortunately for all other stations, the 'Tagesschau' of ARD still has the image of being 'the' news and quite regularly is the ARD programme with the highest audience figures of the day. In order to challenge the position of the 'Tagesschau', most of the commercial channels decided to start their top programme for the day at 20:00. In March 1997, the last of these channels (SAT 1) gave up because of poor audience response. So even today the single most important programme of nearly all public-service and commercial channels has a fixed starting time, 20:15, when the 'Tagesschau' is finished, but apart from that each

Stefan Derrick and his assistant Harry: two German police officers known all over the world.

Photo: ZDF/Renate Schäfer

broadcaster still tries to limit the 'Hauptsendezeit' by individual programming schemes.

Taking a closer look at fiction programmes, German audiences like TV audiences in many other European countries prefer domestic productions over imports – except, of course, if there are outstanding cinematic offerings. As to the contents of German fiction programmes, crime series still are the most popular by far – both at home and abroad. Some of them, like the long-running ZDF series *Derrick*, have been sold to more than 100 countries worldwide. Other popular genres are medical series like the *Schwarzwaldklinik* ('Black Forest Clinic') and holiday series like the *Traumschiff* (which translates as 'Dream Boat' and represents a German re-invention of the American *Love Boat*[2]). Compared to other countries, two genres are less important than might be expected. One is comedy, which has the image of being extremely difficult to write and so is offered only occasionaly. The second is fiction dealing with typical problems of family life – not least because traditional forms of family life are far less relevant in German society than they used to be. Especially in large cities there is a large number of one-person households and single parents with children, a lot of young people prefer living with friends to living in a family context. As a consequence, German daily soaps quite regularly have as their focal point not a family but a group of young people basically practising a communal lifestyle.

3. Broadcaster's Strategies

Even if you only look at broadcasters targeting nationwide audiences, Germany's televisual landscape shows a large variety of strategies concerning the role of fiction programmes in a channel's overall offering.

Public-service station ARD still lives off its image as being the most reliable provider of news and service programmes. The ARD has a lower profile in entertainment, with a remarkably large number of exceptions in the fiction department. The stations's identity continues to be closely linked to the long-running 90-minute crime series *Tatort*, introduced about 1970, and the weekly *Lindenstraße*, a German *Coronation Street* of sorts. The ARD also introduced successfully two early-evening daily soaps aimed at younger viewers, *Marienhof* and *Verbotene Liebe* ('Forbidden Love').

The other public-service channel ZDF also uses long-running crime series but with a 60-minute-format as a main programming ingredient. Two of them, *Derrick* and *Der Alte (The Old One)*, are a large success in various foreign markets. As an important element of the public image of the channel, the ZDF quite frequently invests in costly mini-series, a hugely successful concept. Especially two productions written and directed by Dieter Wedel, *Der große Bellheim* (international title: 'The Gentleman Players'), first broadcast in 1993, and *Der Schattenmann* ('The Shadow Man'), which premiered in January 1996, were massive hits.

Of all major stations, the public image of market leader RTL relies least on fiction programmes – the backbones of RTL's success still are a string of afternoon talk shows plus several prime time game shows. Apart from buying the occasional Hollywood movie like all other stations and showing American series (among them *Columbo*, *Miami Vice* and a newly dubbed version of *Magnum P.I.*), fiction

2 But the authors of the *Traumschiff* claim the idea was their own.

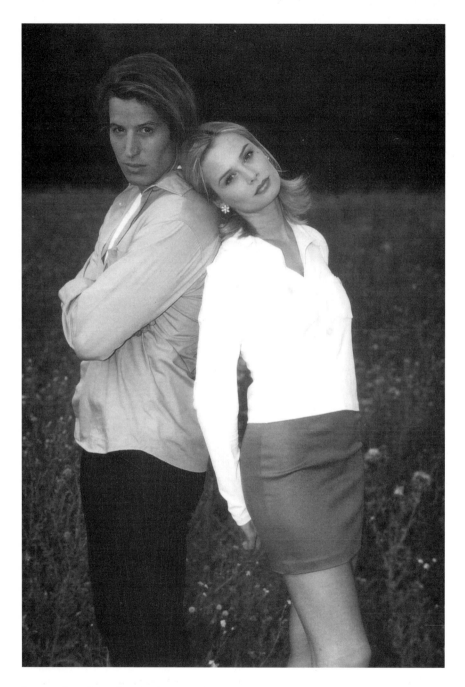

Love at first sight: Jessica (Andrea Suwa) and Alexander (Hakim Maziani) in the daily soap *Verbotene Liebe* (ARD)

Photo: ARD/Frank Dicks

offerings of RTL quite often use foreign formats in adapted versions – which comes as no surprise as RTL cooperates quite frequently with Bill Grundy and the Netherlands' Endemol Group. The most prominent fiction programme of RTL is a low-budget daily soap called *Gute Zeiten, schlechte Zeiten*, the German clone of the Netherlands' version of the Australian soap *The Restless Years*.

RTL also was the first commercial German channel to engage in a co-production with American partners. The highly publicised *Berlin Break*, a CBS/RTL series featuring John Hillerman (of *Magnum, P.I.* fame) and German actress/variety star Hildegard Knef achieved so poor ratings that most episodes were 'buried' by RTL in late-late-night timeslots. After an announcement that RTL would reduce its investment in domestic fiction, a change of policy occured in 1996 when prices for imported films and series rose dramatically, resulting in a renewed interest in home-made action and comedy programmes.

Both domestic and imported fiction (especially *Star Trek* and its more recent reincarnations) play a more important role in the programming of SAT.1, otherwise first of all known as the station presenting the football matches of the *Bundesliga*. One of the top consultants of this station (who just left the station in 1996) had worked for the fiction department of the ZDF for several decades, and this influence is highly visible in the station's commissioned fiction offers. Among the highlights of SAT.1 are quite a few crime, medical and melodrama series which strongly resemble the old ZDF 'school' of dramatic series, i.e. they are well-produced, rather slow and are geared towards older audiences.

All other channels, including PRO 7, show a growing tendency towards new domestic fiction, but only as an occasional highlight to promote the stations' identity, whereas the majority of all fiction programmes is dominated by American series and feature films, including lots of repeats. If these channels invest in new fiction programmes they prefer TV movies and mini-series set in the crime genre to other formats and genres.

4. Sample Week[3]

To be able to estimate the overall importance of all types of fiction programmes, we analyzed the overall volume of fiction offered in one sample week (2–8 March 1996) by all channels with a national orientation[4] (ARD, ZDF, ARTE, 3sat; RTL, SAT.1, PRO 7, RTL 2, Kabel 1, VOX) during the day (defined as starting between 8:00 and 1:00), excluding animation series for children.

Except 3sat and ARTE, all stations rely heavily on fiction programmes, especially commercial broadcasters which in general offer less diversity in their overall schedules. With few exceptions, nearly all channels present 60–70 per cent television fiction, leaving 40–30 per cent for cinematic productions. Surprise results offer ARTE (70 per cent cinematic broadcasts) and market leader RTL (90 per cent television fiction). As far as ARTE is concerned, this station uses fiction only as an occasional ingredient, favouring the unusual – which is more often to be found with cinematic works. RTL, on the other hand, has had problems in securing

3 All data presented in the subsequent chapters (excluding audience figures) were collected and processed by Lars Behrens, Matthias Leidig and Stefan Nickel on behalf of the German branch of 'Eurofiction'.

4 Excluding repeats-only channels like Super RTL.

broadcasting rights for top movies. As a consequence, television fiction plays an outstanding role in RTL's offerings.

Table 3.2 – Broadcast Fiction Over The Sample Week

Station	Length	No. of episodes	No. of productions	Perentage of total length
Public Service Stations				
ARD	44:57	45	30	8.6
ZDF	43:35	43	31	8.3
3sat	19:39	21	17	3.8
ARTE	23:34	19	16	4.5
Commercial Stations				
Kabel 1	49:26	52	31	9.4
PRO7	78:26	87	41	15.0
RTL	53:25	72	36	10.2
RTL2	66:28	65	31	12.6
SAT.1	60:06	52	28	11.5
VOX	84:15	78	24	16.1
TOTAL	523:51	534	285	100.0

Source: Eurofiction

Table 3.3 – Television Fiction and Cinematic Offerings (sample week)

Station	TV Fiction	Cinematic	TOTAL
ARD	28:56 (64.4%)	16:01 (35.6%)	44:57 (100%)
ZDF	31:20 (71.9%)	12:15 (28.1%)	43:35 (100%)
3sat	11:04 (56.3%)	8:35 (43.7%)	19:39 (100%)
ARTE	7:10 (30.4%)	16:24 (69.6%)	23:34 (100%)
Total Public	**78:30 (59.6%)**	**53:15 (40.4%)**	**131:45 (100%)**
Kabel 1	31:27 (63.6%)	17:59 (36.4%)	49:26 (100%)
PRO7	53:10 (67.8%)	25:16 (32.2%)	78:26 (100%)
RTL	48:25 (90.6%)	5:00 (09.4%)	53:25 (100%)
RTL2	41:39 (62.7%)	24:49 (37.3%)	66:28 (100%)
SAT.1	38:53 (64.7%)	21:13 (35.3%)	60:06 (100%)
VOX	64:30 (76.6%)	19:45 (23.4 %)	84:15 (100%)
Total Commercial	**278:04 (70.9%)**	**114:02 (29.1%)**	**392:06 (100%)**
TOTAL	**356:34 (68.1%)**	**167:17 (31.9%)**	**523:51 (100%)**

Source: Eurofiction

A still from the *Tatort* episode 'Heilig Blut'. On the right is police officer Flemming (Martin Lüttge), on the left his assistant Miriam Koch (Roswitha Schderiner). *Tatort* was the new domestic fiction programme which achieved the highest rating in 1996.

Photo: WDR/Bischoff

Although in recent years commercial channels have begun to invest in domestic fiction production, there is still a clear divide between the public-service and the commercial camp. Whereas ARD and ZDF mainly present homemade TV fiction and only buy occasionally on the American market, commercial stations tend to prefer American imports.

Buying fiction from non-American sources may be attractive for German broadcasters because of two possible reasons: reason one, because of their quality (a typical argument for public-service stations); reason two, because the American market is either sold out or too expensive (a typical argument for commercial stations). Bearing this in mind, it comes as no surprise that imports from European countries – few as they are – can mainly be found in the schedules of the ZDF and smaller commercial stations Kabel 1 and VOX.

A final observation: TV fiction with a domestic background (co-productions included) is nearly exclusively new fiction if broadcast via commercial channels, simply because these stations couldn't build libraries (RTL: 91 per cent, SAT.1: 100 per cent). On the other hand, long-term public broadcasters ARD and ZDF have a massive history of fiction production which they use extensively. In the sample week, 28 per cent of ARD's offerings were repeats, the ZDF even had a repeat ratio of 48 per cent.

Table 3.4 – Origin of Television Fiction (sample week)

Station	Domestic/Co-Prod.	Euro Import	US Import	Other Import
ARD	24:06 (83.3%)	–	4:50 (16.7%)	–
ZDF	23:55 (76.3%)	3:55 (12.5%)	3:00 (9.6%)	0:30 (1.6%)
3sat	9:06 (82.2%)	0:58 (8.7%)	–	1:00 (9.0%)
ARTE	4:45 (66.3%)	0:30 (7.0%)	–	1:55 (26.7%)
Tot. Public	**61:52 (78.8%)**	**5:23 (6.9%)**	**7:50 (10.0%)**	**3:25 (04.4%)**
Kabel 1	–	4:00 (12.7%)	27:27 (87.3%)	–
PRO 7	2:31 (4.7%)	–	50:39 (95.3%)	–
RTL	10:35 (21.9%)	–	35:50 (74.0%)	2:00 (4.1%)
RTL 2	–	–	40:44 (97.8%)	0:55 (2.2%)
SAT.1	7:33 (19.4%)	–	30:20 (78.0%)	1:00 (2.6%)
VOX	2:55 (4.5%)	5:45 (08.9%)	53:50 (83.5%)	2:00 (3.1%)
Tot. Commercial	**23:34 (08.5%)**	**9:45 (3.5%)**	**238:50 (85.9%)**	**5:55 (02.1%)**
TOTAL	**85:26 (24.0%)**	**15:08 (4.2%)**	**246:40 (69.2%)**	**9:20 (02.6%)**

Source: Eurofiction

5. Domestic TV Fiction in 1996

Compared to other European countries, German viewers are faced with an avalanche of domestic television fiction. As a logical consequence of Germany's multitude of TV channels the output of TV fiction is much higher than in any other part of Europe. A closer look at the distribution of new fiction between public-service and commercial stations reveals that fiction productions are still primarily commissioned by stations of the public sector of German television. Two out of three fiction programmes have a public-service background although these stations reach lower audience shares than their commercial competitors and have to cope with smaller budgets. In terms of broadcast time and the number of episodes RTL achieves similar figures like ARD and ZDF but only because of two daily soaps which alone contribute about 500 episodes of fiction and approximately 240 hours of broadcast time to RTL's overall result.

In spite of all political progress being made towards a more unified Europe, co-productions with non-German-speaking partners are a very rare exception. German TV fiction is first and foremost homemade fiction, a second option (especially for ARD and ZDF, considering their international relations) are co-productions within the German-speaking language area, i.e. with partners from Austria and/or the German-speaking part of Switzerland. Truly international co-productions can mainly be found (compared to their overall offerings) in the schedules of smaller public-service stations, comprising the regional stations of the ARD and the international ventures ARTE and 3sat. It may surprise some readers that TV stations with a regional perspective show more interest in international co-productions than national channels but this observation can be easily explained. One reason is that these stations do not primarily have to deliver high audience figures like their competitors and so have more freedom to engage in projects of a more ambi-

tious nature, which quite often involve foreign partners. A second reason: quite a few of these regional stations have over the years developed steady contacts with (usually small) TV stations in other countries and use these contacts – among other things – also for co-productions in the field of TV fiction.

Table 3.5 – Domestic TV Fiction in Germany (1996)

Station	Productions	Episodes	Cumulated Length
Public-Service Stations			
ARD	64 (21.5%)	862 (34.0%)	539:39 (31.8%)
ZDF	99 (33.3%)	533 (21.1%)	409:19 (24.2%)
Other	36 (12.1%)	40 (1.6%)	50:40 (3.1%)
Tot. Public	**199 (66.9%)**	**1435 (56.7%)**	**999:38 (59.1%)**
Commercial Stations			
RTL	42 (14.2%)	755 (29.9%)	410:12 (24.3%)
SAT.1	43 (14.5%)	292 (11.5%)	240:13 (14.2%)
Other	13 (4.4%)	50 (1.9%)	39:44 (2.4%)
Tot. Commercial	**98 (33.1%)**	**1097 (43.3%)**	**690:09 (40.9%)**
TOTAL	**297 (100%)**	**2532 (100%)**	**1689:47 (100%)**

Source: Eurofiction

Table 3.6 – Co-Produced TV Fiction in Germany (1996)[5]

Station	with Austrian and/or Swiss Partners	with other European Partners	with non-European Partners
Public-Service Stations			
ARD	66:00 (12.3%)	13:35 (02.5%)	12:16 (2.3%)
ZDF	120:41 (29.5%)	4:35 (1.1%)	3:25 (.8%)
Other	3:05 (6.1%)	11:00 (21.7%)	3:35 (7.1%)
Commercial Stations			
RTL	–	–	–
SAT.1	32:03 (13.3%)	1:40 (0.7%)	–
Other	1:40 (4.2%)	–	–

Source: Eurofiction

All in all, new German television fiction is basically 'modern' fiction: Today's Germany with all its cultural peculiarities is where the narration of the vast majority of all television fiction is set. The stories told take place in the present (99.0 per cent of all broadcast episodes[6]) and in Germany (93.5 per cent). Quite contrary to

5 The relative figures noted in brackets are based on the overall fiction offering of the respective station(s) – including purely domestic productions – and so do not add up to 100 per cent.

6 All figures given are based on a complete analysis of all domestic fiction offerings of 1996, co-productions included.

the standard tourist's perception of Germany being mainly a country of castles, small villages and mountains (Bavaria plus Heidelberg) but very much in line with present-day reality, television fiction usually has an urban setting – 82.9 per cent of all fiction is set in larger towns.[7] There is just one genre which on first glance seems to be an exception from the rule – comedy, as 19.8 per cent of all comedies are linked with small towns (compared to an average 4.5 per cent). But on closer inspection this finding only underlines the dominant urbanism of German television fiction: the small town is the place where you find more silly people, less able to deal with today's life.

A similar orientation towards contemporary life is visible looking at the protagonists of television fiction. Only a minority of all fiction programmes presents a single male (16.3 per cent) or female (4.9 per cent) lead, mixed groups with respect to sex are dominant (71.5 per cent). Further proof for a gradual change of gender roles in Germany can be gained from the distribution of protagonists along genre lines. Female heroes (either single women or groups of women) can only be found in 4.4 per cent of 'general drama' programmes, mainly dealing with family problems and problems in relationships, but in 12.5 per cent of all offerings in the 'crime/action' category.

Wheras these 'Eurofiction' research results are indicators for a massive trend towards contemporary life, there are other areas where German television fiction continues traditions which go back to post-war beginnings of television in Germany. The distribution of genres and sub-genres, for example, still reveals basic patterns which gradually evolved during the 1950s and 1960s and stabilized in the early 1970s, with one important exception. This exception is the 'daily soap', introduced just a few years ago[8] as low-budget fiction for young audiences. There are just a few serials of this type, but because of daily transmission 47.1 per cent of all German fiction episodes (and 28.4 per cent of the overall broadcast time of domestic fiction) belong to this sub-genre.[9]

Apart from this new phenomenon, little has changed: The single most important ingredient of German television fiction continues to be 'crime' (18.2 per cent of all episodes, 27.3 per cent of overall broadcast time), followed by 'family drama' (8.6/9.5 per cent), 'medical drama' (7.2/9.0 per cent), serious 'dramatic' fiction (2.6/5.6 per cent), traditional forms of 'comedy' (3.4/5.1 per cent) and fiction set in a 'holiday' world (2.4/3.2 per cent).

6. Successes and Failures

The aspect of continuity is also visible when changing perspectives from offer to demand, only on an even more impressive scale. Crime fiction does not only constitute a large segment of TV fiction in general but crime stories also achieve the largest viewership. If all individual episodes of serial productions had been taken into account a listing of the 20 most popular German fiction programmes of 1996 would have consisted of little else but crime/action productions. Reviewing audi-

7 Defined as cities with 100.000 inhabitants and more.

8 The first German 'daily soap' was offered by commercial broadcaster RTL in 1992 (*Gute Zeiten, schlechte Zeiten*).

9 In the context of the 'Eurofiction' research network, 'daily soaps' are treated as a subgenre of 'general drama'.

ence figures this way, you would see no less than six episodes of *Tatort* (ARD), five episodes of *Der Alte* (ZDF), four episodes of *Derrick* (ZDF) plus three episodes of *Ein Fall für Zwei* (ZDF) among the top 20, with the first non-crime/action programme appearing on rank 20. All of these series have two things in common: they are broadcast by public-service channels and they are around for decades.

Applying an approach which is more oriented towards diversity, i.e. in case of serial productions counting only the single episode with the highest audience figure, the picture changes only gradually. Table 3.7 again demonstrates the outstanding popularity of crime/action programmes in Germany – this genre occupies all of the top five positions and seven top positions out of ten. It also underlines the leading position of ARD and ZDF with regard to domestic fiction: 14 of the 20 most popular programmes have been produced for these two public-service channels, only six for their commercial competitors RTL and SAT1.

Quite a few of the successful crime/action programmes still prefer a rather old-fashioned and slow narration, concentrating on the intellectual work necessary to solve a crime, an approach exemplified best by the ZDF series *Derrick*. Especially with younger viewers, however, a new type of crime fiction is gaining popularity: It is crime fiction concentrating on visual aspects, action sequences and pyrotechnics, like the RTL series *Alarm für Cobra 11* and the RTL TV movie *Der Clown*.

Continuity also is the basic key to success for most of the general drama offerings among Germany's audience favourites of 1996, although in various forms. *Anna Maria*, the story of a widow taking care of the firm of her deceased husband (a gravel pit), for example, owes much of its success to the long-time popularity of leading actress Uschi Glas. *Das Mädchen Rosemarie* is a TV remake of a legendary German movie of 1958, cashing in on the scandalous life and death of Rosemarie Nitribitt, a high society prostitute in post-war Germany. Other entries demonstrate the on-going popularity of specific sub-genres with German audiences like the holiday series (*Das Traumschiff*) or fiction set in the medical world (*Der Landarzt*).

The same argument also explains the surprisingly high audience figures achieved by an international co-production (*Der kleine Lord*, a German-Italian TV movie). Co-productions usually are not that successful but *Der kleine Lord* is a remake of a remake[10] of a story which over the years has become a necessary ingredient of TV's christmas schedule. In its older incarnations, it is a *Cinderella* story of an American boy living in poor surroundings who gets to know that his father is a rich English aristocrat. He is sent to England and manages to survive in this 'posh' world, even convincing his hard-hearted grandfather. This new version relocates the story, exchanging America for Italy and England for Bavaria and gives it a different cultural background. This time, the grandfather, played by the ever popular Mario Adorf, is the wealthy owner of a brewery living in a castle in the Bavarian mountains.

10 To be precise, there were already two versions of *Der kleine Lord* on German TV – the original 1936 movie and a British TV version of 1980 featurinng Alec Guiness as grandfather.

Comedy continues to be a difficult genre in Germany, so having one comedy among the top 20 episodes of 1996 is a finding worth commentating. *Salto Postale* is a series set in a post office in Potsdam (belonging to the GDR until 1990), featuring Wolfgang Stumph. In the GDR, Wolfgang Stumph was known as a comedian with a sense of humour quite regularly challenging communist authorities, West German audiences got to know him through two comic movies showing the adventures of a family from the East after the opening of the border in 1989. The comedy of *Salto Postale* gives a commentary to problems of German reunification and does so in a way accesible both to Eastern and Western audiences.

Table 3.7 – Top 20 TV Fiction Episodes in 1996

Title	Date	Channel	Genre	Audience	Share
1. *Tatort*	14.01	ARD	crime	11.09	n.a
2. *Der Alte*	29.03	ZDF	crime	10.51	34.60
3. *Alarm für Cobra 11 (P)*	12.03	RTL	crime	10.09	32.80
4. *Derrick*	05.01	ZDF	crime	10.00	n.a
5. *Ein Fall für Zwei*	01.03	ZDF	crime	9.34	30.30
6. *Anna Maria*	29.01	SAT.1	drama	8.97	28.10
7. *Das Mädchen Rosemarie*	13.12	SAT.1	drama	8.83	29.00
8. *Der Clown*	03.11	RTL	crime	8.77	25.50
9. *Das Haus an der Küste*	03.11	ZDF	drama	8.76	n.a.
10. *Alarm für Cobra 11*	09.04	RTL	crime	8.62	9.20
11. *Das Traumschiff*	26.12	ZDF	drama	8.48	25.70
12. *Unser Lehrer Dr. Specht*	12.11	ZDF	drama	8.39	26.70
13. *Lindenstraße*	21.01	ARD	drama	8.37	30.00
14. *Der kleine Lord*	18.12	ARD	drama	8.35	27.30
15. *Polizeiruf 110*	15.09	ARD	crime	8.27	24.80
16. *Salto Postale*	07.01	ZDF	comedy	8.08	n.a
17. *Der Schattenmann*	10.01	ZDF	crime	8.05	25.10
18. *Der Landarzt*	26.01	ZDF	drama	7.95	24.70
19. *Die Männer vom K 3*	28.04	ARD	crime	7.94	25.70
20. *Kommissar Rex*	11.01	SAT.1	crime	7.92	25.60

Source: GfK-Fernsehforschung

7. Trends and Developments

After more than ten years of turbulence because of radical changes in the media system (i.e. the introduction of commercial broadcasters) and seven years of dramatic political change (i.e. German reunification), German television today experiences a phase of consolidation. Both public-service and commercial broadcasters have learnt to accept their respective competitors and try to cope with the still

existing cultural, political and social gap between Germany East and West. Speaking of the programmes offered by all of the numerous German channels, it is still a period of change – but change of a less obvious nature than before. Whereas the 1980s and early 1990s saw the introduction of whole new types of programming, from daily soap to sitcom, the late night show and 'reality TV', the mid-1990s can be described as a time of permanent adaptation to ever changing market conditions. Basically, the television market as a whole consists of three interrelated sub-markets. TV stations acquire broadcast material on the programme market in order to be successful on the audience market, provided they can sell the access to potential audiences on the advertising market. Of course, this model in its entirety is only valid for commercial stations but as even public-service broadcasters in Germany partly depend on advertising revenue they have – to some degree – to act like commercial stations on these three markets. Each of them is dynamic and able to influence what is actually transmitted.

As a consequence, a change in audience tastes is only one of several potential factors influencing programming decisions. In 1996, for example, American fiction imports became far more expensive so RTL and SAT.1 decided to invest more money in commissioned domestic fiction programmes, especially TV movies. Another example: German advertising agencies today are mainly interested in certain segments of the overall TV audience and influence broadcasters to present 'younger' programmes. Bearing this in mind, there are several trends visible in German fiction programming.

Perhaps the most important single phenomenon is a strategy employed by nearly all German broadcasters – presenting new aspects within a well-known conceptual framework. Taking the 'crime' genre as an example, there are basically three ways to achieve this goal. One, the re-construction of gender roles – there is an ever increasing number of female police officers on German TV, sometimes even equipped with handsome male assistants (for example *Die Kommissarin*, ARD). Two, an ironic approach towards genre formulas – best exemplified by *Stockinger* (SAT.1), a series presenting a definitive non-hero in the leading role. Three, crime fiction with an orientation towards younger viewers – a concept used successfully especially by RTL with *Alarm für Cobra 11* and *SK-Babies*. Whereas *Alarm für Cobra 11* is attractive for younger audiences because of its visual style resembling action movies, *SK-Babies* is done in a rather conventional way but aims at the young market by means of cast and plot. The *SK-Babies* are a special police youth squad investigating cases which today have the image of being 'typical' juvenile (drugs offences, satanism, neo-nazi violence etc.).

Not all of these attempts to modernize the crime genre work, of course. One of the most spectacular failures was the highly publicised early-evening series *Die Partner* (ARD). This crime series follows fairly familiar lines as far as cast and plot are concerned but employs a visual style closely related to the aesthetics of music videos and trendy commercials. With its heavy use of steady-cam shots, jump cuts plus a strong musical element *Die Partner* proved too disturbing for most TV viewers.

Other popular (sub-)genres show similar tendencies. All German daily soaps, for example can be read as a youth-oriented alternative to traditional family series, with *Alle zusammen – jeder für sich*[11] (RTL 2) even presenting a hybrid of daily

11 It must be said, however, that until now this attempt to interest younger viewers in the medical world is not very successful. *Alle zusammen – jeder für sich* achieves rather low audience figures.

soap and medical series, a sub-genre usually more popular with older audiences.

A second important trend is the ever growing number of domestic TV movies. This development can be attributed primarily to economic factors. With production costs of an average 1.5 million DM, German TV movies for most broadcasters have become an alternative to buying Hollywood movies which can cost up to 3 million DM, some re-broadcasts included. In 1996, commercial broadcaster SAT.1 tried to promote this trend by commissioning several TV remakes of well-known German movies. Presented as 'German Classics' produced by Bernd Eichinger, a German producer with some Hollywood movie experience, these TV movies did not fare too well. Only one of them, *Das Mädchen Rosemarie*, was a huge success, the other three missed their targeted audiences.

Finally, there is a trend towards comedy productions which, again, has a lot to do with commercial considerations. Of course, comedy in general is a very popular genre but it is also able to attract younger viewers who are especially sought after by advertisers. The popularity of comedy alone would not entice German broadcasters to invest in this genre as domestic comedy is a rather risky programming option. In other words, the track record of fictional German comedy productions is extremely bad – apart from very few notable exceptions, the most prominent being *Ein Herz und eine Seele*, a 1970s German version of *All in the Family* (still shown in repeats on the Third Channels of the ARD), most German comedy productions turned out to be either a disaster with the critics or with the viewers, usually both.

So in spite of the undisputed strategic importance of TV comedy, commercial stations still shy away from this fiction genre.[12] Whereas commercial stations broadcast 40.9 per cent of all German TV fiction in 1996 (figures based on cumulated length of programmes), they only offered 18.7 per cent of all comedy. Public-service stations, contributing 59.1 per cent to the overall fiction offer, presented the vast majority of comedy programmes (81.3 per cent). In this respect, the public-service stations which quite often get criticised for their conservative programming strategies turn out to be the main innovators. As a consequence, it comes as no surprise that the most important German comedy productions of 1996 were three comedy series of ARD and ZDF – the *Familie Heinz Becker* (ARD), a series with a strong regional flavour[13] featuring the well-known comedian Gerd Dudenhöffer, *Salto Postale* (ZDF) and *Lukas* (ZDF), starring Dirk Bach as Lukas.

All in all, German television fiction in 1996 presents itself as a highly complex mixture of elements old and new, continuing German television history as well as reflecting new influences like the commercialization of the German TV system and processes of cultural change. But although today's German fiction programmes tend to present a world where young people live together with their peers (instead of living in a traditional family), where police officers are quite often women and where police assistants even have black skin,[14] the basic function of television fiction has remained the same it has always been: accompanying the eyeryday life of its viewers – offering a bit of consolation but also a bit of challenge.

12 In the comedy department, they prefer theatrical comedy like *RTL Samstag Nacht*, a very popular show loosely based on the American *Saturday Night Live*.

13 The Saarbrücken area, to be precise, is situated in the south-west of Germany.

14 This happens in *Der Alte* (ZDF), a crime series presenting an assistant of black American/Bavarian ancestry.

4. Recombinant Stories[1]

Italian Television Fiction in 1996[2]

Milly Buonanno

1. The Broadcasting System

The Italian broadcasting system is rife with contradiction. It is an environment where heavy concentration exists alongside a splintered distribution network, where the market is rich but investments in production meagre, and where a general state of stability reigns in spite of endless controversy and legislative debates regarding reforms.

The system is fundamentally dualistic, split between two major operators, one public (RAI), the other private (MEDIASET, formerly Fininvest), each owning three national channels which broadcast over the air. These basically control the entire market, both economically speaking and in terms of audience share. A new operator, film-producer Cecchi Gori, entered into the arena in the mid-1990s by purchasing two channels, Telemontecarlo and Videomusic (now TMC 1 and TMC 2). For the time being however, all hopes that this would become Italy's 'third broadcasting power' have gone unanswered. Covering only a part of the national territory, the two TMC channels hold a scant 3 per cent of the market share (a situation which is likely to change after the recent Cecchi Gori purchase of major soccer broadcasting rights).

In order of broadcasting range, the Italian TV landscape also includes several pan-regional networks: Italia 7, Italia 9, Odeon TV, Supersix, Cinquestelle. These are followed by a myriad of local broadcasting channels (almost 700) which, in addition to the news they are required by law to provide, offer almost exclusively home shopping programmes. Rational reorganization of this minute fragmentation of local broadcasting, a typically Italian feature, would most certainly reveal a potential secondary market where fiction could be commercialised more effectively.

1 Todd Gitlin writes about the 'recombinant culture' of the television in *Inside Prime Time*, Routledge, London 1994 (3rd. edition).

2 The Italian branch of the Eurofiction project has been supported by Rai, Mediaset, University of Firenze, University of Salerno, National Council of Research, Italian Bureau of European Commissions, Sacis.

Finally, in the area of pay-TV operators, there are three channels offering scrambled broadcasts: one for movies, another for sport, while the third features cultural programs. All three are owned by Telepiù and now controlled by Canal Plus (previously by NetHold) and the Kirch group. With only 800,000 subscribers, pay-TV still plays a marginal role on the Italian TV scene, where it has difficulties getting a competitive edge on the major national networks, which feature recent movies and live sports events at no extra cost.

Satellite pay-TV plays an even smaller role, in part because it is in the beginning stages. Telepiù Satellite, which launched its first digital package in 1996, counts no more than 80,000 subscribers. As for cable-TV, the only Italian operator – Stream, owned by STET and Telecom – started operating commercially on January 1997, and so far has collected only a few thousand subscriptions.

A bill has been proposed in Parliament to change this situation. This legislation, if passed, would oblige MEDIASET to move one of its channels over to satellite. Moreover, Telepiù's authorisation for over-the-air broadcasting would not be renewed, while advertising would be banned from one of the RAI channels. Finally, incentives would be offered to promote the use of satellite technologies. For the moment, however, the Italian TV landscape has held on to all the structural characteristics which make it so unique on the European front: numerous highly-fragmented local broadcasters, a very limited use of pay-TV and new broadcasting technologies, and total control in the hands of two national operators.

With a population of 57 million, almost 21 million households equipped with an average of two TV sets each, and revenues just under $4.5 billion in 1995, Italy is the fourth largest market in Europe. In terms of revenues from licence fees and advertising, Italy ranks third (after Germany and Great Britain), without considering pay-TV earnings which, as explained previously are among the lowest in Europe. Furthermore, the two major Italian operators rank second in their company categories with respect to turnover: RAI is the second largest public TV network in Europe, after the German ARD, while MEDIASET places second in the private sector, behind Britain's ITV. In terms of market shares, roughly 48 per cent of the total broadcasting-generated earnings in Italy are held by RAI , and 39 per cent by MEDIASET. These figures are generally reflected in audience shares, with a slightly higher score for MEDIASET. In 1996, RAI networks held 47.93 per cent of the daily average while MEDIASET stood at 42.40 per cent. More specifically, the breakdown for private and public channels (for a total of 90 per cent share) is:

Table 4.1 – Market Share of Italian TV Channels

RAI		*MEDIASET*	
Raiuno:	23.27%	Canale 5:	21.33%
Raidue:	14.77%	Italia 1:	12.06%
Raitre:	9.89%	Rete 4:	9.01%

Source: Auditel

Italians watch an average of three and a half hours of television per day, with males consuming three hours, and females four. Prime time (8:30 to 10:30 p.m.) attracts 24 to 25 million viewers over 4 years old, although there has been a slight decrease since 1995. This drop, which has affected all time slots across the board and is particularly striking for families with small children and among the younger viewers,

has sparked numerous debates. Some of Italy's most influential intellectuals have interpreted it as a clear sign that TV for the general public with its catch-all programmes are on the way out.

In reality, there are only two channels in Italy catering purely to the general public: the first RAI channel (Raiuno) and MEDIASET's flag-ship (Canale5), which compete fiercely, especially at prime time. Canale5, for example, has recently moved its afternoon children's slot to Italia1 in order to compete more effectively with afternoon programming on Raiuno, which are oriented toward a more adult target.

The other two public channels are in the process of fine-tuning their policies. Raidue could become an experimental channel aimed particularly at young adults, while the future of Raitre depends on the outcome of the bill currently in Parliament. It will either become a regional channel, or a purely 'public service' broadcasting network financed by licence fees only.

The two remaining private channels are to maintain the distinctive profile they have built up over the years. Retequattro is a female-oriented channel which features dramas (particularly soap operas and Latin American telenovelas) during the day, and popular movies at prime time in order to attract larger audiences. Italia1 is a youth and male oriented channel which serves up generous portions of cartoons, sitcoms, action and adventure movies. Because of the growing importance given to young viewers, on the one hand, and the likelihood that it will be legally forced to transfer one of its channels to satellite, on the other, MEDIASET now seems keen on investing in this channel, at least more so than in the past.

Apart from the specific programming and scheduling strategies which broadcasters use to build up their audiences, the success of Italian TV lies, as a rule, in live musical specials and sports 'events': the Sanremo Festival (an annual pop music competition) and national and international soccer games are regular blockbusters. Variety shows and popular Hollywood movies are also quite popular, whereas domestic fiction productions, contrary to what happens in other European countries, rarely enter into the top 10 or top 20 programmes. This is not because Italian viewers harbour any particular dislike for home-grown fiction programmes, which they, like their European counterparts, follow and enjoy more than imported productions. The fact is that domestic productions are scarce, and prime time, offering viewers the latest popular movies from abroad, has become a highly competitive arena. In 1996, RAI broadcast some 321 films and MEDIASET 577.

2. Sample Week

During the two-decade RAI monopoly, fiction was a cornerstone of television programming, though it was not offered in great quantities. The headliner of Sunday programming was the evening fiction broadcast: the *sceneggiato* (an *ante litteram* mini-series in 4 to 6 episodes, usually adaptations of Italian and European classics). This was an extremely popular genre, in addition to being a genuine national speciality to which the RAI image is still linked. Whereas most TV jargon (e.g. *fiction* as a genre, or the different format labels) has failed to enter into everyday use or even catch on with TV writers and critics, *sceneggiato* is still used widely in this country to indicate any fiction production shown in episodes.

These serials were based initially on historical, literary or biographical subjects before turning increasingly to modern themes. Together with a handful of home-

made police series and American productions, they made up the total amount (a few hundred hours a year) of fiction offered by RAI until the second half of the 1970s.

The situation changed radically, however, when private networks started emerging and importing large quantities of foreign fiction productions. RAI immediately followed suit, and in the 1980s Italy became the leading European importer of foreign fiction (mainly from the US, Japan and Brazil). Almost overnight, both private and public Italian networks offered a total of 11,000 hours per year, a volume which has been sustained ever since.

Despite the fact that RAI has basically doubled the hours of fiction broadcast on its channels over a ten-year period, fiction programmes still fill roughly 12 per cent of the overall programme grid. This has dropped sharply on MEDIASET channels: in 1985 it covered almost half of the schedule, in 1995 only one third of it.[3]

Table 4.2 – Fiction Offer 1985-1995

1985 (hours)		1995 (hours)	
Rai	1,660	Rai	3,194
Fininvest	9,576	Mediaset	8,781
Total	11,236	Total	11,975

Source: Rai

Domestic production did not follow this upward trend in fiction programmes. On the contrary, it actually dropped, in spite of the fact that a new potential producer entered the arena when the private broadcasting company began small-scale productions in the second half of the 1980s. Throughout the decade (1985–1995), the entire sector experienced hard times. A low point was recorded during the first half of the 1990s when domestic fiction dropped by 50 per cent, from 300 to 150 hours per year, on the six national channels. In 1995, the total volume of investments of both public and private networks amounted to no more than £200 billion, and a single 90–100 minute episode of prime time fiction cost between £1–1.5 billion.

The causes of this recession, now definitively over, were primarily economic: imported fiction is far less expensive than home-productions. This is equally true for other countries, but Italy was harder hit because the networks, who up until very recently were in the red, were forced to tighten their budgets. Until the first half of the 1990s, both RAI and MEDIASET preferred to import foreign fiction and invest in genres like variety, reality and talk shows which do not require costly investments and yet are capable of attracting large audiences.

Thus, a generous amount of fiction on the six national channels, particularly the private stations, coupled with a shortage of domestic production provides the context for the figures collected during the sample week going from 2–8 March 1996. Out of a total of 131 hours of TV fiction[4] (plus 80 hours of movies), 73 per cent was shown on private networks, a faithful portrait of the ratio between RAI and MEDIASET with regard to total volume (see above).

3 This fluctuation for the private network, and the stability of the public one, is due to the fact that during this decade, on-the-air time has increased, and is now non-stop.

4 Night-time slots from 1 to 7 a.m. were not monitored.

A distinction must be made, however, between the different MEDIASET channels. Canale5, the private channel catering to families and the general public, with a solid 30 per cent share in the early afternoon thanks to *The Bold and the Beautiful*, offered only 7 per cent of the total fiction shown during the sample week (similar to Raiuno). In fact, 66 per cent of the total 131 hours recorded are split between two stations. On the one hand, Rete4 features soap operas, *telenovelas*, and *Chicago Hope* during the day, while Italia1 boasts a wide range of daytime or early evening series like *Baywatch*, *Beverly Hills 90210*, *Fresh Prince of Bel-Air* and many others, as well as prime time series like *The X Files*.

As for public TV, with a solid 17 per cent, Raidue is the only channel offering a substantial amount of fiction programming. As the figures show, this channel has taken the lead over the other RAI channels as main fiction provider. It also seems the most determined to invest in home-produced series. The TV hit of 1996 was a police series produced by Raidue.

Nearly 70 per cent of the total fiction broadcast during the sample week (90 hours out of 131) was produced in the US, 85 per cent if the fiction produced in Latin America is included in the count. While almost all (90 per cent) fiction programmes shown by MEDIASET were North and South American productions, RAI fiction too was dominated by US dramas (74 per cent), with daytime series and socials like *Murder She Wrote*, *Loving*, and *Santa Barbara*, or prime time attractions like *ER* and TV movies.

Graph 4.1: Origin of Television Fiction in Italy (Sample week 2–8 March 1996)

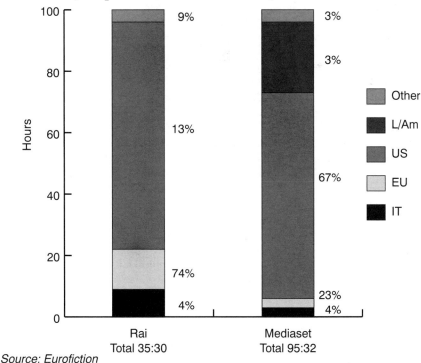

Source: Eurofiction

Very little space is left on the programme grids therefore for Italian or European TV fiction programmes. Italian production is limited to four first-run programmes and no re-runs at all, for a total of just 6 hours. European production is limited to *Derrick* on Raidue and *Premiers baisers* on Italia1. During the sample week, domestic fiction productions accounted for barely 5 per cent of the total weekly supply, climbing to 10 per cent during prime time.

Probably the most marked difference between Italian TV programme schedules and those of other countries is not so much, or not only, the huge gap between imported and domestic fiction, but rather the fact that such a large quantity of US productions are shown at prime time. In most countries, these are used to fill up the horizontal daytime time slots. during the sample week, if movies are included in the count, there are six US productions on RAI and twelve on MEDIASET at prime time. In other words, 43 per cent of the monitored evenings,[5] corresponding in volume hours to 64 per cent of the total evening supply of TV fiction and movies, are filled up by US productions.

Graph 4.2: Film and TV Fiction in Prime Time (Sample week 2–8 March 1996)

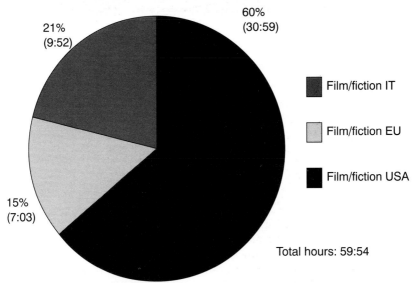

60% (30:59)

21% (9:52)

15% (7:03)

Film/fiction IT

Film/fiction EU

Film/fiction USA

Total hours: 59:54

Source: Eurofiction

The drop in fiction production, therefore, means that Italian networks depend heavily on foreign imports to fill up their programme grids. More importantly, this has stunted the development of an authentic Italian TV industry. However, it has not prevented domestic fiction from telling its own stories, exploring new possibilities, creating its own style, producing its own hits, and, naturally, experiencing its own flops.

After favouring the historical genre for many years, in the early 1980s RAI made a sharp and decisive turn to contemporary Italy, and in particular, to family problems and social issues. RAI produced fiction no longer takes its inspiration from

5 Seven evenings multiplied by six channels = 42.

Il Maresciallo Rocca

Photo: Ufficio stampa Rai

literature and history as it used to, but rather from stories in the news. *La Piovra*, an extremely popular mafia story in Italy, and perhaps the most popular Italian fiction abroad (sold in over 100 countries), is the best example of this type of social drama which deals with issues like organised crime, urban violence, battered and abandoned children, the discontent of youth and much more. Recently, the public network has come back to the police series which, along with the *sceneggiato*, is one of its traditional genres. RAI has re-elaborated the old formula by creating a special mixture of comedy and family drama: *Il Maresciallo Rocca*, the hit-series of 1996, is the perfect model of this new formula.

In contrast, comedy is the cornerstone of the private network, which has produced its own fiction since the second half of the 1980s. It is in fact the only operator showing any interest in producing sitcoms, albeit with some ups-and-downs. *Casa Vianello*, a domesticom starring two popular actors of variety-show ilk, has garnered respectable ratings for six seasons running. This is a rare example of longevity, considering the normally short shelf life of Italian fiction, which fails to take advantage of large-scale production and therefore tends to produce limited runs and one-offs. While the comedy caters mainly to an Italian audience, the fantasy story, MEDIASET's other favourite genre, is more internationally oriented. *Fantaghirò*, based on a fable rediscovered by Italo Calvino, began its sixth season in 1996, and has been sold in 70 countries.

3. Domestic TV Fiction in 1996

In 1996, national TV networks broadcast 221 hours of original Italian fiction. This was the lowest among the five big European countries, although the downward trend which marked the first half of the 1990s had begun to reverse its course.

Table 4.3 – Total Fiction offered in 1996 (in hours)

Raiuno	75:20	Canale 5	65:56
Raidue	52:30	Rete 4	4:30
Raitre	21:40	Italia 1	1:30

Source: Eurofiction

The two general-public channels, one state-owned (Raiuno), the other private (Canale5), broadcast a total of 64 per cent, respectively 75 and 66 hours of domestic production, followed by Raidue (52 hours). MEDIASET's women and youth oriented channels (Rete4 and Italia1), have played a very secondary role, while Raitre has unexpectedly contributed to the expansion of home-grown fiction with *Un posto al sole*, the first Italian-made daily soap opera, produced with the Italian branch of Grundy Productions. Based on the life of a group of young people, this serial has been somewhat improperly scheduled on Raitre, which generally caters to male, adult and possibly 'politically involved' viewers, and does not traditionally broadcast serials. Its less than satisfactory ratings therefore are in part due to the fact that it corresponds to neither the identity nor the audience of the channel.

Out of 42 fiction programmes – 27 on public TV and 15 on the private channels – *Un posto al sole* and three sitcoms broadcast on private channels are the only examples of national productions scheduled in time slots other than prime time, which alone accounts for 83 per cent of the total fiction broadcasts. Italian networks prefer to feature their production in prime time for two reasons. The first is to ensure maximum viewing for the rare home-grown production. Moreover, the national production system is too small-scale to meet the needs of daytime grids.

Graph 4.3: 1996 Italian TV Fiction

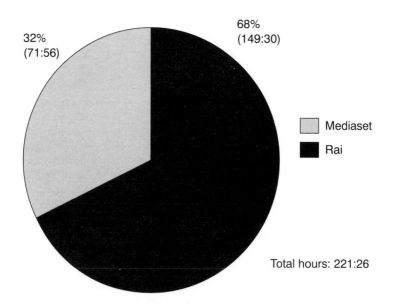

32%
(71:56)

68%
(149:30)

Mediaset
Rai

Total hours: 221:26

Source: Eurofiction

This explains why an episode or instalment in Italy lasts longer (one hour on average) than anywhere else. Programme grids tend to be split either into 30-minute slots for soaps and sitcoms (in 1996, 91 episodes all featured outside prime time), or 80 to 100-minute slots for TV movies, mini-series and prime time series (101 episodes). The 52-minute formats used internationally are rarely adopted in Italy because they do not fit neatly into prime time slots. Episodes of this length (36 in 1996) are usually broadcast in pairs, as are most American series. This however does not necessarily prevent the networks from losing part of their viewers during the break between the two episodes.

Italian fiction, basing its artistic direction and production on examples taken first from theatre then from cinema, has little experience with serial fiction. Series and serials, which in other countries make up the mainstay of programming, have long played a marginal role in the production and programming of domestic fiction. Even 1996 shows a clear prevalence – 29 out of 42 – of non-serial formats like TV movies and mini-series, mostly shown on public channels. Of a total 27 RAI productions, 15 were TV movies and 5 mini-series. Though new to the Italian broadcasting scene, serial programmes are now a vital part of current trends in Italian fiction, as is shown by the ever-increasing volume of programmes offered. Thirteen domestic serial productions were broadcast in 1996, including a daily soap, accounting for slightly more than 50 per cent of total numbers of hours. This figure tops 60 per cent in the case of private channels.

In terms of genre, public and private networks have strategically chosen to avoid head-on competition, creating instead a 'territorial' division of roles: dramas and crime stories, increasingly identified with detective series, are generally featured on RAI channels, while MEDIASET specialises in comedies and fantasy fiction. In 1996, RAI networks broadcast 83 hours of drama, and more than 44 hours of crime stories, corresponding to 85 per cent of its total volume of fiction. For MEDIASET, 75 per cent of its fiction programmes featured comedy (45 hours) and fantasy fiction (10 hours). RAI recognises however that comedy is too popular in Italy, witness its continued success in national cinema, to be dropped completely. Therefore, its producers compensate for the limited production of 'pure' comedies by adding comic elements to dramatic genres. This is particularly true for cop shows.

It would shed little light on the Italian scene to say that Italian fiction generally tells stories about contemporary Italy. This is equally true in most other countries. In the case of Italian fiction, however, the fact that most programmes are deeply-rooted in the national context (90 per cent of the episodes are set in Italy), and in the present (92 per cent), is a relatively recent phenomenon for Italian fiction, in terms of quantity if not substance. The resort to present-day situations is easily explained by the fact that the state-owned networks no longer feature the historical genre, now replaced only in part by fantastic tales of the past and biblical stories. The unprecedented and virtually absolute use of Italian settings and film locations, in contrast, is a direct result of changes in the forms of co-production. In the early 1990s, for entire seasons, Italian locations and landscapes were eclipsed by the foreign settings featured in international co-productions, where the action and characters leapt about from one (co-producing) country to the other.

Co-productions are still numerous, and will continue to play an important role economically and strategically speaking, if Italian fiction hopes to go international (in 1996, out of 42, 20 fiction programmes were co-produced: see Chapter 1). However, Italian broadcasters have caught on to the fact that stories shot in too

many different locations end up losing their identity, thus reaching only a limited audience. Therefore, they prefer to form strategic alliances to co-produce local stories set entirely in Italy, as most of 1996's co-productions demonstrate (*Morte di una strega, Uno di noi, Dio vede e provvede*, etc.). Naturally, this strategy does not include major international co-productions like *La Bibbia* or *I viaggi di Gulliver*. These blockbuster fiction specials are important vehicles through which both private and public broadcasters re-enforce their image on both the national and international scenes.

It is equally important to analyse the information regarding the setting of Italian fiction stories from a diachronic point of view. Again, the prevalence of large cities – 73 per cent of the episodes, but only 60 per cent in terms of volume hours – is quite common in other countries too, and therefore not a peculiarly Italian feature. In Italy however, large cities are seen less frequently on TV, reflecting the switch in consumer tastes, and urban settings are gradually growing smaller, becoming towns and villages. For example, whereas 24 productions (131 hours) are set in the metropolitan areas of Rome, Milan, and Naples, the remaining 18 (90 hours) tell non-metropolitan tales set frequently in small villages or the countryside. This is particularly true for MEDIASET productions.

Moreover, compared to the rest of Europe, Italian fiction is based more on a central figure: 35 per cent of the episodes, (43 per cent in terms of hours) revolve around a lead character or hero, (in some cases the 'everyday hero' so popular in Italy).

Table 4.4 – Italian Main Characters

RAI	Eps.	Hours	MEDIASET	Episodes	Hours
Male	54	73:00	Male	15	23:10
Female	4	6:00	Female	8	12:40
Couple	6	8:50	Couple	36	21:36
Choric	88	61:40	Male group	10	4:00
			Female group	7	10:30
Total	152	149:30	Total	76	71:56

Source: Eurofiction

For a clearer understanding of the figures presented in this table, it is important to point out that Italian culture in general is very individualistic. It is also true that the narrative formats preferred by Italian broadcasters, tends to feature a single central figure, as is the case in TV movies, whereas serialized formats revolve around clusters of main characters. It should also be noted that the main characters are rarely female, almost never in RAI programmes. This telltale sign of a traditional approach is only partially compensated for by the numerous modern female characters who are part of the stories, but never play the central roles.

4. Successes and Failures

1996 was a special year for Italian fiction. Thanks to *Il Maresciallo Rocca*, RAI managed a repeat performance of the ratings it had scored in March 1989 when *La piovra* – the most popular TV fiction programme ever produced in Italy –

Dio vede e provvede

Photo: Ufficio stampa Mediaset

concluded its fourth series with the mafia slaying of the main character. Acclaimed by critics and viewers alike, *Il Maresciallo Rocca* is more than just a simple success story. It has become a popular phenomenon, and succeeded in gathering the dispersed members of the Italian family in front of a TV set. Now the subject of collective discussion *Il Maresciallo Rocca* has given a new life to the sagging image of Italian TV fiction.

Il Maresciallo Rocca is the finished product of a finely-tuned process of producing and marketing TV fiction. This is part of a current trend to break away from the home-made nature of traditional Italian fiction programs, and experiment with new processes and strategies. The creative phase of the series was backed by unusually detailed research. The Carabinieri, Marshal Rocca's Police Corps, were contacted, and scripts were submitted to story editors, a poorly known or poorly-used profession to date in Italy.

Moreover, for the first time in the history of Italian fiction marketing, the series was promoted in an almost movie-like fashion: posters were displayed on the sides of city buses or the walls of railway stations and other crowded places. More importantly, the series was 'trailed' by the evening news, which concluded with a short interview with the lead actor, inviting viewers to stay tuned for the 'stories of everyday heroism of marshal Rocca'. The lead himself appeared on TV during the break between the news and the series to plug a brand of coffee. This kept viewers entertained and interested through the passages from news, to commercials and finally to fiction. Furthermore, an extensive press campaign kept the series in the limelight, creating a generally receptive response to a production which would soon become the emblem of 'good national fiction'.

It goes without saying that a hit like *Il Maresciallo Rocca* cannot be explained simply in terms of effective marketing strategies. The key to its success also lies in the effective use of a purely Italian and *recombinant* recipe for police series. This calls

for a blend of four basic ingredients: (1) a mixture of comedy and drama; (2) a provincial setting; (3) the involvement of family and domestic life in the story; (4) the individuality of the lead character, an 'anti-hero' who represents the common people, the person on the street complete with ordinary vices and virtues.

Table 4.5 – Top 20 TV Fiction Episodes in 1996[6]

No.	Title	Date	Channel	Genre	Audience	Share
1.	*Il Maresciallo Rocca* (8)	12.03	Raidue	crime	15,585	50.27
2.	*Morte di una strega* (2)	7.02	Raiuno	crime	9,541	31.72
3.	*Sansone e Dalila* (1)	16.12	Raiuno	biblical	9,057	32.28
4.	*Il piccolo Lord*	3.01	Raiuno	drama	8,550	31.11
5.	*Caro maestro* (7)	26.04	Canale 5	comedy	8,082	29.81
6.	*Il ritorno di Sandokan* (1)	6.10	Canale 5	action	7,366	29.47
7.	*Dio vede e provvede* (9)	29.10	Canale 5	comedy	7,085	26.55
8.	*I viaggi di Gulliver* (1)	24.11	Canale 5	fantasy	6,772	25.61
9.	*Padre papà* (2)	11.04	Canale 5	drama	6,591	23.28
10.	*Uno di noi* (1)	1.12	Raiuno	drama	6,574	24.77
11.	*Dopo la tempesta*	5.06	Raiuno	crime	6,530	27.80
12.	*Favola*	4.04	Italia 1	comedy	6,509	24.81
13.	*Sorellina* (2)	4.01	Canale 5	fantasy	6,507	22.99
14.	*Donna* (6)	4.04	Raiuno	drama	6,479	21.90
15.	*La tenda nera*	18.02	Raidue	crime	6,259	23.30
16.	*Cascina Vianello* (1)	17.09	Canale 5	comedy	6,229	23.79
17.	*Pazza famiglia* (12)	7.11	Raiuno	comedy	5,811	24.30
18.	*Senza cuore* (2)	17.09	Raiuno	drama	5,590	21.04
19.	*Quei due sopra il varano* (1)	25.10	Canale 5	comedy	5,177	27.65
20.	*Il prezzo del denaro*	24.02	Raidue	drama	4,919	18.77

Source: Auditel

An interpretation of Italian TV fiction hits in 1996 based on cultural indicators reveals that trends in what the market has to offer are closely matched to consumer preferences. This is no doubt due to adaptations made on both sides. With the exception of fiction specials like *Sansone e Dalila*, *Il ritorno di Sandokan*, *I viaggi di Gulliver*, or fables likes *Sorellina*, which tell stories about faraway times and places, headlining the season are dramas and comedies about contemporary Italy, often set in small urban locations, preferably revolving around male leads: a sub-officer of the Carabinieri Corps (*Il Maresciallo Rocca*), an elementary school teacher (*Caro maestro*), the director of an institution for abandoned children (*Uno*

6 This table has been elaborated choosing, for each programme, the top-rated episode or instalment; the number in brackets next to the title indicates the order of the episode or instalment in the airing sequence.

di noi). These and other social figures, featured in the most popular stories of the year, are all similar to the extent that they either play or represent father figures.

Reflecting the prominent role played by the family in the cultural tradition of the country, Italian fiction has for some time now preferred to feature stories about fatherhood (both natural and symbolic), while motherhood is given a low profile or kept totally in the background. The relationship between reality and the fiction is far too complex to be dealt with here in terms of season's highlights. Nevertheless it is possible to note that this trend reflects a widely felt social need for leading figures who are both authoritative and benevolent, responsible and protective, an embodiment of the ideal father figure.

The most atypical success of the year, acclaimed by critics and viewers alike, is undoubtedly the series *Dio vede e provvede*, indeed one the few listings with an all-female cast of characters. Slightly reminiscent of *Sister Act*, this comedy is set in a small community of extravagant nuns led by an even more extravagant main character, an ex-prostitute. The series was preceded by a pilot, a relatively innovative production technique in Italy, though private networks are adopting it more and more frequently.

The casting too was unusual. *Dio vede e provvede* is played by a group of talented and experienced comic actresses, though none of them are real stars. This can be risky business in a country where success for fiction programmes has always hinged on the use of overwhelmingly popular stars from cinema, theatre, or TV variety shows. Well-aware of what was at stake, the producers of *Dio vede e provvede* made this move in an attempt to break down a restrictive star system – at least in the field of serial fiction – which turns out not only to be costly but also hampers production plans and scheduling. There have been several cases recently

Uno di noi
Photo: Lux Vide

where successful series did not go into the next season because the leading actors refused to play the same roles for fear of being 'eaten up' by the characters.

In fact, 1996 was marked by the timid comeback of the very leading character in domestic fiction. Lately, producers had been relatively unsuccessful in creating clearly recognisable central figures that viewers could relate to and sympathise with, who would keep the public's interest, for at least one season. This was caused in part by the lack of serial fiction in Italian production. In ensuring the steady return of the leading characters, serial formats and story-lines provide a more fertile ground for easily identifiable central figures. Serial fiction heroes are also easier to remember because they keep coming back.

In terms of serial production, there is a steady trend in domestic output toward *recombinant* story-telling formulas: the series framed within a mini-series. The idea here is to create a series of separate, self-contained episodes, inserted within the linear development of the continuing story. Such a formula, reaching its highest and most complex point in *Hill Street Blues*, enriches the story-line by intertwining a detective intrigue with the family or love life of the lead, for example. At the same time, the use of repeated patterns (typical of the series) and narrative development (typical of the mini-series) keeps the audience tuned in. However, the limited experience of Italian writers in the field of serial script-writing makes it difficult to guarantee success in a such tricky area. Nevertheless, though somewhat shaky and discontinuous at the moment, this formula could turn out to be a distinctively Italian way of writing drama.

Though they did not make the Top 20, two other productions are worth noting as they provide useful insight into the general situation. *I ragazzi del muretto* is a youth series composed of 50-minute episodes. It has been a prime-time feature on Raidue for three non-consecutive seasons. *Casa Vianello*, broadcast on Canale 5 for six seasons, is a domesticom which recently spun off *Cascina Vianello*. Exceptionally long-running for Italian standards, these two series, which both came to an end in 1996, are the most successful and popular examples in their respective genres: the youth drama and the sitcom.

Given the lukewarm response to *Un posto al sole* so far, the closing of *I ragazzi del muretto* leaves a void in a crucial sector whose viewers watch less TV in terms of hours, but are avid consumers of American programmes, in addition to being an attractive target for advertisers. Because they are international consumers with multi-media orientations and tastes, producers are more likely to choose young audiences to try out new styles and innovative forms.

In contrast, the absence of *Casa Vianello* does not leave a void on the sitcom front, since the private network releases at least two brand new titles every year. However, where *Casa Vianello*, with its tried-and-true stereotypes of the grumpy, discontent husband and unsatisfied, nagging wife, succeeded in creating a credible and evocative image of the irremediable incompatibilities of married life, other sitcoms have been much less successful in many respects. At times over-acted (*Quei due sopra il varano*), with unlikely plots lacking in pace and wit, most Italian sitcoms fail not so much in identifying, but rather in exploring the neuroses, the sore points, the conflicts, and the turning points that characterise contemporary life. Hence, they are not able to exploit them as sources of cutting satire and wit.

5. Looking at the Future

This last decade, particularly the early 1990s, saw a major recession in the production of fiction programmes in Italy. 1996 however brought about a new cycle of growth whose results will be seen in the coming seasons. This recovery was triggered by policy changes made in both the public and private sectors. With healthier budgets, both RAI and MEDIASET are now able to invest in the production of domestic fiction, and take part in European co-productions. Even the third player on the Italian market, film-producer Cecchi Gori, has recently launched into the production of several serial programmes based on hit comic movies.

It was high time the networks got themselves out of the red. But this was not enough to remedy the uneven allocation of financial resources where more was spent on purchasing and flow programming. The real change in tack is due to the fact that operators are now aware that, with the development of cable and satellite technologies, major changes are in store for distributors. Their capacity as major content-providers will become a sink-or-swim issue, if they hope to stay in the production mainstream and avoid being drowned out by foreign competitors.

The following observations can be made:

1. Fiction produced in the US is becoming less and less economical, and with a few exceptions, losing ground in the ratings. The Latin American *telenovelas* have hit rock bottom.

2. Hollywood movies suitable for prime time are no longer available in such large numbers as before. At any rate, televised feature films are bound sooner or later to become an exclusivity of pay channels, while VCRs, now present in 68 per cent of Italian households, make televising feature films less attractive and more difficult to exploit.

3. The stock of flow programmes is running short, since the national and international formats of variety, reality, game and talk shows have been over-exploited. In light of this, Italian networks have no choice but to produce their own fiction programmes.

The near future will reveal the driving force behind this new productive effort, with investments forecast at almost 2500 billion lire by the year 2000. It remains to be seen if emphasis will be given to the requirements – particularly felt by the public networks – of satisfying a purely national demand, hence telling Italian stories to Italians; or wheter this approach will be integrated, as the private networks appear to be doing, into a general strategy aiming to produce fiction with European, even international, flavour and appeal.

5. Family Comedy, Family Doctor

Spanish Television Fiction in 1996

Lorenzo Vilches, Charo Lacalle and Rosa A. Berciano

1. The Industrial Age of Domestic Fiction

Spanish Television seems bound and determined to ride the wave of technological and economic innovation currently sweeping Europe. The battle between private broadcasting companies and public TV networks (often in alliances with private Latin American broadcasting corporations) over digital television is irrefutable proof that both the political powers and mass media in this country are closely linked with the broadcasting business. In a context where private broadcasting companies seem more inclined to making the necessary transformations in their commercial and productive practices, televised fiction is without a doubt proving its worth as a safe and profitable investment in the battle for larger market shares.

Table 5.1 – Market Share of Spanish TV Channels

TVE1	27%
LA2	9.2%
Ant3	24.6%
Tele5	20.7%
Canal+	2%
Auton	15.4%
Others	1.1%

Source: Sofres

Although supply and demand are likely to be more heavily segmented in the future, the 125 million hours of television that 36 million Spaniards watch daily (compared to the European average of 1 billion hours a day) constitute a market with enormous potential for televised fiction. In a country where clear strategies

regarding digital broadcasting have yet to be defined, and the implementation of technological infrastructures is far from complete, large-scale production of fiction is an unprecedented challenge. It is also one of the most solid investments currently on the market. Generally speaking, private broadcasters and production companies are likely to reap the most benefits from this situation. Moreover, in spite of the increased daily volume of fiction (in 1996 the daily average was 499 minutes compared to 470 minutes in 1995), both films and american series fail to capture audience shares in proportion with the supply.

Table 5.2 – Offer and Consumption of Fiction (TV and Film) in 1996 (%)

	TVE1	La 2	TELE 5	ANT. 3	TV3
Offer	44.6	25.9	68.3	53.2	44.5
Consumption	39.8	25.7	51.9	53.1	34.9

Source: Eurofiction

Despite this gap between supply and demand, fiction is by far the genre Spaniards prefer most. Even more significant, and similar to what occurs in other European countries, fiction programmes produced domestically fare better in the ratings than their foreign counterparts.

Tele5 is a case in point. This private broadcasting company's decisive choice to invest in its own productions has paid off. In December 1996, it turned out three series which accounted for a mere 2.9 per cent of the programme grid, but secured a hefty 10 per cent audience share.

This upward trend in the production of televised fiction can be explained in part by its ability to adjust to the social variables of the audience, whose social background is basically low to middle class, with a majority of women preferring TVE1, Antena3 and Tele5. For the most part, the success of this production lies in using formulas, story-lines and characters which are very innovative compared to the fiction produced prior to 1992. In view of the private initiatives and industrial techniques adopted in producing these series, 1996 can be said to have marked the beginning of large-scale production of TV fiction in Spain.

2. A New Production System

In response to this increased demand for domestic fiction, new companies have been created and existing operators have re-organised to adjust to the changing needs of the market. New-born independent producers are gathering momentum, and adopting mass production techniques used by the toughest commercial broadcasters. This large-scale production system is a major breakthrough compared to the former, more craftsmanlike approach which was traditionally anchored in cinema, and featured closed narrative structures. The broadcasting industry has gone professional, with new technical and human resources at its disposal. Admittedly, issues regarding property rights have yet to be solved, and the exploitable market is still relatively small. However, reliable sources reckon on sales figures to the tune of $140 million (20,000 million pesetas) in this sector.

In the case of the national networks, both public and private, most production is 'by commission' whereby the production company and the network enter into contracts

for the purchase of broadcasting rights and/or the programmes themselves. The autonomous Catalan Television offers yet another model by successfully exploiting their own in-house resources, i.e. using their own production departments.

Despite this steady trend towards industrialisation in the TV fiction sector, production costs still vary enormously, with striking variations from one production to the next. It is also important to note that many successful series choose big-name actors and actresses from show business for their lead roles. This makes for an even larger gap in production costs depending on whether the cast features stars or not.

Examples of this abound, notwithstanding the lack of accuracy in the figures, provided by the broadcasting and producing companies. Production costs for the sitcom, a recent 'invention' for Spain which experts claim to be the most profitable domestic format, range on average from $150,000 to $300,000 per episode. In contrast, the two most successful series, *Médico de familia* and *Hostal Royal Manzanares*, which alone costs more than $600,000 per episode, run up bigger bills because of the stars they feature in leading roles. Another characteristic

Médico de familia

Photo: Tele5

feature of the domestic production is the length of the sitcom format. Many of these exceed 50 and 60 minutes.

With regard to the drama series, which fared less well in 1996 than comic genres, it costs an average of $350,000 to $550,000 to produce a one-hour episode. It is important to note that in certain cases, like the Catalan channel, TV3, which produces the entirety of the fiction it broadcasts, costs have been reduced considerably while their script-writers have stepped up output. The TV movie, a relatively rare format in 1996 domestic production, costs roughly $ 600,000. Finally, the Prestige series based on historical drama and literary adaptations may run as high as $1–1.7 million per one-hour episode.

This innovative key role played by fiction has developed within a highly competitive and somewhat economically uncertain framework which has characterised the sector since deregulation. This means that in selecting projects, priorities are given to those guaranteeing immediate returns and marketability. Moreover, conservative choices are made regarding new creations, which tend to favour productions based on tried-and-true ideas and models.

3. Sample Week

From the analysis of one sample week (March 2-8, 1996), it is clear that the Spanish networks have adopted a programming policy aimed at ensuring maximum audience loyalty. The programme grid is divided into zones featuring similar content at set hours, and programming tends to be grouped according to genre, format and product origin. In terms of volume, private channels feature more TV fiction and series than the public networks.

During the sample week 40 per cent (227 hours) of the programmes were fiction and 60 per cent non-fiction (333 hours).

The breakdown for the total amount of fiction offered (TV and films) is as follows: 44 per cent (99 hours) for public networks (TVE +TVC) compared to 56 per cent (128 hours) for private broadcasters (Antena3 and Tele5).

Far more fiction (including films) is broadcast over private channels (Tele5: 66 hours vs. 46 hours of non fiction; Antena3: 62 hours vs. 50 hours). This is considerably less for public stations (39 hours vs. 73 hours on TVE-1; 20 hours vs. 92 hours on La 2; 40 hours vs. 72 hours on TV3). With TV fiction rating higher the ratio between fiction programmes and films is virtually the same for both the public and private networks (TVE1 registered 69 per cent, Tele5 65 per cent, TV3 58 per cent).

Spanish television offers a total 156 hours of exclusively TV fiction. While feature films play a major role, in certain cases like the private channel Antena3, prime time fiction is 100 per cent made-for-TV and entirely domestic. This is partly because the international market is in the hands of the public networks, who, along with one private operator Tele5, have clinched deals with foreign companies, leaving no films available for other channels.

The role of imports in programming has changed in recent years as a result of the boom, both in size and importance, for TV fiction. While the amount of fiction coming from the US is still considerable in terms of quantity (and will be even more so on digital channels), it has been ousted from prime time. Imported series are used as a back-up when domestic production is unable to provide an adequate

supply of the more 'dignified' formats: TV movies and mini-series. They also compensate to a certain extent for shortages in the sector of the drama series.

In terms of origin, the great majority of fiction offered is produced in the US. (65 per cent for TV fiction, 76 per cent movies). In contrast, domestic production (13 per cent TV fiction, and 20 per cent movies) though on its way up, remains insufficient within the European context.

Graph 5.1: Domestic and imported TV fiction

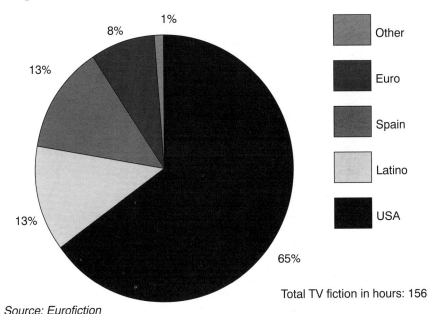

Source: Eurofiction

The amount of US TV fiction broadcast by the leading public channel is considerably less (22.1 per cent) compared to private programming (75.8 per cent on Tele-5 and 85.6 per cent on Antena-3). In the case of TVE1, for example, Latin American fiction programmes account for a solid 13 per cent of the total amount of fiction offered. As for programming within this network, Latin American imports outstrip those from North America, 71.7 per cent to. 22.1 per cent.

On TVE1, Latin American *telenovelas* are important in terms of volume. However, scheduled during secondary time slots with high shares and very low ratings, they compete in afternoon viewing times with the North American TV movies broadcast by private networks.

European fiction programmes are rare and account for only a fraction of national broadcasters' schedule (8.7 per cent). Generally speaking, where European fiction does play a role is in co-productions, most often in the form of the mini-series (Tele5: 18.8 per cent, TV3: 13.5 per cent).

After movies and telenovelas, the most common format featured is the series, particularly in the case of the private networks (61 per cent on Antena 3; 36.2 per cent on Tele5). In terms of genre, drama and action/crime tend to prevail over comedy.

However, this tendency is reversed in prime-time schedules, where the lion's share goes to comedy, almost exclusively home-grown.

Graph 5.2: Origin of films (sample week)

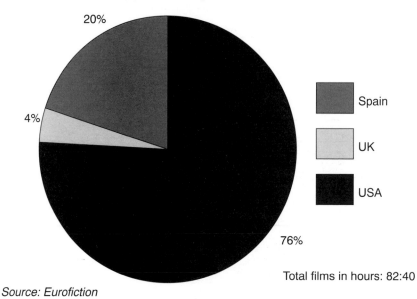

Source: Eurofiction

4. Domestic TV Fiction in 1996

In Spain, there are four nation-wide channels broadcasting over the air: Television Espanola (TVE-1 and La2), Antena3, Tele5 and Canal +. The public regional networks, a unique feature of Spanish broadcasting, play a very different role compared to their European counterparts, and follow their own set of regulations. These Autonomous Broadcasting Systems have their own Board of Directors and budget, and depend on the autonomous governments.

For the Eurofiction's study, the two national public channels belonging to TVE (TV1 and La 2), and two national private networks, A3 and T5 were monitored. Jointly they broadcast more than 306 hours of domestic fiction. The autonomous TV3 of Catalan was also included, given that it accounts for a volume of 153 hours of fiction produced in-house out a total of 459 hours. The magnitude of Catalan's economic and political power is reflected to a certain extent in the number of fiction hours TV3 adds to the public networks. While TVE alone supplies only 35 per cent of the total fiction compared to the 65 per cent produced by private broadcasters, if TV3 is taken into account, the ratio is inverted, with a total of 57 per cent for public networks and 43 per cent for private television.

There are two major broadcasting seasons for domestically-produced programmes. The first starts in January and ends in June, while the second runs from September to December. July and August are low-viewing months. In terms of hours and number of episodes, channels prefer the spring, autumn and winter months. The months of April, October and December offer the largest number of programmes, between 13-14, with a sharp increase in December (up to 87 episodes).

Prime time absorbs most of domestically-produced fiction programmes (69 per cent). Only three titles, all serial dramas modelled after US soap operas and Latin American *telenovelas*, are broadcast in the daytime by Tele5 and TV3. In this way, these two networks ensure a more evenly-balanced distribution in their afternoon and evening fiction programming.

Table 5.3 – Fiction Offer in 1996

Public TV	TVE – La2 (Television Espanola) TV3 (Television de Cataluñya)
Private TV	A3 (Antenna 3), T5 (Tele 5)
Total hours	459
Without TV3	306
Total episodes	696
Without TV3	418
Total Programmes	27
Without TV3	22

Source: Eurofiction

Graph 5.3: Fiction programmes by months

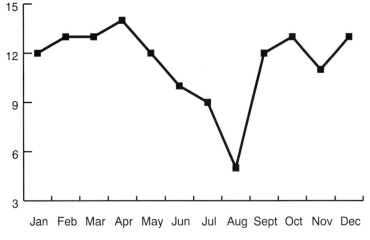

Source: Eurofiction

5. Family Comedies

In 1996, the series was by far the preferred format of Spanish broadcasters (62 per cent of total fiction broadcasts). Even more striking is the low number of other formats (four closed serials and one open serial).

A similar imbalance also shows up in terms of episode length. Generally speaking, short (30 minutes) and medium episodes (45 minutes) are the most prevalent on

Hostal Royal Manzanares

Photo: TVE1

nearly all channels, and amount to a total of 18 listings, twice the number of long episodes (50 and 60 minutes). This is primarily because longer formats require more production time per episode. Several new formulas, such as *Hostal Royal Manzanares* (60 minutes), have made it possible to cut production time down to four days per episode. It is also evident that the daily serials (*Nissaga de poder* on

Graph 5.4: Programmes by length of episodes

Source: Eurofiction

TV3 and *El Super* on Tele5) stand a better chance of being both profitable and popular if they do not last over 30 minutes. In terms of ratings, the longer episodes only work well for comedies (e.g. *Médico de familia* and *Hostal Royal Manzanares*).

With regard to genres, 62 per cent of the hours offered by national networks feature comedy and 34 per cent are dedicated to drama, except in the Catalan region where 62 per cent of the hours offered to audiences feature drama.The criminal or detective genre does not exist in Spain, and the TV movie still plays an insignificant role, though some networks do seem to be developing an interest in this format.

Comedies and sitcoms headline Spanish television, and do consistently well in the ratings. TV comedy is the typical product of a post-monopolistic broadcasting system. In the season 1993–1994, seven episodes of *Farmacia de Guardia* managed to rank among the most-watched hits of the year. In the following season, 1994–1995, two other comedies were broadcast along with *Farmacia de Guardia*. Jointly they succeeded in placing 32 episodes among the top 50, no small feat considering that these series must compete with the all-powerful and ever-present soccer games. In 1995–1996, thanks to two strong contenders already firmly established on the comedy scene (*Hostal Royal Manzanares* and *Médico de familia*), these results have been confirmed, and now more than 37 episodes rank among the 50 most-watched.

Graph 5.5: Genres

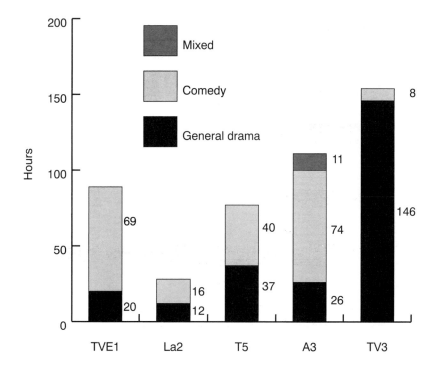

Source: Eurofiction

With these achievements under its belt, the supply of comic genres made a name for itself in 1996. National networks broadcast 16 comedies, compared to only six drama serials. Two comedies, *Hostal Royal Manzanares* and *Médico de familia*, attracted an average audience of nearly 15 million viewers, with average shares of 42.6 and 44.9 respectively.

These two hit series feature leading characters, a man in *Médico* and a woman in *Manzanares*. Both from solid careers in television and theatre, actor Emilio Aragòn and an actress Lina Morgan play a vital role in how the comedy is structured. This blurring of identity between actor and character is distinguishing feature of domestic productions. Other series like *Los Ladrones van a la Oficina*

Todos los hombres sois iguales

Photo: Tele5

(Fernando Fernàn Gòmez), *Yo una mujer* (Concha Velasco), *Menudo es mi padre* (El Fary), *Todos los hombres sois iguales* (Josema Millàn), *Ay Señor, Señor* (Andrés Pajares), also showcase leading actors from the world of theatre, cinema or music. The script-writing for these series is based on the personal appeal of these stars.

As the ratings show, this preference for leads from non-television backgrounds has proved to be successful with TV viewers.

6. Successes and Failures

Domestic fiction has been a powerful weapon in inter-network warfare. It has been equally crucial in helping individual networks build up their brand image. *Médico de familia* for example contributed to both the successful launch of Tele5 and the creation of its new image.

Comedy is at present produced domestically, whereas drama series are usually imported, except in the case of the autonomous networks. In this respect, public broadcasting company TVE offers the most diversified diet of programmes. Here, among a majority of comedies, there are also listings of a different tenor, like the new Don Juan or the thriller series *La virtud del asesino*. In most cases, these are either co-productions with the autonomous networks, as in *Entre naranjos* or *Blasco Ibanez*, or international deals like *Nostromo*, based on the novel by Joseph Conrad.

A recent novelty, many of the national channels are producing in the serial format (*El Sùper*), enabling domestic fiction to take a foothold in daytime scheduling. The year 1996 was marked by the conquest of new daytime and night-time slots. The networks compete with programmes ranging from the above-mentioned serial to the talk show, including night-time programmes of Anglo-Saxon vintage (David Letterman's *Late Show*). This is somewhat of a step backwards for imports, particularly those from the US.

Another common practice is to extend the length of the programmes, both fiction and non, so as to reduce the fragmentation of prime time slots. Therefore, comedies may last close to or exceed 60 minutes, and entertainment programmes such as *Sorpresa, Sorpresa* run for over four hours. It is also customary to broadcast two episodes of a series back-to-back, as is often the case with *The X Files*.

The bulk of the investments and greatest talents in the broadcasting industry continue to be poured into domestic comedy, with a tendency towards favouring younger characters and small innovations wrapped in light humour, and a more or less daring approach to the issues dealt with in programmes, which at any rate, are aimed at a family audience.

The family comedy ranks among the most successful programmes. *Médico de familia, Hostal Royal Manzanares, Menudo es mi padre, Todos los hombres sois iguales, La Casa de los Lios*, all broadcast during prime time and followed by an extremely loyal audience, are the five most watched series. There is a direct link between how much a series deviates from the standards of light comedy on the one hand, and the high and lows of different audience segments, on the other. Touching, sentimental humour is more successful than humour dealing with the picaresque (*Los Ladrones van a la Oficina*), or cunning (*Hermanos de Leche*), the puns and punchlines of the comic (*Makinavaja*), or comedy with sexual innuendos (*La Noche de Ozores*).

Table 5.4 – Top 20 TV Fiction Episodes in 1996

No.	Title	Date	Channel	Genre	Audience (millions)	Share
1.	*Médico de familia*	10.12	T5	comedy	9,489	49.8
2.	*Hostal Royal Manzanares*	21.3	TVE 1	comedy	8,784	47.6
3.	*Menudo es mi padre*	24.10	A3	comedy	5,453	31.8
4.	*Todos loso hombres sois iguales*	16.12	T5	comedy	5,208	29.2
5.	*La casa de los lios*	13.10	A3	comedy	5,087	30.7
6.	*Juntas pero no revueltas*	22.1	TVE1	comedy	5,014	27.3
7.	*Carmen y familia*	22.4	TVE1	comedy	4,977	28.1
8.	*Yo, una mujer*	10.1	A3	comedy	4,831	26.4
9.	*Hermanos de leche*	24.3	A3	comedy	4,282	26.7
10.	*Los ladrones van a la oficina*	3.1	A3	comedy	4,026	24.1
11.	*Este es mi barrio*	27.9	A3	mixed	3,550	24.6
12.	*El super*	27.12	T5	drama	3,394	35.6
13.	*Canguros*	5.5	A3	comedy	3,111	21.1
14.	*Tres hijos para mi solo*	21.1	A3	comedy	2,891	23.0
15.	*Colegio mayor*	17.7	TVE1	comedy	2,818	26.4
16.	*La noche de ozores*	15.1	A3	comedy	2,562	20.1
17.	*Que loca peluqueria!*	1.7	A3	comedy	2,452	22.5
18.	*Turno de oficio*	20.4	TVE1	drama	2,305	17.9
19.	*Hospital*	1.7	A3	drama	2,269	16.2
20.	*Makinavaja*	6.10	La2	comedy	1,573	11.4

Source: Sofres

The play-off between comic and dramatic elements, along with the age-bracket of the cast, seem to be decisive factors in determining success in prime time slots which clearly cater to family viewing, with a high percentage of children and teenagers in the audience. In cases, where drama was chosen and the cast featured older characters (as in *Yo, una mujer* or *Este es mi barrio* or *Carmen y Familia*), the results were disappointing, and at times total flops.

The daytime serial *El Sùper* is an exception, however. Targeted at a prevalently older female audience, it manages nonetheless to attract a younger audience thanks to a flexible narrative structure. Across the board, the characters and issues presented in these programmes are contemporary. A pre-requisite for today's fiction programmes. This explains why a somewhat old-fashioned vaudeville comedy like *Hostal Royal Manzanares* has revamped its decor recently in an effort to 'modernise'.

Most popular fiction programmes share similar characteristics. First and foremost, they deal with relational problems or family issues, which are either traditionally presented, as in the case of *Médico de familia*, and *Menudo es mi Padre*, or set in more unconventional frameworks like *Todos los hombres sois iguales*. Moreover,

they span a wide range of age groups. Some programmes like *Colegio Mayor* and *Canguros* have been disappointing in terms of ratings, even though they were targeted for teenage viewers. When it appears, the professional world of work is used merely as a backdrop for relational and sentimental intrigues, which in turn develop or serve as vehicles for a variety of social issues lending themselves to comic treatment.

Even though most of the fiction programmes are set in large cities, they cannot be defined as urban comedies in the American sense (e.g. *Seinfeld*). Instead, these comedies depict the strong feeling of small community solidarity that might be found in a neighbourhood (*Este es mi barrio*), a modern residential complex (*Médico de familia*), or a popular boarding-house (*Hostal Royal Manzanares*).

The series produced and broadcast in Catalunya (*Rosa, Estació d'Enllaç, Nissaga de poder; Sitges; Oh Espanya!*) rate as the most watched programmes at regional level. This pioneer production differs from its national counterparts because of innovative genres and formats, somewhere between melodrama and suspense, series and serial.

7. *'Médico de familia'*– A Laboratory Series

Médico de familia is an excellent example of the success which has blessed domestic television comedies, and above all of family comedies. In comparison with other comedies, the peculiarity of *Médico de familia* lies in the fact that it has been created and written using the results of a survey on viewers' expectations. Thus, it might be said that the series is a direct response to audience demands. At the same time, it has drawn on past experience and maintained the more traditional formulas.

A team of sixteen people are involved in the writing and production of the series. During 1995-96, the production process was intensive: the 75 minutes which make up each episode were produced in six days. However, since it soon became impossible to keep up with such a rate, the format has been cut down to 55 minutes this year. One page of script corresponds to approximately one hour of shooting.

Médico de familia was designed with the express purpose of keeping the audience tuned in. Thus the narrative structure of the series relies on frequent changes of scene, a clever form of self-induced zapping. In addition, narrative tension is stepped up immediately prior to commercial breaks, only one of which is scheduled ahead of time with the broadcasting company. The viewer consistency gained as a result of these built-in reiterations is re-enforced by airing *Médico de familia* in the same time slot (Tuesday 9:30 pm). This is made possible, once again, thanks to an agreement between the producer of the series and the networks. This is the more crucial considering that Spanish television scheduling is relatively inconsistent.

Médico de familia does not differ greatly from previous comedies, which were tailored around an actor or performer from show business who becomes the cornerstone of the story line. In this case, the leading actor is Emilio Aragòn, a television showman from the circus world who made his debut as a clown at the age of seventeen.

Like other successful family comedies, this series also revolves around a household of several generations living together. This alternative to both the traditional nuclear family, on the one hand, and the new broken families on the other, has proved to be a winning combination in attracting large audiences.

The story develops in two different settings: the home and professional life (the surgery where the main character works). The central story-line is accompanied by secondary intrigues based on the emotional conflicts experienced by the characters. These are treated with a very light hand, while the language used is tempered and family-like in tone. It is also important to point out that this programme contains no violent scenes or sexual overtones.

The minute care given to detail is the key to the credibility of *Médico de familia* which with time has developed a more realistic approach toward the characters. The script-writers claim these characters are based on real people.

With the aim of attracting the widest possible range of viewers, a close link is maintained between the staging of the story and its target audience. This market segment is made up, for the most part, of young adults between the ages of 16 and 34, mostly women. From the first episode on, the series has scored high in the charts. With an average share of 45 per cent, it is watched by over 8 million viewers who correspond socio-demographically with the characters of the series (the doctor, sister-in-law, father, children, housekeeper, etc.).

8. Audience Profiles

One of the remarkable achievements of 1996, a brief but intense period for production in Spain, was the ability, following the exceptional *Farmacia de Guardia*, to perfect two products which went on to become highly representative of current production styles and processes: *Médico de familia* and *Hostal Royal Manzanares*. Feature films and other programmes no longer reign over prime time as they did in the past. Only the soccer game poses a real threat in the race for first place. In this way, viewer attitudes add an element of equilibrium to the structurally unbalanced system underlying most domestic production.

While the ratings for these series speak for themselves, it is interesting to take a look at the social profile of their viewers. For this purpose, we have chosen the 3/12/96 episode of *Médico de familia*, and a *Hostal Royal Manzanares* episode aired on 5/12/96. It was found that women make up the mainstay of viewers in both cases, with a higher percentage for *Hostal Royal Manzanares*. Teenagers and young adults tend to prefer *Médico de familia*, while most viewers over 55 choose *Hostal Royal Manzanares*. *Médico de familia* attracts children between 4 and 12 years old (66.3 per cent), whereas the highest share in the case of *Hostal Royal Manzanares* is among viewers over 64 (60.1 per cent).

The viewers of these two series are also very different in terms of social background. While the highest share for *Médico de familia* are from the middle class, *Hostal Royal Manzanares* attracts a predominantly working-class audience. This even-distribution of viewers according to sociological profiles is consistent with the breakdown of the Spanish TV audience.

In this respect, domestic production has been successful in satisfying the needs of a large part of the audience. What remains to be seen is whether the quality and inventiveness will maintain the degree of popularity obtained so far, and how the formats and themes of these leading domestic programmes will fare on the European front.

6. Friends, Fools and Horses

British Television Fiction in 1996

Richard Paterson

1. A General Overview

Television fiction production in the UK has been a central priority for all terrestrial TV channels for many years. In the UK the BBC retained a monopoly in television until the establishment of ITV, a commercial channel, in 1955. Fiction has always been a central part of the programme schedule and after the establishment of the competitive market there was a rapid evolution of the fictional genre, as the ITV companies sought to address particular audiences in order to enhance their sales of advertising. The programme schedules in the United States influenced developments with the advent of long running serials (on BBC and ITV) and of series. ITV quickly established its pre-eminence in the series format and, in 1960, began broadcasting *Coronation Street*.

In the 1960s the competition for audiences continued but was stimulated by the new-found desire to offer social commentary on the key political issues using fiction. ITV ran the much acclaimed anthology series *Armchair Theatre*, while the BBC ran first *The Wednesday Play* and then its successor *Play for Today*. This tradition continued at the BBC until the mid-1980s by which time the artistic aspirations of many of the directors of these plays (and of the executives in the TV companies) had moved to film. The influence of Channel Four through *Film on Four*, which began broadcasting in 1982, was, in this way, very marked.

One BBC staple for many years was the heritage drama – adaptations from British literary classics, some aimed at child audiences shown late on Sunday afternoons, others in prime time. There was a view by the mid 1980s that the literary adaptation was an exhausted format. There had been a spate of successful adaptations of contemporary novels but these were seen to have displaced original writing for television. The re-emergence of the adaptation in 1994, with a new version of George Eliot's *Middlemarch*, and its subsequent critical success led to a whole spate of new adaptations.

Many feature length dramas are now commissioned based on 'true stories'. This is a particularly significant feature in the BBC's film strands, *Screen One* and *Screen*

Two. A related format which has made a strong comeback is the drama documentary which still remains prone to controversy as it treats social or political events which have not been filmed as documentaries, often because this was not possible, and reconstructs events usually supported by evidence. In 1996 the screening of *Hillsborough*, about the crowd tragedy at the football match between Sheffield Wednesday and Liverpool in 1989, reopened the debate about police responsibility in the incident, and the role of this television approach.

There is a relatively limited range of TV fiction genres. Many new series have been developed but radical innovation is rare. In many TV genres there has been influence and counter-influence between the UK and US television systems. For example, the mini-series format translated from the UK to the US in the 1970s, then returned with a different fact-based inflection to influence the subject matter of UK programmes. The situation comedy has been a very important staple in British television schedules, with the BBC establishing a particular reputation in this field. Again the transatlantic influences have been important as new avenues have been tried on both sides and then exported in both directions.

UK television companies have for many years been successful in selling fiction formats to the United States, especially the situation comedy. In the last few years, format sales have included the BBC series *Men Behaving Badly*, *One Foot in the Grave* and *Absolutely Fabulous*, while in the past the American comedy hits *Three's Company* and *Archie Bunker's Place* derived from the UK series *Man About the House* and *Till Death Us Do Part*.

Fiction provides many of the programmes preferred by the public and, after many years of relatively strict regulatory control, these are still, even in these more lightly regulated times, seen as central to a balanced schedule. One of the problems faced by the new channels is the dearth of new fiction which they can offer because of the high cost of production. This is the case for a channel as profitable as Sky One.

With the advent in the late 1980s of satellite television, little new programming was commissioned other than news and sport. However, lately, Sky has moved tentatively into commissioning original TV fiction with its own serial, *Springhill*, while L!VE TV, a cable only channel owned by the Mirror Group has launched a very low cost daily soap, *Canary Wharf*.

Each of the terrestrial broadcasters has achieved a comparatively strong position in particular fictional genres. Among the ITV companies Granada, Yorkshire, Thames and Central were dominant fiction factories before 1982. When Channel Four was created it identified a particular niche, the film, where it could apply its relatively restricted budgets most effectively. Until Channel Four's timely intervention, UK television companies had never really considered the feature film business as needing their support (there were exceptions to this, such as Black Lion Films at ATV, but none were successful). The 25 per cent quota for independent production across all terrestrial channels and the changes in the licence holders in ITV has altered the situation in the last five years. Important independent production companies are now trying to obtain commissions from the BBC, ITV and Channel Four including Island World (with *Cardiac Arrest*, *Balleykissangel* and *Between the Lines*), Red Rooster (with *Wycliffe* for ITV and *The Sculptress* for BBC), Blue Heaven (*The Ruth Rendell Mysteries*), and Thames (now part of Pearson Television with *The Bill*). However, the main production companies

remain the BBC, and on ITV Carlton, Granada and Yorkshire Television.

In the ITV schedule, drama has been a key audience builder for many years. Programming the main News on ITV at 22:00, by agreement with the regulatory body the ITC, has made it difficult to schedule feature films (most of which have to be broadcast after 21:00 because of adult content and the necessity to observe the Family Viewing Policy, see below), as audiences tended not to stay with a film interrupted by the news. Therefore one of ITV's primary scheduling strategies has been to develop strong drama series for the 21:00 slot. In the same way, the early evening has conventionally been seen as the crucial moment when audiences need to be attracted to the channel. This has led to an ever greater emphasis on the successful continuing serials which guarantee large audiences. *Coronation Street* now has four episodes a week at 19:30, while *Emmerdale* is shown three times a week at 19:00, and *The Bill* at 20:00 twice a week.

It is worth noting that one of the criticisms made by the ITC (Independent Television Commission), the regulatory body for commercial television in the UK in its review of 1996 was that the ITV network had placed undue reliance on fiction in its schedule to the detriment of factual and arts programming. In particular, it pointed out that by extending the number of soap opera episodes each week, programming diversity was being squeezed out.

2. The Audience

Fundamental changes in audience behaviour have occurred in recent years, and broadcasters have sought to respond. Changes within the household have been the object of increasing study, in the wake of the major changes in television viewing habits, related both to increased numbers of sets, the advent of cable and satellite channels, modern lifestyles and the changing demographics of the UK population. Increases have been registered in the number of single households, marriages, women bearing children later in life and single parent households. In addition, in certain areas of the UK, and in particular London and the Midlands, the proportion of ethnic minority viewers has increased significantly.

This changing demography of Britain has been accompanied by major changes in household landscape. More than half of all households now have multiple sets, and in homes with children these are often located in the child's bedroom (although most are in the parents' bedroom); nearly 80 per cent of households own a video. These factors give way not only to time shifting of viewing but also enable children to have access to programming transmitted at any time of day. This is cause for concern amongst politicians and policy makers.

Average viewing time in the UK has stabilised at just over 25 hours per week in the last three years, with satellite viewing now accounting for 10 per cent of the total and time shifted viewing using the video recorder for nearly 3 per cent. The impact of the satellite channels has been greatest for ITV, with a 20 per cent reduction in hours viewed. The increase in the number of computers in households is also significant in diverting certain parts of the audience (and particularly younger viewers).

In recent years there has been a dramatic reduction in television viewing by particular groups: young families are now watching three hours less per week, while retired couples are watching more than four hours less. The only increase registered albeit marginal has been for those living alone – the young and retired single

households. At the same time, and to the dismay of terrestrial television, it is the retired couples and single families which most favour satellite viewing.

Britain's most consistent popular programme is *Coronation Street*, now in its 37th year. Its audience tends to be older, creating problems for ITV, as its competitors seek to capture the younger audience. This is an interesting dilemma for television executives: Britain's population is getting older and the so-called 'grey' spending power is considerable. However, advertisers are more interested in the young (and male) big spenders of the ABC1 audience. The schedule needs both to secure high ratings (as with *Coronation Street*), and to attract those members of demographic groups who are more reticent to sample programmes, such as young men.

The problem of catering to particular audiences in prime time, in an attempt to sell advertising time, impinges also on the BBC schedule, and is a crucial factor in the fiction commissioning process. The variation in audience availability to view influences many commissioning and scheduling decisions. Programming for the prime time hours in the UK – traditionally 19:00 to 22:00 – are strategically segmented according to which audience types are available.

One other important factor affecting the scheduling of fiction is Britain's Family Viewing Policy. Britain has operated this policy since the early 1960s based on a notion of how television is watched in the average household with children. It is a normative policy constructed on the principle that after 21:00 the audience can be assumed to be adult and that therefore programmes can contain more graphic detail, and in particular more violent or sexual content. It is the key watershed for drama series which are aimed at an adult audience. Traditionally the policy has also meant that programmes before 19:00 are suitable for unaccompanied children, while it is assumed that the 'family' gathers together to watch after 19:00. Subscription channels on satellite television operate a different policy which allows 15 rated films to be shown after 20:00.

These changing patterns of viewing and differential availability to view have led to an evolving scheduling pattern. Niche drama has always existed for the 'housewife' and the male audience. These have now been extended to include more sophisticated target breakdowns, and an attempt to serve the teenage audience (Channel Four's *Hollyoaks*) and the Twenty-somethings (*This Life* on BBC-2) are examples of this. These trends have been exacerbated by the advent of satellite and cable television – the multi-channel universe – in which niche channels are a key element.

Table 6.1 – 1996 Market Share of UK TV Channels

BBC1	32.5%
BBC2	11.5%
ITV	35.1%
Channel 4	10.7%
Others	10.1%

Source: BARB

In these changing market conditions the competition for viewers has intensified. The priorities of the programme controllers is now to maximise audience share across the day and even the BBC and Channel Four, with very clear remits to offer

diversity and cater to many tastes, are drawn into this competition: the BBC because it has to justify the continuation of the licence fee basis of its income by appealing to the entire audience at some point across any week; Channel Four because it has to achieve a sufficient market share of audience and advertising revenue, while at the same time maintaining its remit.

3. Sample Week

In the sample week examined in March 1996 a number of surprising statistics emerged. Of the 145 hours offered across the four terrestrial channels, no less than 51 per cent were American in origin. Much of this material was film, with a particular emphasis on older material, shown outside of prime time. The domestic (i.e. UK) production totalled 33 per cent, of which 9 per cent was UK film, while 'other' (mainly Australian serials) provided 16 per cent of the fiction offered. The only non-British European programming shown that week were a couple of French films – indicative of how strongly language-bound British television generally tends to be.

In terms of prime time programming only Channel Four relied heavily on imported US programming. Channel Four has been the main source of high quality US series for many years, although this position has been increasingly challenged recently with the BBC, for example, successfully moving *The X-Files* from BBC-2 to BBC-1, and showing *Superman* and *Murder One*. Channel Four remained the home of the best of American programming in 1996 with *E.R.*, *Friends*, *Roseanne* and *Spin City*, amongst others.

Graph 6.1: Origin of TV fiction in UK (Sample week 2–8 March 1996)

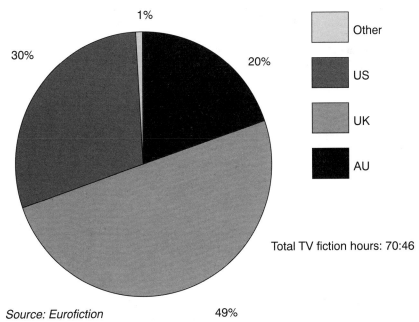

Source: Eurofiction

Repeats (of serials and series i.e. not including film repeats) accounted for 18 per cent of the fiction schedule. There has been a tendency for the BBC to repeat programmes more frequently than ITV (due, it is claimed, to a shortage of resources to commission new programming). This has been a feature of its schedules for many years (assisted by the BBC having two channels to schedule).

Graph 6.2: First run/Repeat

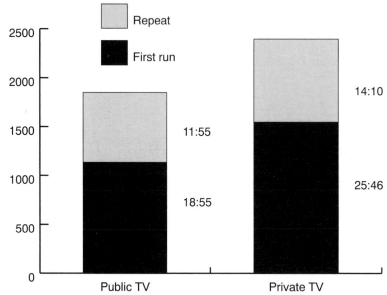

Source: Eurofiction

On BBC-1 the main import in recent years was the Australian serial *Neighbours* shown twice daily at lunch time and before the *Six O'clock News*. The waning popularity of this series, and on ITV of the similar *Home and Away*, is probably significant.

4. Domestic TV Fiction in 1996

British political and cultural life in 1996 was marked by a renewed confidence in the economy and a new assertiveness of British cultural production with the success of new British bands and films like *Trainspotting*. The British television industry continued to evolve structurally in order to deal with technological, market and legislative changes. A new Broadcasting Act was passed enabling the creation of digital terrestrial television services, and amending cross media ownership rules. Further conglomeration followed with Carlton Communications, the Granada Group and United News and Media emerging as the key commercial television companies. The BBC announced major organisational changes including a new divisional structure which separates commissioning from programme production for the first time. The BBC negotiated a partnership with Flextech (itself majority owned by TCI) to develop new digital commercial channels.

The production sector for fiction (both cinematic and televisual) moved towards a new maturity in the UK. However, with regard to television the BBC drama

department was in crisis, losing many key senior members of staff to new start-up companies, many with foreign capital, seeking a foothold in the strengthening British film industry.

A conflict contradiction between producing TV drama for global markets or the unique tastes of the domestic market began to emerge as an issue. British television fiction production transmitted in 1996 totalled 1059 hours.

Table 6.2 – TV Fiction in 1996

Channel	Hours	%
BBC1	364:00	34
BBC2	76:31	7
ITV	474:39	45
Ch 4	143:36	14
Total	1058:46	100

Source: Eurofiction

Of this total there were 384 hours of continuous serials (from 10 programmes), and 314 hours from series (from 65 titles). General drama, covering everything from medical series to family serials, dominated but crime and action fiction accounted for 25 per cent of the total. The vast majority of programmes were set in the present (89 per cent), with a surprisingly small number set in the past (9 per cent). The big town environment for drama also far outnumbered small town, rural or other settings, but this belied the fact that TV fiction is focused around small communities within cities, with a different setting but similar interaction patterns to other bounded communities. The use of multiple protagonists was also a significant majority, but it is interesting to note that the single male or male group was twice as prevalent as the single female or female group.

These cultural indicators are only a basic indication of the complexity of the relationship between British culture, in all its diversity, and its representation in television fiction. In the UK, the large number of action series are a cause for continuing political comment (as in many other countries) in terms of their violent content, while the lack of ethnic diversity amongst the protagonists has been a source of concern. There have been a number of attempts to remedy this situation and the continuous serials in particular are now more representative of the population in Britain's cities. Recently some effort has been made to offer a more representative variety of regions and nations with many more dramas, especially from the BBC, set in Scottish and Irish locations.

4. Successes and Failures

In 1996 a number of new dramas made considerable impact. However, the year was also marked by a number of failures. As one commentator has pointed out, the number of returning hit series, particularly from ITV, has fallen dramatically over recent years.

In terms of ratings, the hit of the year was the final episode of *Only Fools and Horses*, a BBC-1 situation comedy which first aired in 1981. The stories were based on the exploits of two brothers Rodney and Del Trotter in Peckham, South London.

Their priority was on securing their family's survival living in a council flat. Their *modus vivendi* was the trading of goods of dubious origin. Screened on Christmas Day, the three episodes gained massive audiences, with the last programme reaching 24.35 million viewers. The BBC has for many years used the ploy of airing its successful situation comedies over Christmas often at feature length. This one had the added piquancy of being the last ever episodes for two much loved characters. Like many subsequently successful BBC comedies *Only Fools and Horses* came close to cancellation after its first series which failed to secure large audiences. Written by a single writer, John Sullivan – the BBC has never engaged in team-written comedies, unlike successful US programmes – the programme went on to include seven series and 12 Christmas specials and won many awards.

Another programme which came to an end in 1996 was the BBC comedy series *Absolutely Fabulous*, written by Jennifer Saunders, featuring the writer herself and Joanna Lumley as businesswomen with outrageous habits. The series had moved from BBC-2 to BBC-1 when it gained a cult following, and was one of the few landmark comedies of recent years. Its format was sold to the US (to Roseanne Barr's company) but its subject matter (sex and drugs and a wild lifestyle) proved impossible to translate into an acceptable form for that market.

As ever, the most consistent ratings successes through the year were episodes of the continuing serials. Granada's *Coronation Street* (for ITV) boasted three episodes which garnered an audience in excess of 19 million during the year, while four episodes of the BBC's *EastEnders* gained an audience of more than 17 million. *Coronation Street* added a fourth weekly episode in November (it is now broadcast on Monday, Wednesday, Friday and Sunday) but its storylines had become increasingly tired, almost trivial, in comparison to the social realism of *EastEnders* or Channel Four's *Brookside*. In comparison, the realist serials have become part of the public conversation, touching social and cultural issues of contemporary relevance: including AIDS, incest and gay relationships.

Successful returning dramas which gained big audiences included the BBC's Saturday night medical drama *Casualty*, and two programmes from Yorkshire Television: *Touch of Frost*, a series of occasional 2-hour features starring David Jason as Inspector Frost, and *Heartbeat* a series featuring a rural policeman.

During 1996, on ITV, a whole range of series returned but with varying fortunes. Some, such as LWT's *London's Burning* (a drama set in the fire service), Granada's *Band of Gold* (a crime drama), and Carlton's *Peak Practice* (a rural medical drama), *Soldier, Soldier* (a contemporary military drama), and Kavanagh QC (a legal drama) continued to attract considerable audiences. Others, however, like *Wycliffe* (a crime drama from Red Rooster for HTV) and *Bramwell* (a period drama about a woman doctor in London in the 1890s) were less successful with audiences, although they fared better with the critics. On the BBC a number of returning situation comedies; *One Foot in the Grave, Vicar of Dibley, Ballykissangel, Birds of a Feather, Men Behaving Badly, The Thin Blue Line* and *Goodnight Sweetheart* maintained their ratings success as did *Dangerfield*, a drama series about a police surgeon.

The number of new programmes which achieve a sufficient audience (or are considered worthy of support and capable of developing an audience) is a key marker of future ratings share. The BBC has in recent years had greater success in this area than ITV. Its most successful new dramas were detective stories: *Silent Witness*, starring Amanda Burton (as a forensic pathologist) and *Hetty Wainthrop*

Investigates starring Patricia Routledge. It is perhaps not insignificant that in each of these 'crime' dramas the leading character is female. On ITV of the new series scheduled *Thief Takers* (from Carlton/Central) performed most creditably.

Table 6.3 – Top 20 TV Fiction Episodes in 1996

Title	Date	Channel	Genre	Audience (,000)	Share
1. Only Fools and Horses	29.12	BBC1	comedy	24,349	72
2. Coronation Street	28.02	ITV	drama	19,800	76
3. Casualty	24.02	BBC1	drama	18,046	65
4. EastEnders	7.10	BBC1	drama	17,920	69
5. A Touch of Frost	4.02	ITV	crime	17,574	60
6. Heartbeat	8.12	ITV	drama	17,548	64
7. One Foot in the Grave	26.12	BBC1	comedy	17,469	64
8. London's Burning	13.10	ITV	action/crime	16,557	68
9. The Bill	26.01	ITV	action/crime	16,441	61
10. The Vicar of Dibley	25.12	BBC1	comedy	15,154	61
11. Ballykissangel	10.03	BBC1	comedy	14,993	54
12. Prime Suspect V	21.10	ITV	crime	14,939	59
13. Inspector Morse	27.11	ITV	crime	14,770	56
14. Emmerdale	22.02	ITV	drama	14,652	55
15. Cracker	28.10	ITV	crime	14,160	56
16. Moll Flanders	8.12	ITV	drama	13,350	54
17. Band of Gold	24.03	ITV	crime	13,235	51
18. Catherine Cookson's The Girl	23.02	ITV	drama	13,103	51
19. Goodnight Sweetheart	19.02	BBC1	comedy	13,064	48
20. Peak Practice	30.04	ITV	drama	13,035	54

Source: BARB

An increasing number of special features based on the exploits of particular characters has emerged in recent years, particularly on ITV. During 1996, successful examples of this strategy included *Prime Suspect*, *Inspector Morse*, *Cracker*, *The Ruth Rendell Mysteries*, *Sharpe* and Agatha Christie's *Inspector Poirot*, all returning for single features or short runs. At the same time, following the BBC's success with a number of literary adaptations, there has been a profusion of dramas based on literary classics. *Moll Flanders* (from Granada and WGBH) achieved an audience of 13.35 million, Jane Austen's *Emma* (from LWT with A&E) 11.26 million. The BBC offered adaptations of Bronte's *The Tenant of Wildfell Hall* (a co-production with CBC and WGBH) and Wilkie Collins' *The Moonstone*.

One of the year's biggest failures was the BBC's series on *Rhodes*, a key figure in British colonial Africa in the nineteenth century. The idea for the series, which had

been mooted since the early 1980s, was finally realised by Zenith Productions in ten parts, but its unimaginative narrative and possibly unsuitable material for a mass audience led to a small and reducing rating over its run. It has however been successful in the international sales arena. Other poor performers included *Annie's Bar* on Channel Four (from Ardent Films, the company owned by Prince Edward) and the BBC's *Nostromo*.

Films are a strategic part of any channel's schedule. The financing of films has been a key part of the Channel Four strategy since its launch in 1982 – under the *Film on Four* banner. There have been a number of notable successes over the years with theatrical release preceding first television showing by up to two years. In 1996 Channel Four finally brought to the screen the award winning *The Madness of King George*, as well as *Bhaji on the Beach*, *Ladybird, Ladybird* and *Backbeat*. The BBC film investment strategy (and first release theatrically) has only emerged recently. In 1996, however, most of its films in the *Screen One* and *Screen Two* slots were straight to television features, many based on contemporary stories. Examples included Michael Whyte's *Flowers of the Forest* which presented the theme of child abuse.

The year's biggest critical success was *Our Friends in the North* on BBC-2, a nine part chronicle of the life of a sixties radical as his world and his relationships transformed through the following decades. Other acclaimed dramas included the adaptation of Iain Banks' novel, *The Crow Road*, and the four part drama *The Sculptress*, both on BBC. 1996 also witnessed the broadcasting of Dennis Potter's final works, *Cold Lazarus* and *Karaoke*, uniquely co-financed and shown on both Channel Four and the BBC.

One interesting, but not particularly successful formula adopted was the reworking of earlier successful programmes. Situation comedies like *The Liver Birds* (from the 1960s) and *The Legacy of Reginald Perrin* (from the 1970s) were shown on BBC, alongside a feature length *Doctor Who* adventure (in a co-production with Spielberg's company Amblin Entertainment), while on ITV some of the most successful programmes from the writing team Galton and Simpson were remade with Paul Merton in the lead role, and the melodrama *Poldark*, based on the novels of Winston Graham was revived. ITV also repackaged *Doctor Finlay*, a 1960's BBC success featuring a Scottish doctor's surgery.

It is perhaps worth noting that British television fiction has benefitted from a number of star actors such as David Jason, Nicholas Lyndhurst, Patricia Routledge, Dawn French, Rowan Atkinson and also a large pool of writers. The authors of television are more clearly the writers than the directors and this is a key difference between film and television for many commentators. The relatively protected spaces which have been reserved for cultural content writers in UK television – particularly at the BBC – are now under increasing pressure from the organisational changes coming out of the technological and regulatory changes. The coming of the independent production company in recent years has led to a replication of film industry norms in television fiction production which could prove detrimental to TV in the longer term. The bidding up of star salaries and the closure of the nursery slopes for writers are dangers which must be guarded against.

Co-production has in the past been seen as one way of increasing cost and improving style of production while spreading the financing over a number of broadcasters. It has also been seen as a danger, as mid-Atlantic or Europuddings were feared

to result with no clear cultural anchorage. The BBC has often pre-sold its fiction programmes to PBS, or in more recent times to the Arts and Entertainment Channel, in the United States. But it has invariably maintained complete artistic control. In 1996 a number of programmes benefitted from these arrangements, but co-production was a much more common strategy in film production and a number of BBC and Channel Four films were financed in this way.

There were a number of commissioning trends in 1996: more episodes of successful serials each week and increasing numbers of one-off features from successful formats were the strategy adopted by both the BBC and ITV. Channel Four, with its distinctive remit and with less money to invest in drama, maintained its different approach. *Film on Four* received an increased allocation of money while a significant financial commitment was made to the teenage soap *Hollyoaks*. Channel Four was also the British partner in the international co-production of *Gulliver's Travels*. The channel's only successful commissioned situation comedies in recent years (and there have been very few) were *Father Ted*, about an Irish priest, and *Drop The Dead Donkey*, set in a TV newsroom.

The changes emerging across all channels are related to a perception of the different needs of the various generations which comprise the audience. They are focused as much on thematic choice as generic inflections. Clearly the Eurofiction cultural indicators provide an initial appraisal of these macro changes in the cultural representations offered. But a culture and its values move in cycles. These differences need to be defined with more complexity, if we are to evaluate the success of TV in representing a society to itself. Britain in 1996 was a society which continued to wrestle with its future destiny as a part of Europe. The narrative paths in its TV fiction almost completely ignored this task. Therein lies a commentary in itself.

Part Two

Programme Index

The Programme Index is a compilation of 100 profiles for fiction programmes broadcast in 1996, with 20 entries for each of the five European countries.

Each programme profile is divided into two sections: Section One contains technical specifications and credits, while Section Two gives a brief synopsis of the programme.

Generally speaking, the 'Twenty Programmes of the Year' selected for each country correspond to the most successful productions in terms of audience figures. It was deemed appropriate however, to give the individual research teams free rein in compiling the indexes. This flexibility means that criteria for selection was based not only on ratings, but on other indicative factors as well.

Therefore, in addition to the top 'hits' of the year, some indexes may include entries for programmes which created fads or niche markets, shows garnering acclaim from the critics, or even certain 'interesting' flops.

FRANCE

TOP FIFTEEN PROGRAMMES

(1) UNE FEMME D'HONNEUR

Format: series (105 minutes)
Year of Production: 1996
Date of (first) Broadcast: November 21, 20:50
Channel: TF1
Audience: 22.2%

Produced: Via Productions, TF1
Director: Marion Sarraut
Writers: Éric Kristy, Pierre Rosière
Cast: Corinne Touzet, François-Éric Gendron, Yves Beneyton, Dominique Labourier

Une femme d'honneur, the first of a new cop series constructed around the same central character, introduces features which have up to now not been found in the series produced by TF1. The central character is a woman, chief (first class) warrant officer in the gendarmerie in her first assignment in a small provincial town. Isabelle Florent is following the path mapped out for her by her father. In her very first investigation, she is called on to handle a sensitive case – the rape and assault of the daughter of one of the gendarmes she has under her command. For the fact is, this young woman heads a squad responsible for conducting judicial investigations This 'neighbourhood' series is counting on its realism: the bit players, for example, are gendarmes in real life.

(2) JULIE LESCAUT

Format: series of 5 episodes of 93 to 101 minutes each (series begun in 1992)
Year of Production: 1995/96
Date of (first) Broadcast: February 29, March 28, April 25, October 3 and Nov 7, around 20:55
Channel: TF1
Audience: 20.4%

Produced: (only the October 3 episode was co-produced with Switzerland). GMT Productions, TF1

Directors: Josée Dayan (3), Alain Bonnot (1), Jacob Berger (1)

Writers: Thomas Saez, Éric Kristy, Frédéric Krivine, François Peroche

Music: Didier Vasseur

Cast: Véronique Genest, Mouss Diouf, Renaud Marx, Alexis Desseaux, etc.

Superintendent Lescaut is an elegant and attractive woman who conducts her investigations aided by several young inspectors and the whole police station staff. A large part of daily life, both at the police station and at Julie Lescaut's home, enters into the episodes, alongside the strictly police work. Julie Lescaut's two little girls or someone close to her sometimes becomes involved in the plot. Secondary dramas are played out around the main police story and they involve either another police officer at her station or her children. Working conditions and the difficulties of a woman executive who is also raising her two children alone have been a central theme of the series in all the episodes.

The final episode, *Le Secret des origines*, tackles the problems of a child brought up in public care who is trying to find out who her parents are. The child in question is in the same class as one of Julie Lescaut's own daughters. Murder and investigations are there, of course, but the episodes are becoming more and more psychological and less and less a cop series.

(3) NAVARRO

Format: series in three episodes, each 90, 93 and 82 minutes respectively (series begun in 1989)

Date of (first) Broadcast: March 14, April 11 and May 9, around 20:50

Channel: TF1

Audience: between 17.6% and 21.1%

Produced: Hamster Productions, TF1

Director: Patrick Jamain

Writers: Tito Topin, Sylviane Corgiat, Éric Prungnaud, Frédérique Topin

Cast: Roger Hanin, Christian Rauth, Daniel Rialet, Jacques Martial, Jean Claude Caron, Catherine Allegret

Episode after episode, *Commissaire* Navarro moves in a familiar world – his office, the squad he works with, his inspectors, his family, his favourite bar & restaurant and its landlady to whom he confides his problems. In his work, Navarro has to deal with drugs, organised crime, criminals recovering booty from a former hold-up. The plots can include elements from his family circle, his own sentimental experiences or those of people in his usual environment unexpectedly caught up in a criminal case. After more or less violent adventures, depending on the episodes, Navarro's good sense and humanist ethics finally triumph over evil and overcome any bungling by his fellow police officers.

(4) LES CORDIER, JUGE ET FLIC

Format: series in 5 episodes, each between 85 and 102 minutes (series begun in 1994)

Year of Production: 1996

Date of (first) Broadcast: February 22, March 21, June 20, Sept 5 and October 24

Channel: TF1

Audience: 16.8%, 15.5%, 14.9%, 17.6% and 17%

Produced: Telfrance, TF1

Directors: Gilles Behat, Christiane Leherissey, Bruno Herbulot

Writers: Alain Robillard, Jean-Pierre Hasson, Jean-Christophe Lecru, Alain Page

Music: Nicolas Jorelle

Cast: Pierre Mondy, Bruno Madinier, Charlotte Valandrey

The father of the Cordier family is a police superintendent; son Bruno is an examining magistrate; daughter Myriam is a journalist. With a bit of luck, the same case could be officially investigated by the father, prepared by the son and committed for trial, and given media coverage by the daughter. The three have no lack of subjects for investigating – pro-life hit groups, fundamentalist terrorism, newspaper denunciations of sleaze, settling of scores – often echoing current events in our society. The ups and downs of investigations, which are sometimes turbulent, become interlaced with sentimental and domestic problems which are also present in the life of this special family.

(5) TERRE INDIGO

Format: closed serial of 8 episodes of 99 to 114 minutes each

Year of Production: 1995

Date of (first) Broadcast: from July 8 to August 26, 1996, around 20:50

Channel: TF1

Audience: 14.2%

Co-produced: France, Cuba, Germany, Switzerland. Néria Productions, TF1

Director: Jean Sagols

Writers: Gilles Gérardin, Éric-Emmanuel Schmitt

Music: Catherine Lara

Cast: Francis Huster, Marie-José Nat, Cristiana Réali, Jean-Marc Thibault, Xavier Deluc, Charlotte Kady, Barbara Schulz, Mathieu Delarive, Mireille Darc, etc.

This is a story, told in eight episodes, of a French family who emigrates to Cuba in 1920. When the vine phylloxera wipes out the family's vineyards in the Bordeaux region, the Valognes emigrate to Cuba where they own land. The father

has been murdered and it is the mother, Mathilde, who takes charge of the clan – the son Joseph and his young and beautiful wife Constance, their 10-year-old son and two big teenage children brought up by the sister of Constance since their parents' death. There is only Pierre missing. He is Joseph's brother and has been sentenced to the penal colony of Cayenne for murdering his father. Constance is still in love with Joseph, and the latter will break out of the penal colony to prove his innocence. Discovering that their land is only an uncultivated swamp, the Vallognes courageously take the plunge and embark on a new and difficult life with determination.

Substantial resources went into the shooting of this romantic story in Cuba's beautiful natural surroundings. The direction is of high quality and has won praise from *Télérama* (France's most cultural television magazine), which comments: 'The pictures are golden-brown, peaceful and powerful. The landscapes are radiant, so are the faces.'

(6) UNE FAMILLE FORMIDABLE

Format: mini-series in 3 episodes of 103, 102 and 98 minutes respectively

Date of (first) Broadcast: March 22, 29 and April 5, 1996

Channel: TF1

Audience: 17.7%, 16.9% and 18%

Produced: Banco Production, TF1

Director: Joël Santoni

Cast: Anny Duperey, Bernard Le Coq, Beata Niiska, Philippe Khorsand, Daniel Gelin

This is the third mini-series chronicling the life of the Beaumont family. Two seasons of three episodes each have already been broadcast with good audience ratings in 1992 and 1993. Anny Duperey and Bernard Le Coq play a couple who have recently moved into a large suburban house. As in a vaudeville performance, around them other couples keep forming and breaking up to the accompaniment of intertwining professional problems in a well-to-do social environment. Meanwhile, the children, barely out of their teens and very often from broken homes, make their first discoveries of love confronting those responsible for their education with their share of confusing anxieties and tangled situations. All this is spiced up a grandfather who had dropped out of sight a quarter of a century earlier making a sudden reappearance. It is neat production, the treatment of the story is lively with dramatic situations always offset by a good measure of humour that sets the miniseries' overall tone.

(7) LE BÉBÉ D'ELSA

Format: TV movie, 94 minutes

Year of Production: 1996

Date of (first) Broadcast: November 20, 1996, 20:53

Channel: France2

Audience: 17%

Produced: France, Belgium. Son et Lumière, France2

Director: Michaël Perotta

Writer: Sylvie Simon

Music: Charles Court

Cast: Corinne Touzet, Jean-Yves Gautier, Tiphanie Doucet, Olivia Capeta

The TV movie fits in well with the public channel's editorial line for its *Mercredis de la vie* schedule. A 40-year-old mother is confronted at the same time by the discovery that her husband is unfaithful to her and that her 14-year-old daughter is expecting a baby she is quite incapable of coping with. Her life is drastically changed by the experience. It's not always easy to be a mother...

(8) L'INSTIT

Format: series of 3 episodes of 89, 91 and 93 minutes each (series begun in 1993)

Year of Production: 1995/96

Date of (first) Broadcast: February 28, September 4 and October 23, 1996 around 20:55

Channel: France2

Audience: 18.6%, 14% and 16.2%

Produced: France (and Switzerland for the last two episodes). Hamster Productions, France 2

Directors: Christian Karcher, Pierre Koralnik and François Velle

Writer: Didier Cohen

Music: Jean Musy

Cast: Gérard Klein

The hero of this series is Victor Novak, a stand-in teacher, who happens to a former juvenile court magistrate. Each episode sees him working at a different school and confronting new, generally dramatic, situations. The plot is always constructed around a difficulty encountered by a child (adoption, battered child, death or serious illness of a parent, child victim of a road accident) and is played out following rules very similar to that of cop story where there is a truth to be discovered. In the 4 September, 1996 episode, which takes place in Switzerland, there is even a murder which has been witnessed by a child who suffers from loss of memory as a result of a car accident.

A novel feature of the series is that stand-in teacher and former juvenile court magistrate Novak is the only character who appears in all the episodes; he has no per-

manent team, no regular secondary figures. And his private life is never shown. The stand-in teacher is a character without ties, who appears to be informed by a crusading zeal. While teaching skills are not central to the plot, Novak does slip into a morally instructive role when he examines a problem, such as providing information about Aids, loss of memory and so on.

(9) L'ORANGE DE NOËL

Format: TV movie (119 minutes)
Year of Production: 1995
Date of (first) Broadcast: November 11, 1996, 20:50
Channel: France2
Audience: 16.3%

Produced: King Movies, France2
Director: Jean-Louis Lorenzi
Writers: Béatrice Rubinstein and Jean-Louis Lorenzi
Based on: Michel Peyramaure's novel of the same name
Cast: Sophie Aubry, Jean-Yves Berteloot, Lys Caro, Stéphan Guérin-Tillié, Paul Le Person

The action takes place early this century (1913) in a small Correzian village. The leading character is a young schoolmistress, a recent graduate from the École Normale (teacher-training college). She has to battle hard with the villagers and a fundamentalist Roman Catholic priest, Abbé Brissaud, to get them to accept non-denominational education. Only children of the village's better-off families receive an education – at a religious institution. The village inhabitants consider that working in the fields is more important and find it hard to accept the idea of compulsory schooling for all. The young schoolmistress takes over the schooling of Malvina, regarded in the village as a wild, feeble-minded child, and guides her up to the moment she obtains the school-leaving certificate.

(10) LES STEENFORT, MAÎTRES DE L'ORGE

Format: mini-series (3 episodes of 104 minutes each)
Year of Production: 1995
Date of (first) Broadcast: November 25, 1996, around 20:55
Channel: France2
Audience: 14.8%

Produced: France, Belgium. Son et Lumière, France2
Director: Jean Daniel Verhæghe
Writer: Jean Van Hamme

Music: Caroline Petit

Cast: Yann Tregouet, Julie du Page, Michaël Pas, Paul Andrieu, Gilbert Charles, Jean-Claude Drouot

With *Les maîtres du pain*, France2 in 1995 undertook to chronicle the family histories of traditional trades. *Les Steenfort, maîtres de l'orge* tells the story of a family of brewers in Northern France. The action spans the years 1854 to 1919 and covers several generations. As the Steenforts' story develops, with its jealousies, love affairs and acts of revenge, it is intruded upon by the larger drama unfolding in the historical background (industrialisation, labour movements and World War I).

(11) LES FEUX DE SAINT JEAN

Format: mini-series in two parts, each 86 and 83 minutes
Year of Production: 1996
Date of (first) Broadcast: May 18 and 25, 1996, around 20:50
Channel: France3
Audience: 9.6% and 11.4%

Produced: Télécip, SFP Productions, France3
Directors: François Luciani and Michel Erard
Writers: Sylvain Joubert and Pierre Lary, adapted from an idea by Roland Gritti
Music: Antoine Duhamel
Cast: Roland Blanche, Catherine Arditi, Jean-Pierre Bagot, Johan Leysen, Virgile Bayle, Vincent Winterhalter, Anne Coësens, Vanessa Guedj, etc.

This two-part mini-series is very much in the traditional style of rural drama unfolding against a historical backdrop. The daily life of country folk just before the outbreak of the 2nd World War is filmed in poetic fashion with the camera lingering on farmers working in the field, harvesting, tying up sheaves of mown corn, backs bent and faces dripping with sweat.

Summer 1939. Two farmers, Anselme and Fernand, decide to pool their resources and work their land jointly. François, the first farmer's eldest son hopes to take advantage of the opportunity to announce his intention to marry Fernand's daughter Marie. But Fernand hates her; although he officially recognised her as his daughter when he got back home at the end of the 1st World War, he knew Marie's father was in fact a German.

(12) LE SECRET DE JULIA

Format: TV movie (90 minutes)
Year of Production: 1996

Date of (first) Broadcast: November 23, 1996, 20:50
Channel: France3
Audience: 11.2%

Produced: Alya Productions, France3
Director: Philom Esposito
Writers: Philom Esposito, Patrick Laurent
Based on: Jacques Mazeaud's novel *Le Retour de Jean*
Cast: Julien Guiomar, Chantal Lauby, Etienne Chicot, Agathe de la Fontaine

The year is 1946 and the setting rural. Julia lives at her parents' farm with her two daughters, Léone and Anna. The older girl, Léone, is in search of her identity and wants to know why her father disappeared six months earlier. But nobody on the farm wants to talk about it. One day Jean, a former lover of Julia's, turns up at the farm and moves in with the family. He also happens to be Anna's father. The atmosphere at the farm is charged, but the characters are strong and the situation does not turn into tragedy.

(13) LE REFUGE

Format: series (2 episodes of 90 minutes each)
Year of Production: 1995/96
Date of (first) Broadcast: March 23, 1996, around 20:50
Channel: France3
Audience: 8.5%

Produced: Ellipse Programme, France3
Director: A. Schwarzstein
Writers: A. Schwarzstein, Patrick Laurent
Music: Christi Gaubert
Cast: Maxime Leroux, Marie-Dominique Dessez, François Marthouret, Dora Doll, Clément Sibony, Jacques Spiesser, Annie Cordy, Féodor Atkine

This is a new series with the same central character, in this case a veterinarian, appearing in both episodes. Paul Grimon returns to his home village in the Ardèche to attend the funeral of his father, also a veterinarian. He finds the family home turned into an animal shelter (whence the title of the series) and his father's finances in the red. He sets up house with his childhood sweetheart, Véronique. He has to cope with the rivalry of another veterinarian who wants to acquire his property so as to build his own clinic. Grimon stands for the positive character — kind, full of good intentions, ever ready to lend a hand to resolve the village's problems. In each series, this is counterbalanced by a baddy. Exaggeratedly black-and-white, the series fails to convince; the main character overdoes it a bit and the others are not believable.

(14) DOCTEUR SYLVESTRE

Format: Series in 4 episodes of 90 minutes each (series begun in 1995)
Year of Production: 1995/96
Date of (first) Broadcast: January 27, April 27, September 28 and November 2 around 20:50
Channel: France3
Audience: 8.4%

Produced: Alya Productions, France3 (the episode *D'origine inconnue* broadcast on September 29, 1996 is a Franco-Swiss coproduction.)
Director: D. Tabuteau
Writers: Christ François, Élisabeth Rio
Cast: Jérôme Anger, Maria Pacôme, Isabelle Renauld, Sarah-Laure Estragnat, Alexandre Zloto, Agnès Garreau, Alain Baugil, Charlotte Valandrey, Vania Villers, Jean-François Stevenin, Clothilde Baudon, Francis Renaud, Hélène de Saint-Père, Jean-Marie Winling, Claire Wauthion, Hélène Alexandridis

Following the example of the schoolteacher in *L'Instit*, the series broadcast on France2, the young Docteur Sylvestre often fills in as locum for doctors in small provincial towns. Assisted by his bubbly secretary (played by Maria Pacôme), Dr Sylvestre (Pierre to his friends), a charmer when he is off duty, takes on problems that often exceed the bounds of medicine. The subjects broached in the episodes broadcast in 1996 refer to real-life social problems – an incurable disease and the possibility it might be hereditary, the right to have an abortion, a teenage girls in trouble or reuniting a dislocated family. The central character of the series is like-able and close to people. His comradely relationship with his secretary to whom he confides his worries and love affairs makes him quite human, an ordinary hero.

(15) PASSION MORTELLE

Format: TV movie, 100 minutes
Year of Production: 1995
Date of (first) Broadcast: April 3, 20:50
Channel: M6
Audience: 8.2%

Produced: Alizés Films, M6
Director: Claude Michel Rome
Cast: Bruno Wolkowitch, Natacha Lindinger, Corinne Touzet, Denis Karvil

Crime squad inspector Sartey is investigating murders of men committed by a woman psychopath who lures her victims using a Minitel (videotex) dating ser-vice. The inspector conducts his investigations by joining the circle of acquain-

tances arranged by the videotex agency. Here he meets a blonde who matches the description of the wanted woman and promptly falls in love with her. This adventure interferes with the inspector's private life.

The thriller maintains its suspense to the end with unexpected developments and won a special mention as the Cognac festival of crime films. All the same, the production fails to avoid a few stock situations and a certain affectation.

THREE PRIMETIME PROGRAMMES OF INTEREST

(1) LE JUSTE

Format: series of 2 episodes of 103 and 98 minutes
Year of Production: 1995
Date of (first) Broadcast: April 12, and September 28, 1996, around 20:50
Channel: TF1
Audience: 17.9% and 9.5%

*Produced::*Protécréa, TF1
Director: Franck Apprédéris
Writers: Jean-Pierre Cottet, Tito Topin, Sylvie Simon
Music: Jean Musy
Cast: Claude Brasseur, Amélie Pick, Tania Sourseva, etc.

The first adventures of Father Simon (called The Just), a former police inspector who becomes a priest and works out of a parish in a North Marseilles neighbourhood where he gives shelter to teenagers having problems in a disused factory called the Confiserie. A man with the common touch, close to people and their concerns, Father Simon encounters the problems of youth in deprived neighbourhoods – abandoned children, no work, drug trafficking, crime etc. Marseilles is very present in the series (and very well filmed) and so is the Marseilles accent.

This character of a priest committed to social services who is also a former cop helps to break out of the cop story genre while simultaneously weaving a plot similar to a police investigation. In one way or another, the central character undertakes his own investigation alongside that of the police when his protégés become involved in any nasty business.

(2) UN COIN DE SOLEIL

Format: closed serial (8 episodes of 90 minutes each)
Year of Production: 1996
Date of (first) Broadcast: July 8, 1996, around 20:50
Channel: France2
Audience: 5.5%

Produced: GMT Productions, France2, LUX, RAI

Director: Fabrizio Costa

Writers: Massimo De Rita, Simone De Rita

Music: Lucio Dalla, Beppe D'Onghia

Cast: Giole Dix, Lucrezia Lante Della Rovere, Heio von Stetten, Constance Engelbrecht, Virna Lisi, Fabiano Vagnarelli, Ciro Esposito, Roberta Scardola, Gabriele Mazzuccato, Gianluca Malavisita, Giacomo Ecossi, Simone Melis, Matteo Ripaldi, Felice Andreasi, Monica Guerritore, Marta Meloni, Béatrice Palme

The series is set in a run-down Rome orphanage. Each episode is constructed around one of the children in the establishment. Social problems such as adoption, child prostitution, disabled children and social inequalities are examined in the series. *Un coin de soleil* did not really go down with French viewers and the ratings were poor. What's more, only eight of the 12 episodes produced have been broadcast. Entirely Italian-made, the series poses the problem of European productions in view of the fact that viewers in each country prefer home-made drama. Furthermore, the series was not advantageously scheduled by France2. Broadcast in the summer in direct competition (same day, same hour) with TF1's series *Terre indigo*, it suffered from the fact of being in the wrong place at the wrong time and the 'exoticism' of the commercial channel's fare, more suited to the holiday period.

(3) MARIAGE D'AMOUR

Format: TV movie, 102 minutes

Year of Production: 1996

Date of (first) Broadcast: September 25, 1996, 20:50

Channel: M6

Audience: 3.5%

Produced: Capa Drama, M6

Director: Pascale Bailly

Writers: Pascale Bailly, Alain Tasma

Cast: Mathilde Seigner, Roschdy Zem, Marianne Groves, Marion Loran

Mariage d'amour is part of the *Combats de femmes* anthology made up of self-contained TV movies all based on real-life happenings, news items and events in today's society. *Mariage d'amour* is based on a real happening that sheds light on one of the most controversial aspects of the so-called Pasqua Amendment imposing restrictions on foreigners living in France. Here it is the legal suspicion hanging over mixed marriages (between French nationals and foreigners) that they might turn out to be marriages of convenience.

The love story between Nadine and Georges (an Egyptian) which should have normally resulted in their marriage runs into problems with the French administration.

Georges again finds himself in a situation where he is in breach of regulations and is arrested. The marriage is performed in prison. Accused of unlawfully attempting to protect a foreigner deemed unwanted in France and who is due to be expelled at the end of the movie, Nadine faces a lawsuit.

Produced with great restraint, tact and naturalness, the TV movie measures up to its intentions and the active commitment to human rights underlying it.

TWO NON-PRIMETIME PROGRAMMES OF INTEREST

(1) C'EST COOL

Format: sitcom: 41 episodes of 26 minutes each

Year of Production: 1996

Date of (first) Broadcast: two instalments between March 26 and April 30, and between December 2 and 20, five days a week, around 17:30

Channel: France 2

Audience: between 2% and 2.5%

Produced: Flach TV, France2

Director: Olivier Guignard

Cast: Igor Butler, Pascal Jaubert, Julie Craignault, Laure Fourcade

A group of young persons (in their twenties) of different ethnic origins meet in some sort of suburban loft where they try to overcome the social difficulties of the moment by resorting to all kinds of expedients (such as salvaging and repairing and so on) but always staying on the right side of the law. The France2 sitcom stands out in sharp contrast to usual productions of this genre. The young people in question are all in serious social situations and they courageously try to cope with them. The drama gives a positive image of the efforts the young folk are making to get out of their predicaments. The ethnic mix is also different from the usual. The proof, if any is needed, is that the series stands apart from the rest by not having any canned laughter. Where settings, locations and camera angles are concerned, *C'est cool* is appreciably less badly off (one wouldn't like to say richer) than the competing series. The situations dealt with can be more or less trying, even dramatic, but the tone will have a touch of lightness for the abiding concern here is to find a positive and exemplary outcome to these young heroes' adventures.

(2) JAMAIS DEUX SANS TOI...

Format: sitcom: 83 episodes of 25 minutes each

Year of Production: 1996

Date of (first) Broadcast: July 1 to October 25, five days a week, around 17:50

Channel: TF1

Audience: 3%

Produced: TF1 (in-house production)

Writers: Christian Bouveron, Éric Assous

Cast: Stéphanie Lagarde, Emma Colberti, Franck Neel, Astrid Veillon, Xavier Vilsek, Marie Emmanuelle Lassegue

Valentine and Thomas each take possession of an apartment left to them by a parent – the mother in one case and the father in the other. The two do not know each other at all. To their surprise they discover it is one and the same apartment because in fact there had once been two apartments which were subsequently joined together by knocking down a partition wall. The odd situation arises from the fact that the apartment was the love nest where the father of one of the two young people and the mother of the other had carried on an illicit relationship. From now on the two get to know each other better and bring their respective groups of friends into the secret. Utilising this framework, the sitcom explores all the possible sentimental combinations between these young people who are neither too under-privileged nor overburdened by problems of work or studies. The production allots a relatively substantial place (for a sitcom) to special visual and musical effects. One distinguishing feature is the use of off-screen observations the characters make in the course of a scene – aimed exclusively at the audience – which appear superimposed on the screen. This helps to create a certain theatrical alienation that it would be exaggerated to describe as 'Brechtian'.

GERMANY

TOP TEN PROGRAMMES

(1) ALARM FÜR COBRA 11 – DIE AUTOBAHNPOLIZEI

Format: TV movie (Pilot)
Year of Production: 1995
Date of (first) Broadcast: 12.03.96
Channel: RTL
Audience: 10,090,000

Produced: Polyphon Film- und Fernsehgesellschaft mbH
Director: Leo Zahn
Writer: Claude Cueni
Music: Franz Bartzsch, Reinhard Scheuregger
Cast: Johannes Brandrup, Erdogan Altalay, Almut Eggert

With bombings of construction workers and attempted assassinations of police officers, a criminal who calls himself 'Rascar Capac' tries to blackmail the government. He demands one million DM. The scientific analysis of the explosives used by Rascar Capac leads the police officers of the special autobahn police unit Cobra 11 finally on the track of the culprit. The pilot of the *Alarm für Cobra 11* series had a weak story but was unusually strong on pyrotechnics, almost up to cinema standards. This film started an unexpected action boom in German television.

(2) DER ALTE

Format: series
Year of Production: 1995
Date of (first) Broadcast: 19.01–20.12.96 (current programme)
Channel: ZDF
Audience Average: 8,930,000

Produced: Neue Münchener Fernsehproduktion
Producer: Helmut Ringelmann
Directors: Various
Writers: Various
Music: Eberhard Schoener
Cast: Rolf Schimpf, Michael Ande, Charly M. Huber

Der Alte meaning 'the old man' is the nickname inspector Kress is known by in the police department. Kress is a kind of enigma, always one step ahead of the suspects and his two assistants, one of whom is black. The crimes he has to solve are usually psychologically inspired murders in upper middle class suburbia. *Der Alte* is a long running German crime series. The looks and plots of the series are in a very similar vein like *Derrick*.

(3) DERRICK

Format: series
Year of Production: 1995
Date of (first) Broadcast: 05.01–13.12.96 (current programme)
Channel: ZDF
Audience Average: 8,860,000

Produced: Telenova Film- und Fernsehproduktion
Producer: Helmut Ringelmann
Directors: Various
Writer: Herbert Reinecker
Music: Eberhard Schoener, Main Theme: Les Humphries
Cast: Horst Tappert, Fritz Wepper

Main character of this series is police inspector Stefan Derrick. He and his assistant Harry Klein solve murder cases in Munich's upper middle class society. The motives for the murders are usually found in the relationships between the involved persons. Accordingly the focus is not on the normal police work, but on the ability of Inspector Derrick to gain insights into the behaviour and feelings of the suspects. This programme is among the longest running in German television and has seen extensive foreign sales.

(4) DAS MÄDCHEN ROSEMARIE

Format: TV movie
Year of Production: 1996
Date of (first) Broadcast: 13.12.96

Channel: SAT 1
Audience: 8,830,000

Produced: Constantin Film
Producer: Bernd Eichinger
Director: Bernd Eichinger
Writers: Bernd Eichinger, Uwe Wilhelm
Music: Norbert J. Schneider
Cast: Nina Hoss, Heiner Lauterbach, Mathieu Carrire

The TV movie deals with the life and never solved murder of the callgirl Rosemarie Nitribitt. The police investigation into her death lead to a major scandal in fifties Germany as many important public figures were found to be among her clients. The story was turned into a movie then, causing another scandal. This recent remake succesfully tried to profit from the glory of the original cinema production helped by a bunch of high caliber actors and German producer number one Bernd Eichinger.

(5) DER CLOWN

Format: TV movie
Year of Production: 1996
Date of (first) Broadcast: 03.11.96
Channel: RTL
Audience: 8,770,000

Producer: Jan Fantl
Director: Herman Joha
Writer: Claude Cueni
Music: Helmuth Zerlett, Arno Steffen
Cast: Sven Martinek, Diana Frank, Hanns Zischler

When his partner and friend is killed by Russian mobsters, police officer Max Zander swears revenge. While on duty it is business as usual. But off duty he disguises himself as a clown and battles it out with the foreign gangster with handgrenades and automatic weapons right in German posh town Dusseldorf. The heavy use of action elements and pyrotechniques was inspired by the huge sucess of *Alarm für Cobra 11*. Subsequent TV movies or a whole series are rumored to be planed after the success of the programme.

(6) DAS HAUS AN DER KÜSTE

Format: TV movie
Year of Production: 1996

Date of (first) Broadcast: 03.11.96
Channel: ZDF
Audience: 8,760,000

Director: Dieter Kehler
Writers: Jake Korn, Christiane Sadlo
Based on: a novel by Rosamunde Pilcher
Music: Richard Blackford
Cast: Maria Furthwängler, Gerhart Lippert

After her husband's death young widow Veronica moves from London to Cornwall with her children. In order to get over her loss she becomes quite a workaholic. Soon the beautiful woman has two admirers, her boss Frank and the professor for mathematics Markus, whom she prefers. The plot is based on a novel by British novelist Rosamunde Pilcher who is immensely popular with a female audience in Germany. The film is one of several screen adaptations of her novels played by German actors on British locations.

(7) DAS TRAUMSCHIFF

Format: series
Year of Production: 1996
Date of (first) Broadcast: 26.12.96
Channel: ZDF
Audience Average: 8,480,000

Produced: Polyphon Film- und Fernsehgesellschaft mbH
Producer: Wolfgang Rademann
Director: Karola Zeisberg
Authors: Gerry Baldau, Marlies Ewald, Charles Lewinsky
Music: Hans Hammerschmitt. *Title Theme:* James Last
Cast: Heinz Weiss, Heide Keller, Horst Naumann

The 'Traumschiff', or 'Ship of dreams' in English, is a German cruiser sailing to changing destinations. A usual episode is a mixed bag of love stories and other human relationships problems among the passengers and the crew of the ship. This setting combines rather exotic locations from all over the world with family series plot elements. In the pilot for the new episodes of this long running programme Captain Hansen has to stave off a secret admirer among his passengers.

(8) EIN FALL FÜR ZWEI

Format: series
Year of Production: 1995
Date of (first) Broadcast: 26.01.-27.12.96 (current programme)
Channel: ZDF
Audience Aaverage: 8,470

Produced: Odeon Film
Producers: Georg Althammer, H. Joachim Mendig
Directors: Various
Writers: Various
Music: Klaus Doldinger
Cast: Claus T. Gärtner, Rainer Hunold

Dr. Frank works as a lawyer in Frankfurt. He is mostly involved in criminal law cases. From time to time he needs the assistance of private eye Matula, when he has to check the alibi of a client or seek an elusive witness, for example. The couple contrasts much, while Dr. Frank is a typical upper class personality, Matula is a worn out working class kind of guy. Nonetheless the two men are bound by a very close friendship. This long running programme is almost as old as *Derrick* and *Der Alte* but moves somewhat faster.

(9) DER KLEINE LORD

Format: TV movie
Year of Production: 1994
Date of (first) Broadcast: 18.12.96
Channel: ARD
Audience: 8,350,000

Produced: Redfilm Group, RAI, Taurus Film
Producer: Mario Rossini
Director: Gianfranco Albano
Writers: Sergio Donati, Lorenzo Donati
Based on: the novel 'Little Lord Fauntleroy' by F. H. Burnett
Music: Carlo Silotti
Cast: Mario Adorf, Marianne Sägebrecht, Francesco De Pasquale

Brewery owner Carl Schneibel wants to take the education of his only grandson and heir Christian in his own hands. So he has the boy brought to him, from Italy where he lives with his mother, widow of Schneibel's only son. But things turn out

different. Instead of turning the boy into a person hard and unforgiving like himself, Schneibel is changed by Christian's charming nature. The film is based on an American movie with the same title.

(10) ANNA MARIA – EINE FRAU GEHT IHREN WEG

Format: serial
Year of Production: 1995
Date of (first) Broadcast: 08.01–26.02.96
Channel: SAT 1
Audience Average: 8,030

Produced: CBM
Director: Celino Bleiweiá
Writer: Barbara Wilde
Cast: Uschi Glas, Siegfried Lowitz, Christian Kohlund

After her husband's death by accident in a newly purchased heavy truck, Anna Maria has to run the family enterprise, a gravel pit. At first she is totally unprepared for the job but catches up with the competition fast. All the while she has to fence off unpleasant and not so unpleasant admirers. Up to now, nobody has managed to marry her. The whole serial is basically a star vehicle for famous actress Uschi Glas, who shines in the role of the independent, yet decidedly lady-like single female.

FIVE TOP QUALITY PROGRAMMES

(1) DER SCHATTENMANN

Format: mini-series
Year of Production: 1995
Date of (first) Broadcast: 01.01–10.01.96
Channel: ZDF
Audience Average: 6,870,000

Produced: Corona Film
Producer, director, writer: Dieter Wedel
Music: Günter Fischer, Rainer Kühn, Main Theme: Willy DeVille
Cast: Mario Adorf, Heinz Hoenig, Günther Strack, Constanze Engelbrecht

Undercover investigator Held is to acquire the trust of the god-father of Frankfurt, Herzog. He manages to get into the criminal organisation but after a while he isn't

sure about his loyalties anymore. On the one hand is his rather dull and bad-paid job as a police officer, on the other the fascinating Herzog and all the money to be earned. When he finally realizes Herzogs true nature, he fights him relentlessly.

(2) *FAMILIE HEINZ BECKER*

Format: series
Year of Production: 1995
Date of (first) Broadcast: 16.01–20.02.96
Channel: ARD
Audience Average: 5,450,000

Produced: WDR, SR
Directors: Rudi Bergmann, Gerd Dudenhöffer
Writer: Gerd Dudenhöffer
Music: Horst B. Friedrich, Martin Ernst
Cast: Gerd Dudenhöffer, Alice Hoffmann, Gregor Weber

Comedy series featuring the working class character Heinz Becker, a stage personality of famous comedian Gerd Dudenhöffer. Supporting characters are Heinz Becker's wife and son. Becker is always at odds with the world, constantly arguing and complaining. The programme earned high praise from the critics because it is not an adaption of an American concept, but evolved from Gerd Dudenhöffer's satire performed in his strong Saar area dialect.

(3) *GEFÄHRLICHE FREUNDIN*

Format: TV movie
Year of Production: 1996
Date of (first) Broadcast: 20.11.96
Channel: ARD
Audience: 5,210,000

Produced: Tag/Traum
Producer: Gerd Haag
Director: Hermine Huntgeburth
Writer: Lothar Kurzawa
Music: Otmar Jenner; Folke Jensen
Cast: Katharina Thalbach; Corinna Harfouch; Anna Thalbach

Forty-year old Hanna is talked into spending a night on the town with her friend Bibi. The two women enjoy themselves and meet two truck drivers. Unfortunately

for Hanna, the two are only interested in attractive Bibi. Hanna is deeply frustrated. The next morning one of the truckers is found stabbed. But it wasn't Hanna that killed him, but Bibbi who is not the happy-go-lucky woman one thought her to be.

(4) SPERLING UND DAS LOCH IN DER WAND

Format: TV movie
Year of Production: 1996
Date of (first) Broadcast: 02.03.96
Channel: ZDF
Audience: 4,530,000

Produced: Polyphon Film- und Fernsehgesellschaft mbH
Director: Dominik Graf
Writer: Rolf Basedow
Based on: an idea by Dieter Pfaff und Rolf Asedow
Music: Dominik Graf, Helmut Spanner, Main Theme: Andreas Bick
Cast: Dieter Pfaff, Benno Führmann, Petra Kleinert

More or less by accident inspector Sperling takes the bank robber Krause in custody. As he promised him to help Krause to make him give up, Sperling invests further into the case. He finds out that Krause was forced by mobsters who run an illegal gambling operation to pay his debts. As Sperling sees it, these men are the real criminals not the desperate Krause so he tries to bring them to justice.

(5) DER LETZTE KURIER

Format: mini-series
Year of Production: 1995
Date of (first) Broadcast: 03.11–06.11.96
Channel: ARD
Audience Average: 3,920,000

Producer: Christiane Schaefer
Director: Adolf Winkelmann
Writer: Mathias Seelig
Music: Hans Peter Kuhn
Cast: Sissy Perlinger, Sergej Garmasch, Hans Martin Stier

Vera, wife of a antiques dealer Rohleder, has to travel to Moscow in order to identify her husband after his alledged death in a car bombing. The corpse the police

shows her isn't the one of her husband. She and the Russian inspector Bubka suspect that Rohleder faked his own death. Searching for him Vera and Bubka learn that he had connections to former KGB agents now turned criminals. Things get complicated when Rohleder indeed is found to be alive claiming to be the victim of a plot while Bubka deeply in love with Vera suspects him of murder.

FIVE UNFAVOURABLY RECEIVED PROGRAMMES

(1) DIE HALBSTARKEN

Format: TV movie
Year of Production: 1996
Date of (first) Broadcast: 21.12.96
Channel: SAT 1
Audience: 3,580,000

Produced: Constantin Film
Producers: Bernd Eichinger, Uschi Reich
Director: Urs Egger
Writers: Bernd Eichinger, Uwe Wilhelm
Music: Various
Cast: Till Schweiger, Sandra Speichert, Roman Knizka

This TV movie is a remake of a German cinema production of 1956. It belongs to the 'German Classics' concept of the SAT 1 channel. Young Freddy is the leader of a gang of small time criminals in Cologne. He and his friends Kudde, Willi and Mario steal more for fun than to earn a living out of it. But Freddy one day decides that he wants to live a good life with his girl-friend Sissy. He plans a big robbery with a his friends. In the big coup that follows their bounty unfortunately consists not of money but of letters.

(2) BEI AUFSCHLAG MORD

Format: TV movie
Year of Production: 1995
Date of (first) Broadcast: 05.07.96
Channel: SAT 1
Audience: 2,090,000

Produced: Nostro Film
Producers: Werner Kleiá, Karl Heinz Willschrei
Director: Bernhard Stephan

Writer: Hartmann Schniege
Music: Peter Kühnel
Cast: Katja Studt, Hans Czypionka, Dieter Krebs

The young tennis player Simone leaves her choleric manager and uncle Arthur. In the following month she is hampered by her fears of his possible revenge. She hires ex-police officer Markus as a bodyguard. Markus is not only happy to leave behind a boring office job but also falls in love with Simone. At the next big competition he cannot prevent her from being kidnapped. The criminals want three million DM as a ransom. Prime suspect is uncle Arthur who might want to compensate himself for losing Simone.

(3) NATASCHA – WETTLAUF MIT DEM TOD

Format: TV movie
Year of Production: 1996
Date of (first) Broadcast: 31.03.96
Channel: SAT 1
Audience: 2,080,000

Produced: Regina Ziegler Filmproduktion
Director: Bernd Böhlich
Writer: Knut Boeser
Music: Andy Goldner
Cast: Luise Helm, Julia Jäger, Florian Martens, Maja Maranow

The Bär family is shocked when they learn that their seven-year old Natascha hasn't an appendicitis but cancer. Natascha is brought into a hospital for children with cancer. But none of the physicians seems to have the time to really care for the child or have a proper talk with her parents. Then a dubious naturopath shows up and promises to heal Natascha. So her parents take her out of hospital. The story is based on a real event that culminated in a court order to bring the girl back into the care of a proper physician.

(4) DIE PARTNER

Format: series
Year of Production: 1995
Date of (first) Broadcast: 03.01–17.04.96
Channel: ARD
Audience Average: 1,870,000

Produced: Colonia Media

Producer: Jan Hinter

Director: Various

Writer: Richard Reitinger

Music: Harald Kloser, Thomas Schobel, Main Theme: Barbara Dennerlein

Cast: Jan J. Liefers, Ann-Kathrin Kramer, Ulrich Noethen, Heinrich Giskes

This crime story features a young couple that works as private investigators in the town of Dusseldorf. They are close friends to a slightly elder police inspector who plays an almost equally dominant role in the episodes. The crime cases the couple has to solve are of the usual type for this kind of unspecific crime series. The distinguishing trait of the programme was its MTV asthetics. Jump cuts, steady cam shots and the like were used heavily. While arguably the most innovative series of its kind in years it failed miserably with its intended audience.

(5) JEDE MENGE LEBEN

Format: serial

Year of Production: 1996

Date of (first) Broadcast: 02.01–30.09.96

Channel: ZDF

Audience Average: 740,000

Produced: Colonia Media

Directors: Various

Writers: Various

Music: Norbert J. Schneider, Main Theme: Rainer Matuschek, Peter Richter

Cast: Olivia Silhavy, Markus Pfeiffer, Claus Wilcke

A typical daily soap where the main concerns are the constantly resctructered patterns of relationships between the actors. It was aimed at a somewhat older and thus larger audience. The core for the plot was the day-to-day life of a large family including several generations. This is an example of a daily soap that failed to develop the kind of core viewership necessary for success.

ITALY

TWENTY TOP AND INTERESTING PROGRAMMES

(1) IL MARESCIALLO ROCCA

Format: series in 8 episodes x 90 minutes
Year of Production: 1995
Date of (first) Broadcast: Tuesday, from 16/01 to 12/03 1996 – Prime time
Channel: Raidue
Audience Average: 11,938,000

Produced by: Rai (IT), Adriano and Guglielmo Arié (Solaris Cinematografica) (IT)
Rai producer: Luciana Tissi
Directors: Giorgio Capitani, Lodovico Gasparini
Writers: Laura Toscano, Franco Marotta
Music: Guido and Maurizio De Angelis
Cast: Gigi Proietti, Stefania Sandrelli, Sergio Fiorentini, Mattia Sbragia, Roberto Accornero, Maurizio Aiello, Enrico Brignano, Francesco Lodolo, Francesca Rinaldi, Angelo Sorino, Paolo Gasparini, Daniele Pertruccioli, Ruben Rigillo, Massimiliano Virgili, Giacomo Piperno, Anita Zagaria, Ugo Campili, Edoardo Siravo, Marina Viro

It is a rare, in the history of Italian television, that a domestic police series tops the audience charts. This however is the case with *Il maresciallo Rocca*, which literally outstripped all other programmes in competition in 1996. Articulated into eight episodes, the series owes its success to the personality of the hero, a friendly officer in the *Carabinieri* corps, as well as to the fact that the stories are set in a small historical village, and the blend of drama and humour. The leading character uses firmness, sensibility and devotion for his work to solve the crimes which arise in his district. Since the cases are inspired by topical issues, Rocca is constantly faced with problems such as usury, drug-traffic, illegal immigration, and kidnapping. In telling the story of the lead's private life, the series offers a family-love story which provides an on-going framework for the self-contained plots of the episodes.

(2) MORTE DI UNA STREGA

Format: mini-series in 2 episodes x 90 minutes
Year of Production: 1995
Date of (first) Broadcast: Monday 5, Wednesday 7/02 1996 – Prime time
Channel: Raiuno
Audience Average: 9,440,000

Co-produced by: Rai (IT), ZDF (DE), Roberto Sessa (Aran) (IT)
Rai producer: Giovanni Bormioli
Director: Cinzia TH Torrini
Writers: Laura Toscano, Franco Marotta
Based on: the novel 'Morte di una strega' by Laura Toscano
Music: Savio Riccardi
Cast: Remo Girone, Eleonora Giorgi, Ida Di Benedetto, Christine Reinhart, Nicola Pistoia, Amanda Sandrelli, Pino Ammendola, Pina Cei, Bianca Galva, Alessandra Acciai, Laura Nardi, Arturo Paglia, Vanny Corbellini, Pietro Biondi, Vincenzo Crocitti, Pippo Pattavina, Orso Maria Guerrini, Massimo Bonetti

This mini-series, set in an apartment building in Rome, is a classical thriller. A young woman, the fortune-teller and loan-shark nick-named 'the witch', is mysteriously murdered. The photo-reporter living next door snaps a few photographs which contain the clues to identifying the murderer. The generous dose of suspense, the careful direction and the effective acting come together to fully justify the high ratings achieved by this drama.

(3) IL PICCOLO LORD

Format: TV movie – 100 minutes
Year of Production: 1994
Date of (first) Broadcast: Sunday, 3/01 1996 – Prime time
Channel: Raiuno
Audience: 8,550,000

Co-produced by: Raiuno (IT), Taurus Film (DE), Mario Rossini (Red Film Group) (IT)
Rai producer: Cecilia Cope
Director: Gianfranco Albano
Writers: Sergio Donati, Lorenzo Donati
Based on: a novel by F. H. Burnett
Music: Carlo Siliotto
Cast: Mario Adorf, Marianne Sägebrecht, Antonella Ponziani, Francesco De Pasquale, Giovanni Mauriello, Edoardo Velo, Giancarlo Puglisi, Armando De Ceccon, Giuseppe Ieracitano.

This TV movie is a contemporary version of the children's classic of the same name, but set in a different location: the story no longer alternates between England and the USA, but between Southern Italy and Germany. A rich German businessman discovers he has a grandson living on the island of Ponza. After an initial conflict with the child's mother, the family is finally happily reunited. Despite a slight imbalance in the script, the obviously evocative power of the title, the story of a disputed child, as well as the rediscovery of love as a force capable of overcoming social barriers, all contribute to the resounding success of this TV movie.

(4) SANSONE E DALILA

Format: mini-series in 2 episodes x 90 minutes

Date of (first) Broadcast: Monday 16, Tuesday 17/12 1996 – Prime time

Channel: Raiuno

Audience Average: 8,127,000

Co-produced by: LUBE in association with Lux Vide (IT), Betafilm (DE), Raiuno (IT), Turner Pictures (US)

Rai producer: Eleonora Andreatta

Director: Nicolas Roeg

Writer: Allan Scott

Music: Marco Frisina with the supervision of Ennio Morricone

Cast: Dennis Hopper, Diana Rigg, Michael Gambon, Eric Thal, Elisabeth Hurley, Daniel Massey, Paul Freeman, Ben Becker, Jale Arikan, Alessandro Gassman, Debora Caprioglio

This mini-series is the fourth episode of the 'Bible project', co-produced by Italy, Germany and the United States. The intense spirituality of the biblical text, fully reflected in the TV scripts, the sumptuous stage setting and costumes, the refined packaging have all helped this project to fare well in the ratings in Italy. This episode, which tells the story of Samson and Delilah, and is probably the most earthly of the entire Old Testament, has lived up to expectations, though it has performed fared slightly less well in the ratings compared to the previous episodes, *Abramo*, *Giuseppe*, and *Mosé*.

(5) CARO MAESTRO

Format: series in 7 episodes x 90 minutes

Year of Production: 1995

Date of (first) Broadcast: Friday, from 8/03 to 19/04 1996 – Prime time

Channel: Canale 5

Audience Average: 7,484,000

Produced: Mediaset (IT), R.T.I. (IT), Roberto Sessa (Aran) (IT)

R.T.I. producer: Antonino Antonucci Ferrara

Director: Rossella Izzo

Writers: Simona Izzo, Roberta Colombo, Francesco Bonelli

Based on: concept by Massimo Del Frate

Music: Antonio Di Pofi

Cast: Marco Columbro, Elena Sofia Ricci, Sandra Mondaini, Franca Valeri, Francesca Reggiani, Nicola Pistoia, Isa Gallinelli, Francesco Bonelli, Barbara Cupisti, Edoardo Nevola, Cinzia Monreale, Pietro Biondi, Deddi Savagnone, Vittorio Amandola, Barbara Pieruccetti, Pino Ammendola, Pino Colizzi, Roberto Alpi

This is a comedy series set in an elementary school in Tuscany. The episodes recount the life of the leading character, a young schoolteacher, his attempts to win back the love of the headmistress, the daily problems of the school, the life experiences of the pupils as they grow up. The success of the series lies in its rediscovery of community values and bonds. The ties between the family, the children, the school, town and neighbourhood are all seen through the delicate and ironic eye of comedy. The cast includes also some relatively popular Italian TV personalities.

(6) IL RITORNO DI SANDOKAN

Format: mini-series in 4 episodes x 90 minutes

Year of Production: 1995

Date of (first) Broadcast: Sunday, from 6 to 27/10 1996 – Prime time

Channel: Canale 5

Audience Average: 6,691,000

Co-produced by: Guido Lombardo (Titanus) (IT), Mediaset (IT), Taurus Film (DE), Sat 1 (DE)

Director: Enzo G. Castellari

Writer: Luigi Montefiori

Based on: a concept of Adriano Bolzoni, Luigi Montefiori

Music: Guido and Maurizio De Angelis

Cast: Kabir Bedi, Mandala Tayde, Mathieu Carriere, Romina Power, Fabio Testi, Franco Nero, Tobias Hoesl, Randi Ingerman, Vittoria Belvedere, Friedrich Von Thun, Lorenzo Crespi

After two memorable series broadcast on RAI during the 1970s, the adventures of Sandokan, the hero created by Emilio Salgari, make a come back on a MEDIASET channel. The story is set in India in 1875. The imaginary kingdom of Assam is threatened by the wicked Prince Raska. The hero of Mompracem comes to rescue the queen. Despite a fragmentary and episodic narrative structure, the sumptuous

costumes, the beauty of the natural settings and the evocative charm of Indian actor Kabir Bedi, still quite popular among Italian viewers, are the basis of the success of this well-packaged product.

(7) DOPO LA TEMPESTA

Format: TV movie – 100 minutes
Year of Production: 1995
Date of (first) Broadcast: Wednesday 5/06 1996 – Prime time
Channel: Raiuno
Audience Average: 6,530,000

Co-produced by: Rai (IT), Taurus (DE), Maurizio Tini (Compact) (IT)
Rai producers: Cecilia Cope, Francesco Nardella
Directors: Andrea and Antonio Frazzi
Writers: Lidia Ravera, Mimmo Rafele in association with Andrea and Antonio Frazzi
Music: Luis Bacalov
Cast: Senta Berger, Omero Antonutti, Rinaldo Rocco, Adelmo Togliani, Judith Kernke, Gudrun Gabriel, Alessio Boni, Massimiliano Franciosa, Marco Quaglia, Pietro Biondi, Giacomo Piperno, Paolo Maria Scalondro

Structured like a crime story, this TV movie investigates the psychological relationships within a middle-class family whose members are faced by a dramatic event. After spending a 'wild' night on the town, a lawyer's eighteen-year-old son is found in a state of shock beside the corpse of his girlfriend. Accused of rape and murder, the young man is defended by his father, but it is his mother who discovers the real culprits, together with an unexpected detail: their son is homosexual. The effective direction, convincing acting, and above all a screenplay capable of representing credible characters without neglecting the suspense factor typical of the thriller, all come together to produce a successful TV movie.

(8) FAVOLA

Format: TV movie – 90 minutes
Year of Production: 1995
Date of (first) Broadcast: Thursday, 4th April 1996 – Prime time
Channel: Italia 1
Audience: 6,509,000

Produced: Fulvia Film (IT), in association with Mediaset (IT)
Director: Fabrizio De Angelis
Writers: Fabrizio De Angelis, Dardano Sacchetti

Music: Aldo Donati

Cast: Ambra Angiolini, Ryan Krause, Adriana Asti, Enzo Cannavale, Guido Nicheli, Toni Ucci, David Warbeck, Agostina Belli, Milena Vukotic

A contemporary fable, loosely inspired by William Wyler's *Roman Holiday*, this TV movie tells the story of the encounter in Rome between a young shop-girl, who dreams of becoming a top model, and the crown prince of a small imaginary kingdom. After a series of misunderstandings, secret identities, fashion shows, and acquired titles of nobility, the love story between the girl and the prince finally finds its way to a happy ending. The high ratings of the show are mostly due to the presence of TV star Ambra Angiolini, at that time enjoying extensive, though widely debated popularity.

(9) SORELLINA E IL PRINCIPE DEL SOGNO

Format: mini-series in 2 episodes x 100 minutes

Year of Production: 1995

Date of (first) Broadcast: Tuesday 2, Thursday 4/01 1996 – Prime time

Channel: Canale 5

Audience Average: 6,496,000

Co-produced by: Mediaset (IT), Taurus Film – Sat1 (DE), Lamberto Bava and Andrea Piazzesi (Anfri) (IT)

Producers: Lamberto Bava, Andrea Piazzesi

Director: Lamberto Bava

Writer: Gianni Romoli

Music: Amedeo Minghi

Cast: Veronika Logan, Nicole Grimaudo, Jurgen Prochnow, Raz Degan, Brigitte Karner, Valeria Marini, Christopher Lee, Oliver Christian Rudolf, Anja Kruse

A Christmas fable full of references from literature and the cinema, this mini-series is centred on the love-story between a woodsman's very poor orphaned daughter and a prince whose father is violent and cruel. A wicked magician casts spells over them to prevent their love, but the providential intervention of the Spirit of the Source helps the two lovers make their dream come true. Halfway between love-story and an exotic fable, this mini-series is a good example of the fantasy genre which was revived in the 1990s by Italian private TV who was fairly successful in exporting it abroad.

(10) LA TENDA NERA

Format: TV movie – 90 minutes

Year of Production: 1995

Date of (first) Broadcast: Sunday, 18/02 1996 – Prime time

Channel: Raidue
Audience Average: 6,259,000

Produced: Rai (IT), Susanna Bolchi and Aureliano Lalli Persiani (First Film) (IT)
Rai producer: Anna Giolitti
Director: Luciano Mannuzzi
Writers: Pier Giuseppe Murgia, Carlo Lucarelli
Music: Carlo Siliotto
Cast: Luca Barbareschi, Anna Kanakis, Tony Bertorelli, Antonio Catania, Veronica Barelli, Vincenzo Crivello, Stefano Abbati, Claudia Pozzi, Gianni Musy, Alessandra Di Sanzo, Valeria Cavalli

This crime story, whose lead character is an officer in the *Carabinieri*, is set in a provincial town shaken by both public and private scandals: corruption, drugs, prostitution of minors, etc. The series of murderers are linked by satanic cults, a fairly common phenomenon in the Italian provinces. Since its theme is both topical and controversial, this TV movie has had resounding success, despite a few imperfections in the screenplay and some lulls in the narrative rhythm.

(11) PADRE PAPA'

Format: mini-series in 2 episodes x 90 minutes
Year of Production: 1995
Date of (first) Broadcast: Tuesday 9, Thursday 11/04 1996 – Prime time
Channel: Canale 5
Audience Average: 6,068,000

Co-produced by: Titanus (IT), Mediaset (IT), Taurus Film – Sat 1 (DE)
Producer: Guido Lombardo
Executive producer: Anselmo Parrinello
Director: Sergio Martino
Writers: Maria Carmela Cicinnati, Pietro Exacoustos, Giovanni Simonelli
Music: Peppe Vessicchio
Cast: Antonio Sabàto Jr., Maria Grazia Cucinotta, Sonja Kirchberger, Alexander Kerst, Karin Anselm, Calogero Zambito, Regina Bianchi

This mini-series, in the tradition of the melodrama, tells the troubled story of an impossible love affair: a priest, and a murder witness who is being hunted by both the police and the killers. The woman finally dies to save the life of her son (born from her relationship with the man before he entered priesthood). The relatively satisfactory success of this melodrama is due primarily to the popularity of the two main characters, Sabáto and Cucinotta, who garnered international acclaim for her role in the movie *Il postino*.

(12) DONNA

Format: mini-series in 6 episodes x 90 minutes
Year of Production: 1995
Date of (first) Broadcast: Sunday, from 3 to 31/03 – Monday, 1/04 1996 – Prime time
Channel: Raiuno
Audience Average: 5,932,000

Produced by: Rai (IT), Sergio Silva TV Production (IT), in association with Susanna Bolchi and Aureliano Lalli Persiani (First Film) (IT)
Rai producer: Maria Giovanna Bufano
Director: Gianfranco Giagni
Writers: Carlotta Wittig, Tullio Pinelli in association with Luca D'Ascanio
Based on: a concept by Carlotta Wittig
Music: Franco Piersanti
Cast: Ottavia Piccolo, Edwige Fenech, Angelo Infanti, Simona Cavallari, Agnese Nano, Paki Valente, Stefania Casini, Davide Bechini, Viviana Natale, Daniele Liotti, Imma Piro, Emilio Bonucci, Giacomo Piperno, Matteo Naldi

This mini-series is the condensed TV version of an Italian radio soap opera. The peaceful family life of a forty-year-old woman is upset by a series of dramatic events: the older daughter elopes with a questionable businessman; the younger son quits university and becomes involved with his mother's best friend; the husband gets into trouble with justice; the married couple breaks up, and much, much more... The show is weighed down by an excess of narrative material which cannot possibly develop adequately within the confines of the mini-series format.

(13) I VIAGGI DI GULLIVER

Format: mini-series in 2 episodes x 90 minutes
Year of Production: 1995
Date of (first) Broadcast: Sunday 24, Wednesday 27/11 1996 – Prime time
Channel: Canale 5
Audience Average: 5,849,000

Co-produced by: Jim Henson Productions (US) in association with Hallmark Entertainment (US), Channel Four Television (GB), Mediaset (IT)
Director: Charles Sturridge
Writer: Simon Moore
Based on: the novel by Jonathan Swift
Music: Trevor Jones
Cast: Ted Danson, Mary Steenburgen, James Fox, Geraldine Chaplin, Graham

Crowen, Sir John Gielgud, Robert Hardy, Shashi Kapoor, Edward Petherbridge, Kristin Scott Thomas, Omar Sharif, Richard Wilson

Inspired by the famous novel by Jonathan Swift, this mini-series is a perfect example of the excellent results which can be reached through economic and creative co-operation between different countries. Admittedly, the double temporal and narrative structure of the story makes *I viaggi di Gulliver* somewhat difficult to follow. Broadcast ahead of schedule due to programming constraints, the series did not reap the benefits of a substantial promotional campaign which might have procured it more success.

(14) DIO VEDE E PROVVEDE

Format: series in 7 episodes x 90 minutes
Year of production: 1995
Date of (first) Broadcast: Tuesday, from 29/10 to 10/12 1996 – Prime time
Channel: Canale 5
Audience Average: 5,802,000

Co-produced: Matilde Bernabei (Lux Vide) (IT), Mediaset (IT), in association with Taurus Film (DE)
Director: Enrico Oldoini
Writer: Enrico Oldoini
Music: Franz Di Coccio, Patrick Djivas
Cast: Angela Finocchiaro, Athina Cenci, Nadia Rinaldi, Billie Zockler, Cecila Dazzi, Nathalie Guettà, Antonella Attili, Remo Girone, Luca Zingaretti, Carmela Pecoraro, Veronica Visentin, Maria Amelia Monti, Philippe Caroit, Carlo Croccolo, Paolo Bonacelli

This series was preceded by a pilot, still a relatively rare practice among TV Italian producers. Vaguely inspired by the US movie *Sister Act*, this comedy is set in a small town near the capital and recounts the adventures of a group of nuns which has been infiltrated by a candid and extravagant prostitute. Despite the lively and harmonious acting of the female characters, played by some of the best Italian cinema and TV actresses, the series has probably suffered from a lack of continuity in the quality of the episodic plots.

(15) UNO DI NOI

Format: series in 12 episodes x 90 minutes
Year of Production: 1996
Date of (first) Broadcast: Sunday, from 29/09 to 22/12 1996 – Prime time
Channel: Raiuno
Audience Average: 5,603,000

Co-produced by: Lux Vide (IT), Raiuno (IT), Taurus Film (DE), Sat 1 (DE), in association with France 2 (FR), Gmt Productions (FR)

Rai producer: Roberto Pace

Director: Fabrizio Costa

Writers: Stefano Sudrié, Paola Pascolini, Luisa Montagnana

Based on: a concept by Massimo De Rita, Simone De Rita

Music: Lucio Dalla, Beppe D'Onghia

Cast: Gioele Dix, Lucrezia Lante Della Rovere, Heio Von Stetten, Virna Lisi, Constance Engelbrecht, Glauco Onorato, Axel Pape, Isa Bellini, Flavio Insinna, Elda Alvigini

This series, with an intentional stress on moral values, focuses on social issues such as child abandonment and adoption. A successful architect, raised by a rich adoptive family, accepts temporarily the task of managing the orphanage where he lived as a child. This well-packaged production, written with a sensitive touch, and free of the excesses that such themes often lead to, has done fairly well, especially considering the explicit ethical and aesthetic rigor.

(16) PAZZA FAMIGLIA 2

Format: series in 12 episodes x 50 minutes

Year of Production: 1996

Date of (first) Broadcast: Thursday, from 3/10 to 7/11 1996 – Prime time

Channel: Raiuno

Audience Average: 5,371,000

Produced by: Rai (IT), Adriano and Guglielmo Ariè (Solaris Cinematografica) (IT)

Rai producer: Paola Cortese

Director: Enrico Montesano

Writers: Ottavio Iemma, Enrico Vaime, Antonello Dose, Marco Presta, Enrico Montesano

Music: Claudio Mattone

Cast: Enrico Montesano, Paolo Panelli, Alessandra Casella, Kay Rush, Alessandra Bellini, Fabrizio Cerusico, Vincenzo Crociti, Idris, Caterina Sylos Labini, Carlo Monni, Enzo Cannavale

This show is the sequel to a first series broadcast in 1995. With light, ironic and overtones, the twelve episodes narrate the ordinary domestic problems of an enlarged family. The main character, an architect, lives with his two children born from two different marriages, a father-in- law, and a black servant. He tries in vain to regain the love of his second wife, marry a young career woman, and follow his children as they grow up. Identical to the first series, the sequel relies on the popularity and humour of comic theatre actor Enrico Montesano, to deal with a theme of current interest. It is only partially successful.

(17) CASCINA VIANELLO

Format: series in 5 episodes x 80 minutes
Year of Production: 1996
Date of (first) Broadcast: Tuesday, from 17/09 to 15/10 1996 – Prime time
Channel: Canale 5
Audience Average: 5,358,000

Produced: R.T.I. (IT)
Director: Paolo Zenatello
R.T.I. Producer: Antonino Antonucci Ferrara
Writers: Giambattista Avellino, Alberto Consarino, Alessandro Continenza, Raimondo Vianello
Music: Silvio Amato
Cast: Raimondo Vianello, Sandra Mondaini, Paola Barale, Giorgia Trasselli, Renato Scarpa

The first spin-off in the history of Italian TV fiction, *Cascina Vianello*, a follow-up of *Casa Vianello*, the longest running (six seasons) of the MEDIASET sitcoms, is interpreted by two popular comic theatre actors. The setting has changed: it is no longer a city apartment, but a comfortable farm-house in the Lombard countryside, where the married couple retire to escape urban stress and discover the pleasures of a small community. The popularity and quality acting of the lead characters – a married couple in real life too – have often compensated for the weaknesses of diluted plots.

(18) SENZA CUORE

Format: mini-series in 2 episodes x 90 minutes
Date of (first) Broadcast: Sunday 15, Tuesday 17/09 1996 – Prime time
Channel: Raiuno
Audience Average: 4,958,000

Produced by: RAI (IT), Raffaello Monteverde (Leader Cinematografica) (IT)
Director: Mario Caiano
Writer: Stefano Sudrié
Based on: a script of Maria Carmela Cicinnati, Pietro Exacoustos
Music: Filippo Trecca
Cast: Eleonora Brigliadori, Philippe Leroy, Nicola Farron, Martin Imhof Ramirez, Javier Vidal, Marina de Luca, Valentina Lainati, Pierre Cosso

A family melodrama combined with ingredients from the action/crime genre, this mini-series, almost entirely set in Venezuela, tells the story of the daughter of a

rich landowner who believes she has lost the son she gave birth to during her affair with an Italian journalist. The child in fact was raised by a family of poor fishermen. The story features many of the narrative elements typical of the *telenovela* which, given also the South American setting of the mini-series, could have been exploited better.

(19) L'UOMO CHE HO UCCISO

Format: TV movie – 90 minutes

Year of Production: 1995

Date of (first) Broadcast: Monday 1/07 1996 – Prime time

Channel: Raidue

Audience Average: 4,547,000

Co-produced by: Raidue (IT), Produzioni Cinematografiche CEP (IT), Telecip (FR), France2 (FR)

Rai producers: Stefano Munafò, Luciana Tissi

Director: Giorgio Ferrara

Writers: Mimmo Rafele, Giorgio Ferrara, Pierre Dumayet

Based on: the novel '1912 + 1' by Leonardo Sciascia

Music: Joanna Bruzdowicz

Cast: Ludmila Mikael, Carlo Cecchi, Didier Sandre, Delia Boccardo, Patrice Kerbrat, Antonella Fattori, Danilo Esposito, Nicola Farron, Paolo Graziosi, Daniela Valentini

Probably at a disadvantage due to summer season programming, this TV movie – based on a novel by Leonardo Sciascia – is a well-packaged thriller with a solid narrative structure. Set in the provinces, it tells the double-edged story of a crime and the intriguing love affair between a married man and woman who are at once adulterers and accomplices. The strong point of this TV movie is the in-depth psychological analysis of each character which underpins the investigative plot at all times.

(20) UN POSTO AL SOLE

Format: serial in 52 episodes out 230 x 25 minutes

Year of Production: 1996

Date of (first) Broadcast: Monday to Friday, from 21/10 to 31/12 1996 – Early evening

Channel: Raitre

Audience Average: 1,291,000

Produced by: Grundy Productions (IT), Rai – Format (IT)

Directors: Gianbattistia Avellino, Roberto Velentini, Daniele Carnacina, Bruno Nappi

Writing editors: Gino Ventriglia, Achille Pisanti

Based on: a concept by Wayne Doyle, Gino Ventriglia, Adam Bowen in association with Michele Zetta

Music: Antonio Annona

Cast: Maurizio Aiello, Luisa Amatucci, Gian Guido Baldi, Maria Basile, Germano Bellavia, Roberto Bisacco, Gaia Desideri, Ida Di Benedetto, Luigi Di Fiore, Marzio Honorato, Cristina Moglia, Adele Pandolfi, Patrizio Rispo, Alberto Rossi, Claudia Ruffo, Samuela Sardo, Marina Tagliaferri, Francesco Vitiello

The remarkable thing about this serial, inspired by the Australian *Neighbours*, is not its performance in the ratings, but rather the fact that it is a novelty: it is the first daily soap opera ever produced in Italy with typically Anglo-Saxon shooting techniques, script-writing procedures and formats. The story revolves around a group of characters from different social classes — aristocrats, professionals, office workers, students, and jobless – all living in the same large block of flats in Naples. Despite the inevitable stereotypes, a believable setting is enhanced by lively, informal dialogues and the freshness of live shooting. In contrast, the narrative structure and construction of the characters are somewhat weak.

SPAIN

TOP TWENTY PROGRAMMES

(1) MÉDICO DE FAMILIA

Format: series in 43 episodes (23 in 1996) x 65 minutes each
Year of Production: 1995 and 1996
Date of (first) Broadcast: Tuesday from 5/03 to 24/12 1996 (still on air)
Channel: Tele 5
Audience Average: 7,910,000

Produced: Globomedia and Max TV (Geca Formats) for Tele 5
Producer: Julia de Frutos
Directors: Daniel Écija, Arancha Écija, Jesús Rodrigo y Javier Jiménez
Autors: Ernesto Pozuelo, José Camacho
Writers: Manuel Valdivia y Juan Carlos Cueto (editors)
Cast: Emilio Aragón, Lydia Bosch, Luisa Martín, Gemma Cuervo, Pedro Pe Jiménez

A young doctor, widower with children, tries to bring up his family and at the same time develop his career in a public health hospital. To the small family problems those derived from his uncommitted sentimental life must be added. Family comedy with classical overtones and lots of saccharine.

(2) HOSTAL ROYAL MANZANARES

Format: series in 42 episodes (34 in 1996) x 65 minutes each
Year of Production: 1995 and 1996
Date of (first) Broadcast: Thurdsay 12/02 to 26/12 1996 (still on air)
Channel: TVE-1
Audience Average: 7,039,000

Produced: Prime Time Communications, for TVE

Producers: Valerio Lazarov (Executive Producer), José Luis Berlanga (Executive Producer For Prime Time), Miguel María Delgado (TVE Producer), Gerardo Zubiría (TVE Producer)

Director: Julián García Flores

Writer and Director: Sebastiá Junyent

Cast: Lina Morgan, Joaquín Kremel, Ana García Obregón, Silvia Tortosa, Julia Martínez, Mari Begoña Fernando Delgado. Mónica Pont, Lara Blasco, Carlos G. Marzo, Marta Puig

Vaudeville comedy which benefits from the routines and the character created by the popular comedy actress Lina Morgan. A somewhat naive and simple girl but with a heart of gold leaves her village in order to live with her family in a border-house located in Madrid that is run by her aunt. A comedy hardly classifiable in any of the traditional television genres.

(3) MENUDO ES MI PADRE

Format: series in 40 episodes (25 in 1996) x 55 minutes each
Year of Production: 1996
Date of (first) Broadcast: Thursday from 15/04 to 26/12 1996 (still on air)
Channel: Antena 3
Audience Average: 4,555,000

Produced: Max TV (Geca Formats) Globomedia para Antena 3

Producers: Alfonso Mardones, Andrés Gándara (Executive Producer)

Directors: Margarita F. Galende, Manuel Valdivia

Writers: Felipe Mellizo, Manuel Ríos (Script Editors)

Cast: José Luis Cantero 'El Fary', Kity Manver, Miguel Rellán, Juan Llaneras, Julián González, Olga Molina, María Garralón, Cesáreo Estébanez, Saturnino García

The popular singer José Luis Cantero, called 'El Fary', is the leading character of this series – a taxi driver happily married with three children who suffers the typical conflicts of a modest household. An emotional comedy that has been created to fit the personality of this popular personage. In the latest part of the series, the main character is a widower who has married a woman with two teenage children.

(4) TODOS LOS HOMBRES SOIS IGUALES

Format: series in 26 episodes (12 in 1996) x 58 minutes each
Year of Production: 1996
Date of (first) Broadcast: Monday, from 23/09 to 16/12 1996

Channel: Tele 5
Audience Average: 4,418,000

Produced: Tele 5 with Boca a Boca Producciones S.A.
Producers: Cesar Benitez (Boca a Boca Prods.), Miguel Morán (Tele 5)
Director: Jesús Font
Writers: Joaquín Oristrell, Yolanda García Serrano, Juan Luis Iborra, Manuel Gómez Pereira
Cast: Josema Yuste, Fernando Valverde, Luis Fernando Alvés, Ana Otero, Isabel Ordaz, Elisa Matilla, Isabel Prinz, Laura Pamplona

Family and love ups and downs of three divorced men that share a flat and a seductive and challenging housemaid.

(5) LA CASA DE LOS LÍOS

Format: series in 35 episodes (15 in 1996) x 45 minutes each
Year of Production: 1996
Date of (first) Broadcast: Sunday from 15/09 to 22/12 1996 (still on air)
Channel: Antena 3
Audience Average: 4,166,000

Produced: Antena 3 Television and Cartel
Producers: Eduardo Campoy; Germán Álvarez Blanco (Executive Producer), Fernando Marguerie (Head of Production) and Provi Bermejo (Antena 3 Producer)
Directors: Miguel Ángel Díez, Emilio Mac Gregor
Writer: Germán Álvarez Blanco
Cast: Arturo Fernández, Lola Herrera, Miriam Díaz Aroca, Florinda Chico, Emma Ozores, Patricia Vico, Goyo González, Mabel Lozano, Natalia Menéndez, Alicia Rozas, Alejandro Zafiria

Arthur, a wily fifty years old bachelor living off his sister and nieces, is always messing up all the lines of business he pursues, which usually involves his long-suffering family.

(6) YO, UNA MUJER

Format: closed serial in 13 episodes x 60 minutes each
Year of Production: 1995
Date of (first) Broadcast: Wednesday from 10/01 to April 10 1996
Channel: Antena 3
Audience Average: 3,575,000

Produced: José Frade /Producciones Cinematográficas S.A., for TVE

Producers: José Frade, Joaquín Domingo

Director: Ricardo Franco

Writers: Santiago Moncada with Carmen Rigalt, based on a story of José Frade y Santiago Moncada

Cast: Concha Velasco, Víctor Valverde, Ramón Langa, Silvia Tortosa, Lola Cardona, Asunción Balaguer, María José Goyanes, Cayetana Guillén, Javier Escribá, Concha Hidalgo, Pilar López Ayala

Life of a lady in her fifties that is about to be a grandmother and decides to leave her comfortable but senseless life next to her husband and children in order to start a new life. A women's drama.

7) *LOS LADRONES VAN A LA OFICINA*

Format: series in 118 episodes (3 in 1996) x 45 minutes

Year of Production: 1992

Date of (first) Broadcast: Wednesday 3 – Monday 22/01 and Friday 2/02 1996

Channel: Antena 3

Audience Average: 3,464,000

Produced: Miguel Angel Bernardau

Producer: Eduardo Campoy (Executive Producer)

Director : Tito Fernández

Writer: Miguel Martín

Cast: Agustín González, Francisco Rabal, Antonio Resines, Mabel Lozano, Fernando Fernán Gómez, Guillermo Montesinos, Anabel Alonso, Manuel Alexandre, José Luis López Vázquez, Rossy de Palma

The art of using guile and one's wits to take advantage of other people is the common trait of this series' characters, politically outspoken and with occasional references to current political and social events; with the participation of some of the best secondary actors in the Spanish cinema.

(8) *HERMANOS DE LECHE*

Format: series in 78 episodes (13 in 1996) x 43 minutes each

Year of Production: 1994

Date of (first) Broadcast: Sunday from 7/01 to 7/04 1996

Channel: Antena 3

Audience Average: 3,361,000

Produced: José Frade/ Producciones Cinematográficas, S.A., for Antena 3

Producers: José Frade, César Martínez (Head of Production), Alfredo Malibrán (Antena 3 Producer)

Directors: Manuel Cuesta, Carlos Serrano, Pablo Ibá.), Alfredo Malib*Writers:* Santiago Moncada, Diana Laffond Yges and a team of writers, based on a story of Moncada

Cast: José Coronado, Juan Echanove, Gran Wyoming, Fiorella Faltoyano, Cristina Higueras, Ingrid Asensio, Alaska, Conrado San Martín, Encarna Paso, Elisa Montes, José Lifante

A strange duet of two divorced friends that live in the same apartment and share their love affairs as well as the household tasks; one of them plays the role of the housewife and the other is the seducer who works occasionally. Singles comedy with a more adult humour than the average family comedy.

(9) JUNTAS PERO NO REVUELTAS

Format: series in 26 episodes (18 in 1996) x 30 minutes each

Year of Production: 1995

Date of (first) Broadcast: Monday, Saturday from 3/01 to 18/05 1996

Channel: TVE1

Audience Average: 3,186,000

Produced: TVE

Producers: Eduardo Esquide (Executive Producer), Carlos Martínez (TVE Executive Producer) Gloria Concostrina

Directors: Antonio del Real, Enrique Argüelles

Writers: Fermín Cabal, Antonio del Real

Cast: Amparo Baró, Mónica Randall, Mercedes Sampietro, Kity Manver

Three mature women and the mother of one of them share a flat and their love affairs. The comedy rests on a self-ironical humour based also on sexual wordplay and, at the same time, it deals with the problems of a middle aged women and her struggle to survive in a society that does not give many chances to elderly people. A Spanish version of American *Golden Girls*.

(10) CARMEN Y FAMILIA

Format: series in 26 episodes (12 in 1996) x 45 minutes each

Year of Production: 1995

Date of (first) Broadcast: Monday, Sunday, Saturday from 15/04 to 27/07 1996

Channel:TVE1

Audience Average: 2,937,000

Produced: Eclipse Films and Ega Medios Audiovisuales for TVE

Producers: Rafael Carratalá, Ángel Huete (Executive Producer), Fernando Quejido (TVE Executive Producer)

Directors: Oscar Ladoire, Pablo IbáHuet

Writer: Antonio Corencia

Cast: Beatriz Carvajal, José Sancho, Achero Mad.), Fernando Quejido (TVE Executive Producer)

Life in a popular neighbourhood as seen by a group of characters including Carmen, the leading actress, an enterprising widow running a tobacco store. It is a very free adaptation of a movie called *La estanquera de Vallecas.*

(11) *ESTE ES MI BARRIO*

Format: series in 31 episodes (15 in 1996) x 45 minutes each

Year of Production: 1996

Date of (first) Broadcast: Friday from 13/09 to 22/12 1996 (still on air)

Channel: Antenna 3

Audience Average: 2,876,000

Produced: ASPA Cine-Video S. L. for Antena 3 Televisiòn

Producers: Vincente Ascrivà Jr. (Exec. Prod.), Tedy Villalba (Head of Prod.)

Directors: Vincente Escrivà, José Antonio Escrivà

Writers: Vincente Escrivà, José Antonio Escrivà

Music: Fernando Arbex

Cast: José Sacrisàn, Aiejandra Grepi, Paloma Hurtado, Maru Valdivieso, Carmen Rossi, Marc Martinez, Melanie Olivares, Javier Càmara, Saturnino Garcia, Kimbo, José Carabias, Alberto San Juan, Paco Arévalo, Javier Escrivà, Agustin Gonzàlez, Angeles Martin, Rubén Ramirez

Candido, a 53-year old widower and father of two children, is an honest, hardworking man. A major crisis in his professional life opens his eyes and convinces him to set aside more time for his family and the people in his neighbourhood, a community in Madrid which, unlike the heartless urban jungle around it, has maintained a sense of friendship and caring.

(12) *EL SÚPER*

Format: open serial in 142 episodes (80 in 1996) x 28 minutes each

Year of Production: 1996

Date of (first) Broadcast: Weekly 6/09 to 31/12 1996 (still on air)

Channel: Tele 5

Audience Average: 2,446,000

Produced: Zeppelin (Ybon Celaya), La Principal (Queti Domínguez and Eugeni Margallo)

Producers: Lola Moreno (Tele 5 Producer), Joan Bas, Jaume Banacolocha, José Velasco, Secundino F. Velasco (Executive Producer), Miguel Morán (Tele 5)

Director: Orestes Lara

Writers: Rodolf Sirera, con Gisela Pou, Enric Gomá, Julia Altares, Nacho Faena, Antonio Onetti, Boris Izaguirre, Marta Molins, Adolfo Puerta

Cast: Natalia Millán, Chisco Amado, Paca Gabaldón, Manuel Navarro, Andrés Resino, Mercedes Alonso, Manolo Zarzo

A supermarket is the setting for love and labour intrigues between employers and employees.

(13) QUE LOCA PELUQUERIA!

Format: series in 26 episodes (3 in 1996) x 28 minutes each

Year of Production: 1994

Date of (first) Broadcast: Monday from 1/07 to 15/07 1996

Channel: Antena 3

Audience Average: 2,196,000

Produced: Cartel TV for Antena 3 Televisión

Producers: Eduardo Campoy (Executive Producer), Andrés Gàndara (Head of Production)

Director, writer: Eloy Arenas

Music: Mario de Benito

Cast: Mónica Randall, Oscar Ladoire, Eva Cobo, Eva Pedraza, Nathalie Seseña, Itziar Àlvarez, Paco andrés Valdivia, Miriam Fernández, Esther del Prado, Nacho Novo, Manoio Cal

Love and other catastrophies in an extravagant hair salon with a peculiar assortment of customers. Takes a humourous, not always politically correct look at the war between the sexes and sexual misunderstandings.

(14) TRES HIJOS PARA MÍ SOLO

Format: series in 13 episodes (7 in 1996) x 55 minutes each

Year of Production: 1995

Date of (first) Broadcast: Sunday from 14/01 to 3/03 1996

Channel: Antena 3

Audience Average: 2,169,000

Produced: José Frade/ Producciones Cinematográfica S.A. for Antena 3

Producers: José Frade (Producer), Pedro Gorriti (Head of Production)

Director: José Ganga

Writers: J. Gerricaechevarría, Marisol Farpé, Alberto Macías, based on a story of José Frade and Constantino Frade

Cast: Enrique Simón, Eugenia Santana, Verónica Reyes, Carmen Ramírez, María del Puy

A widower with three small children must handle this new situation and overcome his desire to throw in the sponge. A family comedy with classical overtones.

(15) CANGUROS

Format: series in 61 episodes (21 in 1996) x 36 minutes each

Year of Production: 1994 and 1995

Date of (first) Broadcast: Sunday from 8/03 to 25/08 1996

Channel: Antena 3

Audience Average: 2,129,000

Produced: José Frade /Producciones Cinematográficas S.A. for Antena 3

Producers: José Frade, Carlos Cascales (Head Production), Julio Parra

Director: José Ganga

Writers: Jorge Guerrika Echevarría, Miguel Ángel Fernández, Jorge Barriuso

Cast: Maribel Verdú, Silvia Marsó, Ana Risueño, Lia Chapman, Paula Vázquez, Mar Flores, Luis Merlo, Blas Moya

Four girls share a flat in the city. The different personalities and their intense love affairs are the nucleus of the different short stories of this television comedy with a teenage following.

(16) HOSPITAL

Format: open serial in 9 episodes (5 in 1996) x 44 minutes each

Year of Production: 1996

Date of (first) Broadcast: Monday 1-8-15/07, Sunday 28/07, 25/08 1996

Channel: Antena 3

Audience Average: 1,632,000

Produced: Gestmusic (Gestmusic Endemol) for Antena 3 Televisión

Producers: Clara Padrós, Anna Camprubí

Directors: Joan Guitart, Jaume Santacana

Writers: Doc Comparato, Jonathan Gelabert, Enric Gomá

Music: Tullio Tonelli

Cast: Xavier Elorriaga, Mercedes Sampietro, Montse Guallar, Jaime Pujol, Paulina Gálvez, Jorge de Juan, Alejandra Torray, Tony Zené, Montse Pérez, Juan Carlos Gustems, Beatriz Guevara, Joaquín Galán, Karim Alammi, Paul Berrondo

A medical drama set in a major hospital.

(17) LA NOCHE DE OZORES

Format: series in 13 episodes (10 in 1996) x 45 minutes each

Year of production: 1994

Date of (first) Broadcast: Monday, Sunday from 15/01 to 31/03 1996

Channel: TVE-1 and Antena 3

Audience Average: 1,548,000

Produced: TVE

Producers: José Truchado (Head of Production), José A.Cascales (Executive Producer)

Director and writer: Mariano Ozores

Cast: Antonio Ozores, Florinda Chico, Emma Ozores, Freda Lorente, Nuria González, Rafael Rojas, Juanito Navarro, Quique Camoiras, José Carabias, Valeriano Andrés

Coarse and very popular humour of the comedian Ozores here at the service of a story dealing with a sexologist. The consultation room of a specialist in sexual traumas is the ideal framework to portray nude scenes which are the strong point of more of the films produced by the Ozores family.

(18) TURNO DE OFICIO. DIEZ AÑOS DESPUÉS

Format: series in 26 episodes 23 in 1996 x 55 minutes each

Year of production: 1995

Date fo (first) Broadcast: Friday 20/04 to 27/12 1996

Channel: TVE1 and La 2

Audience Average: 1,161,000

Produced: Alma Ata Films, Xaloc PC, S.A., Galiardo Producciones S.A. for TVE

Producers: José Mª Calleja (Executive Producer), Martín Cabañas (Head of Production), Manual Guijarrp (TVE Producerr)

Directors: Manuel Matjí and Juan Echanove

Writers: Joaquín Jordá, Fernando Leon, Jorge Barriuso, José Ángel Esteban,

Carlos López, Jaime Palacios, Luis Marías, Jesús Díaz, Manuel Ruiz Castillo, Juan Bas, Esmeralda Adán, Ángeles Sinde, Miguel Ángel Fernández, Luís María Amodo, Jesús Díaz, José María Biurrún, Luís Ramírez, Federico Ribes, Manuel Guijarro, Martín Cabañas, Manolo Matjí

Cast: Juan Echanove, Juan Luis Galiardo, Carmen Elías, Esperanza Campuzano, Julieta Serrano, Ángeles Macua, Luis Pérez Aqua, Flora María Álvaro, Carmen Arbex, Antonio de la Fuente, Antonio de la Torre, Luis Mario, Enrique Navarro

Legal drama with a social flavour which is a sequel of the first series *Turno de oficio*. Cosme, the protagonist, is now a respected and established judge who meets his former friends and colleagues, with whom he shares professional and personal problems. The series strives to be a mirror image of the passions and the tensions that characterize the urban society of our times.

(19) COLEGIO MAYOR

Format: series in 32 episodes (19 in 1996) x 43 minutes each

Year of Production: 1994

Date of (first) Broadcast: First shown on Regional television. Then, weekly at national channel La 2 from July 17, 1996 to September 4, 1996. Daily from December 5, 1996, to January 17, 1997

Channel: La 2. Previously on Regional Channels

Audience Average: 1,142,000

Produced: Central de Producciones Audiovisuales S.L. for TVE, ETB and Canal 9

Producers: Javier Zulueta, Juan M. Sánchez del Pozo (TVE), Rafael Díaz Salgado, José Luis Olaizola M.

Director: José Luis Pavón

Writers: Nacho Cabana, Manuel Ríos San Martín, based on a concept of José Luis Olaizola M.

Cast: Antonio Resines, Jorge Sanz, Ángeles Martín, Marta Fernández Muro, Quique San Francisco, Achero Mañas, Carlos de Gabriel, Vicente Haro, Carola Manzanares, José Sacristán Jr., Sandra Rodríguez, Miguel A. Valcarcel, Eva Isanta, Rafael Castejón, Débora Izaguirre, María Elena Flores, Cristina Collado

The series recounts several day-to-day stories that are a reflection of the style of life and the emotional relationships of the young people in the nineties. The setting is a University College and the private home of a family that has close ties with the College.

(20) MAKINAVAJA

Format: series in 53 episodes (32 in 1996) x 30 minutes each

Year of Production: 1994 and 1995

Date of (first) Broadcast: Sunday from 28/01 to 13/10 1996

Channel: La 2

Audience Average: 1,082,000

Produced: Tesauro and Dos Ochos Cine for TVE. The second part is a Izaro Films production for TVE

Producers: Miguel Gil (Head of Production), Fernando Quejido (TVE Producer), Miguel Torrente

Directors: Carlos Suárez, José Luis Cuerda (*Makinavaja II*)

Writers: Carlos Suárez, José Luis Cuerda, Pedro Montero (Part Two) and José Rubianes

Cast: Pepe Rubianes, Ricardo Borrás, Mario Pardo, Pedro Reyes, Lázaro Escarceller, Florinda Chico, Jordi Dauder

An adaptation for TV of a famous comic-strip, dealing with a winning character hailing from the marginal Red Light district of Barcelona; a delinquent pressed by necessity, of human and sympathetic nature. 'Charlot with influences of Valle Inclán', according to José Luis Cuerda, who adapted this story.

UNITED KINGDOM

TOP TEN PROGRAMMES

(1) ONLY FOOLS AND HORSES

Format: mini-series – situation comedy
Year of Production: 1996
Date of (first) Broadcast: 25/12/96
Channel: BBC1
Audience Average: 22,329,000

Produced: BBC
Producer: Gareth Gwenlan
Director: Tony Dow
Writer: John Sullivan
Cast: David Jason, Nicholas Lyndhurst, Buster Merryfield, Paul Barber, John Challis

The quintessential 1980s British sitcom set in South East London. It centres around Derek 'Del Boy' Trotter, who runs a market stall, selling cheap goods of a suspicious origin, his brother Rodney Trotter and Grandfather Trotter who all share a council flat in a high rise building.

(2) ONE FOOT IN THE GRAVE

Format: series
Year of Production: 1996
Date of (first) Broadcast: 26/12/96
Channel: BBC1
Audience Average: 17,469,000

Produced: BBC
*Producer, director:*Susan Belbin
Writer: David Renwick

149

Cast: Richard Wilson, Annette Crosby, Angus Deayton, Janine Duvitski, Doreen Mantle

Comedy series focusing on a retired security guard who more than wears out the patience of the people around him, including his wife.

(3) A TOUCH OF FROST

Format: series
Year of Production: 1996
Date of (first) Broadcast: 7/1/96
Channel: ITV
Audience Average: 17,172,000

Produced: Yorkshire
Producer: Simon Lewis
Director: Don Leaver
Writer: Christopher Russell
Cast: David Jason, John Lyons, Camille Coduri

A series following the investigations of Yorkshire detective Frost who is lonely, disorganised, idiosyncratic, impatient of authority, and whose personal life is in shambles, yet is fiercely dedicated to his profession.

(4) CORONATION STREET

Format: open serial
Year of Production: 1996
Date of (first) Broadcast: 1/1/96
Channel: ITV
Audience Average: 15,748,000

Produced: Granada
Producer: Sue Pritchard
Director: Mervyn Cumming
Writer: Adele Rose
Cast: William Tarmey, Elizabeth Dawn, Betty Driver, Peter Baldwin

A British institution, running since 1960, and still one of the most popular programmes on TV. Set in a small street in a fictional suburb of Manchester, following the daily lives of working class families living there.

(5) *PRIME SUSPECT*

Format: mini-series
Year of Production: 1996
Date of (first) Broadcast: 20/10/96
Channel: ITV
Audience Average: 14,827,000

Produced: Granada
Producer: Lynn Horsford
Director: Philip Davies
Writer: Adrew Guy
Cast: Helen Mirren, John McArdel, Julia Lane, David O'Hara

Police drama featuring a senior female detective working as part Metropolitan Police's Murder Squad. Working in an all-male police team, she faces discrimination yet she manages to carry out her work proficiently.

(6) *CASUALTY*

Format: closed serial
Year of Production: 1996
Date of (first) Broadcast: 6/1/96
Channel: BBC1
Audience Average: 14,784,000

Produced: BBC
Producer: Corinne Hollingworth
Director: David Innes Edwards
Writer: David Joss Buckley
Cast: Lisa Coleman, Derek Thompson, Julia Merrells, Todd Boyce, Paul Barber, John Challis

A hospital drama, set in emergency room of (fictional) Holby City Hospital. Reminiscent of US programmes such as *Hill Street Blues* and *St. Elsewhere*, in its realist approach to drama. The series has often been considered controversial in its representation of the National Health Service, dealing with subjects such as AIDS, anorexia, as well as terrorism and rioting.

(7) INSPECTOR MORSE

Format: TV movie
Year of Production: 1996
Date of (first) Broadcast: 27/11/96
Channel: ITV
Audience: 14,770,000

Produced: Carlton UK
Producer: Chris Burt
Director: Herbert Wise
Writer: Julian Mitchell
Cast: John Thaw, Kevin Whately, James Grout, Clare Holman

Police drama. Chief Inspector Morse is an unusual policeman: an Oxford graduate who loves poetry and opera, and has an eye for the ladies. He drives around the streets of Oxford in his trademark 1960 Jaguar, solving crimes at a leisurely pace.

(8) EASTENDERS

Format: open serial
Year of Production: 1996
Date of (first) Broadcast: 1/1/96
Channel: BBC1
Audience Average: 14,702,000

Produced: BBC
Producer: Alison Davis
Director: Jonathan Dent
Writer: Rachel Pole and Tony Jordan
Cast: Adam Woolyatt, Michelle Collins, Gillian Taylforth, Mike Reid

Soap opera charting the lives of working class life in London's East End. It follows the lives of the multiethnic community, living in an empoverished Victorian quarter, including pub landlords, vegetable stand owners, the unemployed, yuppies, grocers etc.

(9) HEARTBEAT

Format: series
Year of Production: 1996
Date of (first) Broadcast: 1/9/96

Channel: ITV
Audience Average: 14,604,000

Produced: Yorkshire
Producer: Gerry Mill
Director: Tim Dowd
Writer: David Lane
Cast: Nick Berry, Derek Fowlds, Bill Maynard, William Simons, Mark Jordan

Police drama about a Yorkshire policeman, set in the 1960s. Nostalgic look at a rural community where only small time crime takes place.

(10) BALLYKISSANGEL

Format: series
Year of Production: 1996
Date of (first) Broadcast: 11/2/96
Channel: BBC1
Audience Average: 14,462,000

Produced: Ballykea Productions
Producer: Joy Lale
Director: Paul Harrison
Writer: John Forte
Cast: Stephen Tompkinson, Dervla Kirwan, Tony Doyle, Nial Toibin, Tina Kellegher, Gary Whelan

Drama set in the small Irish town of Ballykissangel. Father Clifford arrives from Manchester to serve the community in Ballykissangel. After some initial difficulties, he becomes intimately involved with the lives of the local people.

FIVE FAVOURABLY RECEIVED PROGRAMMES

(1) HAMISH MACBETH

Format: closed serial
Year of Production: 1996
Date of (first) Broadcast: 24/3/96
Channel: BBC1
Audience Average: 9,557,000

Produced: Zenith
Producer: Deirdre Keir
Director: Nicholas Renton
Writer: Danny Boyle
Cast: Robert Carlyle, Ralph Riach, Stuart Davids, Brian Pettifer, Anne Lacey

Series about a policeman whose beat is a sleepy Higland village.

(2) HILLSBOROUGH

Format: TV movie
Year of Production: 1996
Date of (first) Broadcast: 5/12/1996
Channel: ITV
Audience Average: 6,676,000

Produced: Granada
Producer: Nicola Shindler
Director: Charles McDougall
Writer: Jimmy McGovern
Cast: Christopher Eccleston, Ricky Tomlinson, Annabelle Apsion, Rachel Davies, Mary Womack

Drama documentary about the 1989 football stadium disaster in which 95 people died. Follows three families' stories from their initial excitement as they get tickets for the FA Cup semi-final, to the emotional turmoil and legal struggle which follows the disaster.

(3) OUR FRIENDS IN THE NORTH

Format: closed serial
Year of Production: 1996
Date of (first) Broadcast: 15/1/96
Channel: BBC2
Audience Average: 4,589,000

Produced: BBC
Producer: Charles Pattinson
Director: Stuart Urban
Writer: Peter Flannery
Music: Colin Towns

Cast: Tony Haygarth, Alan Turner, Terence Rigby, Christopher Eccleston, Tony Barton, Phil Atkinson, Geoffrey Hutchings

Nine part epic drama series charting thirty years in the friendship of four Geordie friends from 1965–1995.

(4) CROSSING THE FLOOR

Format: TV movie
Year of Production: 1996
Date of (first) Broadcast: 5/10/1996
Channel: BBC2
Audience Average: 2,954,000

Produced: BBC
Producer: Lissa Evans
Director: Guy Jenkin
Writer: Guy Jenkin
Music: Matthew Scott
Cast: Tom Wilkinson, Helen Baxendale, Clive Russell, James Fleet

Political comedy drama. In a desperate bid to save his career, Home Secretary David Hanratty resigns from an unpopular Conservative government to join forces with the Labour Party and its new leader Tom Peel. Hanratty finds he has to juggle the demands of his wife and mistress and he soon reaches breaking point.

(5) THE CROW ROAD

Format: mini-series
Year of Production: 1996
Date of (first) Broadcast: 4/11/96
Channel: BBC2
Audience Average: 2,799,000

Produced: Union Pictures
Producer: Bradley Adams
Director: Gavin Millar
Writer: Bryan Elsley
Music: Colin Towns
Cast: Joseph Mcfadden, Bill Paterson, Peter Capaldi, Valerie Edmond, Stella Gonet

Family drama series set in Scotland.

FIVE UNFAVOURABLY RECEIVED PROGRAMMES

(1) THE LIVER BIRDS

Format: series
Date of (first) Broadcast: 5/5/1996
Channel: BBC1
Audience Average: 8,477,000

Produced: BBC
Producer: Philip Kampff
Director: Angela De Chastelai Smith
Writer: Carla Lane
Cast: Nerys Hughes, Polly James, Mollie Sugden, Michael Angelis

1990s remake of classic 1970s sitcom following the lives of the original characters 20 years on.

(2) POLDARK

Format: TV movie
Year of Production: 1996
Date of (first) Broadcast: 2/10/96
Channel: ITV
Audience Average: 7,962,000

Produced: HTV
Producer: Sally Haynes
Director: Richard Laxton
Writer: Robin Mukherjee
Based on: the books of Winston Graham
Music: Ian Hughes
Cast: John Bowe, Mel Martin, Ioan Gruffudd, Kelly Reilly, Nicholas Gleaves

Family drama set in 1810 in Cornwall and London. Ross Poldark is an MP, works in Westminster but still encounters his rival George Warleggan.

(3) HARPUR AND ILES

Format: mini-series
Year of Production: 1996
Date of (first) Broadcast: 7/9/1996
Channel: BBC 1
Audience Average: 6,626,000

Produced: BBC Wales
Producer: Jane Dauncey
Director: Jim Hill
Writer: Don Shaw
Based on: the novel by Bill James
Cast: Hywel Bennett, Aneirin Hughes, Patrick Robinson, Dafydd Hywel

Crime thriller set in a Welsh seaport city. Assistant Chief Constable Desmond Iles is facing an internal police investigation following rumours of police corruption within his force. Two rival gangs of protection racketeers are waging war and the son of local underworld boss is kidnapped DS Harpour and SD Iles are at logger-heads about how to deal with the gangs.

(4) RHODES

Format: closed serial
Year of Production: 1996
Date of (first) Broadcast: 15/9/96
Channel: BBC1
Audience Average: 4,546,000

Produced: Zenith
Producer: Charles Salmon/Scott Meek
Director: David Drury
Writer: Anthony Thomas
Cast: Martin Shaw, Frances Barber, Frantz Dobrowsky, David Butler

Drama series charting the life of British adventurer and empire-builder Cecil Rhodes. Aged seventeen, Cecil Rhodes joins his brother in Southern Africa for the diamond rush of 1871. He outwits his fellow prospectors in Kimberley and reor-ganised the workforce. He has a vision to the British Empire form Cape to Cairo.

(5) ANNIE'S BAR

Format: closed serial
Year of Production: 1996
Date of (first) Broadcast: 1/2/96
Channel: Channel 4
Audience Average: 1,095,000

Produced: Ardent
Producer: Richard Handford
Director: Baz Taylor
Writer: Andy Armitage
Cast: Dominic Taylor, Larry Lamb, Geoff McGivern, Paul Brooke

Topical ten-part soap about the world of backbench politics.

Appendix

EUROFICTION Project

1. EUROFICTION: a European Observatory on Television Fiction

1.1. Scenario of the EUROFICTION project

The strategic relevance of the audio-visual field for the economics and culture of European countries is the focus of intense discussion involving a variety of interested parties: from broadcasters to producers, to policy-makers, to intellectual and scientific community, to public opinion. There is now a diffused awareness that a game or a battle is going on in the audio-visual arena which will be decisive for the economic improvement (increasingly linked to the production and circulation of 'symbolic' goods) and moreover for the cultural autonomy of Europe. The audio-visual is therefore a central element in the raising of crucial questions concerning the ceaseless construction and negotiation of cultural identities, as well as the promotion of a European culture in the context of rapidly advancing processes of globalisation.

Television fiction has a special role to play in this field, because of its double identity: cultural and economic. Without wishing to deny the importance of cinema as an industrial and artistic expression, it has to be admitted that television has became and still remains the 'central story-teller system' of contemporary society, the real 'supernarrator' which by means of fiction stories articulates the themes and problems of daily life, interprets and orients the changes in our cultures, is a repository of our traditions and memories. At the same time, television fiction is a product of enormous relevance for the economic assets of media systems: it creates industry and market, supports employement, activates financial flows, feeds related activities such as marketing and training. From both cultural and economic point of view, it is really much more than meets the eyes.

However, as is known, European countries are suffering at the moment a serious deficit in television fiction production and offer. National television fiction programming, to a greater or lesser extent, depends on imported products from north and south America; the circulation and exchange of fiction of European origin is marginal. The increase in the number of channels encouraged by new technologies, and consequently the huge amount of contents needed to fill up those same channels, may lead to an aggravation of this disequilibrium. In terms of the overall European audio-visual scenario – allowing for differences from one country to another – television fiction is characterised by a sharp contradiction: it is a prod-

uct of strong strategic value but it is weak on the production, offer and circulation front. This weakness which has repercussions on the same information level: in fact, a detailed and up-to-date knowledge of what is going on in European countries in the arena of television fiction is so far not easily available.

1.2. What is EUROFICTION

With reference to the above sketched scenario, the EUROFICTION project was born of the firm belief on the part of its Italian promoters (Master in comunicazione e media dell'Università di Firenze, Fondazione Hypercampo and Osservatorio sulla Fiction Italiana) that, wishing to put into practice appropriate policies in favour of television fiction, a systematic, well documented, analytical and comprehensive information and knowledge is an absolute priority.

EUROFICTION is a European Observatory on Television Fiction basically aimed at quantitative and qualitative monitoring of fiction annualy produced and offered in European countries. To begin with, and without precluding the possibility for other countries to join the network in the near future, five national research teams and institutions are involved in the already established and effective (since 1996) Observatory:

- in Italy: Fondazione Hypercampo and Osservatorio sulla Fiction Italiana (co-ord. Milly Buonanno)
- in France: Institut National de l'Audiovisuel (co-ordinator Régine Chaniac)
- in Germany: Universität Siegen (co-ordinator Gerd Hallenberger)
- in Spain: Universitat Autónoma de Barcelona (co-ordinator Lorenzo Vilches)
- in United Kingdom: British Film Institute (co-ordinator Richard Paterson).

Carried out on the basis of harmonised data-gathering criteria and data elaboration, the annual work of the EUROFICTION concerns:

- monitoring the main variables of the offer: titles, episodes, length, scheduling, format, genre, rating and share;
- classifying some dimensions of the story content as cultural indicators: time, place, environment, main character;
- compiling a programme index and a synopsis of the main programmes;
- making in-depth analysis of the most successful or trendy productions of the year;
- providing data about investments, imports, exports;
- exploring in turn specific issues, such as marketing, star system, training of professional figures and so on.

The main output of EUROFICTION will be an Annual Report offering comparative overviews and analysis and syntesis of the most significant fiction trends within and across the European countries.

The aim is two-fold: (1) produce and circulate knowledge likely to meet the interests of differents categories of people: television professionals, policy-makers, media researchers; (2) favour the conditions for a greater exploitation and valorization of European television fiction and its cultural and economic functions.

Most of the data and information that EUROFICTION intends providing cannot be found elsewhere or is dispersed and fragmented. Re-arranging all this into an

organic whole, following its evolution in time, will provide with new and fruitful knowledge. It is the knowledge of a significant part of European cultural production and consumption that will be thus rendered transparent and available, with the added value of the reciprocity favoured by a comparative framework of research.

2. The EUROFICTION Network

2. 1 Italy

Fondazione Hypercampo
Osservatorio sulla Fiction Italiana (OFI)

The Ossevatorio sulla Fiction Italiana, headed by the sociologist and media scholar Milly Buonanno, was created in 1988 on the initiative of 'il Campo', a private media research centre based in Rome, now paralleled by Fondazione Hypercampo, a public foundation which operates in connection with the Master in Communication and Media established since 1993 in Firenze by the Faculty of Political Sciences 'Cesare Alfieri' (University of Firenze).

The Osservatorio and the Foundation are backed by the Research Department of public television (Rai), and the Marketing Department of private television (Mediaset).

The Osservatorio carries out a long-term research covering all first-run television fiction programmes produced and co-produced in Italy and broadcast by the six public and private national channels. The aim of this work is double: on the one hand, systematically monitoring quantity, genres, formats, audience of Italian television fiction; on the other hand, analysing the representation of contemporary Italian society offered by fiction stories.

The Osservatorio annually provides a wide-ranging research report, published in the RAI -VQPT series. Under the same headline *La fiction italiana/L'Italia nella fiction* (Italian fiction/ Italy in fiction), seven reports came out until now. All volumes are edited by Milly Buonanno:

- **1997** *Il senso del luogo*. La fiction italiana/L'Italia nella fiction. Anno ottavo. RAI-ERI, Roma, pp. 208
- **1996** *Ciak!Si gira*, La fiction italiana/L'Italia nella fiction. Anno settimo. RAI-ERI, Roma, pp. 308
- **1995** *E' arrivata la serialità*, La fiction italiana/L'Italia nella fiction. Anno sesto. ERI-VQPT, Torino, pp. 289
- **1994** *Il bardo sonnacchioso*. La fiction italiana/L'Italia nella fiction. Anno quinto. Torino, ERI-VQPT, pp.280
- **1993** *Non è la stessa storia*. La fiction italiana/L'Italia nella fiction. Anno quarto. ERI-VQPT, Torino, pp. 284
- **1992** *Sceneggiare la cronaca*. La fiction italiana/L'Italia nella fiction. Anno terzo. ERI-VQPT, Torino, pp. 200
- **1991** *Il reale è immaginario*. La fiction italiana/l'Italia nella fiction. ERI-VQPT, Torino, pp. 260

2. 2 France

Institut national de l'Audiovisuel (INA)

The INA's study sector is part of the Research Department and provides valuable information on the developments affecting programme offers (production economy, programme policies, competition, etc.) as well as conditions of reception (audience behaviour).

Given the framework, it is only natural that the INA should focus upon the ever-popular television drama programmes. This is the subject at the heart of all audio-visual creation, it is both the most-watched form of programme and the most expensive to make. It is also the longest kind in the making and the one that requires the greatest number of different professions. Drama programmes can also be long-lived and attract a genuinely international market.

For the last ten years or so, the INA has been carrying out studies and publishing specialist articles on various aspects of French television drama: programming and formats, audience figures, sales and repeats, financing and production costs of unpublished drama, the broadcasters' involvement, the relationship between cinema and television, etc. Notable publications include *La Fiction télévisée, inventaire, mutations et perspectives* ('Televised Drama, Inventory, Shifts and Perspectives') which, back in 1988, forecast the comeback of drama in France; R. Chaniac and J. Bianchi, *Feuilletons et séries à la télévision française, généalogies*, Ministry of Research, 1989 ('Series on French Television, Genealogy') which recounted the history of drama on French TV; and J-P. Jézéquel, *La fiction de 20h30, CNC and SJTI*, 1991 ('Drama in the 8.30 evening slot'), which examined prime-time drama over three years (1988-90).

Some of these analysis resulted in regular publications. The annual review of programme offer and audiences – R. Chaniac and S. Dessault, *La Télévision de 1983 à 1993, chronique des programmes et de leur public*, INA/SJTI, La Documentation française, 1994 – put drama back up among the other major programme categories. From production to export, the *Observatoire de la Création* provided an analysis of drama, documentaries and animation, the three main constituents of programme catalogues.

Our work takes place mainly, however, within an international, especially European perspective; more recently, Jean-Pierre Jézéquel's work on the *Production de fiction en Europe*, CNC/INA/Ministry of Culture/La Documentation française, Paris, 1994. ('Drama Production in Europe', shows the impact of specific national characteristics on European co-production.

Eurodience, the newsletter on programmes and audiences in Europe, gives monthly results of the most popular programme in each country and regularly publishes features on drama's position in European programme schedules. Ina offers sector professionals an extension of this publication, the Euro TV- Programmes database, which, at their request, locates, records and analyses programmes of the major European channels. This new service means developments in serialised drama format (sitcom, soaps, series) can now be monitored.

2. 3 Germany

Universität of Siegen

Although the city of Siegen has a rather young university, just recently celebrating its 20th birthday, the work of its scholars in media studies is well known all over Germany. Mainly due to the initiative of the Department of Literature, Siegen in 1986 became host of a special research unit in media studies on behalf of the German research council, DFG; the only research institution of its kind in this field. In the beginning, this special research Unit comprised eleven different projects, most of them analysing German television history regarding various genres of programming. Today there are sixteen projects in the Special Research Unit 'Screen Media', researching a broad range of topics in the audiovisual mediascape, including recent developments in the fields of television and computing. They employ diverse research methods – apart from some projects with a firm background in programme analysis, there are others rooted in media theory, the social sciences, economic theory, law studies and even art history.

This mixture of topics and approaches was intended to become the basis of an interdisciplinary approach, which in fact became the case. On the one hand, the idea of bringing together researches with diverse backgrounds and interests was the basis for the successful work of 'Screen Media', on the other hand this success became the starting point for further activities like the introduction of the media studies course at the University of Siegen.

In 1995, as part of a joint project carried out by the University of Siegen and the Siegen district administration, the Fortbildungsakademie Medien (FAM) was founded; an academy offering media related course for various professions. This created courses for teachers wanting to obtain basic information on today's mediascape as well as educational programmes for civil servants and businessmen in search of ways to make the best use of new media and even courses for media professionals who want to improve their knowledge. Apart from its educational effort, FAM also engages in research work of its own.

The German branch of EUROFICTION is contained within this network: it contributes to the research activities of FAM and has its roots in the work of the research project 'Television and new media in Europe in the 1990's'; a branch of the Special Research Unit 'Screen Media', with additional financial support supplied by the Landersaustelt für Rundfunk, the regional regulating authority for commercial broadcasting in the State of North Rhine-Westphalia.

The German branch of EUROFICTION can build upon the research findings of several individual projects (past and current) of the Special Research unit 'Screen Media', concerning various aspects of TV fiction, for example the history and development of the German TV series and plays, and the influence of American and English productions on German offerings in this field.

2. 4 Spain

Universitat Autónoma de Barcelona

Research activity on television fiction preceding EUROFICTION developed in four ways: (a) production and European markets for television fiction; (b) schedule,

genres and contents on television fiction in Spain; (c) development of computerised tools for script writing in audiovisual fiction; (d) schedule on television fiction aimed at teenagers.

Production and European markets for television fiction: research for the report 'Relationship between cinema and television. Investigation of the European audiovisual production crisis' was carried out in 1988 and 1989 with the support of the Comissió Interdepartmental d'Investigació Technològica, CIRIT, Geralitat de Catalunya and was directed by Lorenzo Vilches and J. Luis Fecé. This research, based on the current economic structure of the European audiovisual scene, analyses the causes of the audiovisual sector's crisis at the time of television liberalisation in Spain and presents case studies on Televisión Española, Channel Four and Canal Plus. This investigation was used as a basis to organise the report that was presented in the first audiovisual production seminar of the Media Programme in Spain and was supported by the Universidad Internacional Menendez y Pelayo and the Ministry of Culture.

Schedules, genres and contents on television fiction in Spain: research carried in 1990 and 1991 aimed to evaluate production and programme schedule strategies in Spain during the time of change from the public television monopoly to the private television system. It was directed by Lorenzo Vilches and a team from the Universidad Autónoma de Barcelona with the co-operation of CTP (Club de Técnicas de Producción).

Industrial products for fiction writing: in June 1989, the ministerial conference gave the Eureka label (EU305) to the CAP 'Computer Assisted Production' project. This project, which unites efforts from several Spanish and French private companies (CTP, BDE, C. LAUBIN) along with the Universitat Autónoma de Barcelona, focuses on obtaining technological advances for computerising cinema and television production processes. Its scientific director is Lorenzo Vilches and its first prototype was presented in 1994.

European youth television: research on television fiction aimed at teenagers was promoted by RAI, France 2 and Televisión Española with the support of the Universities of Rome, Rennes and Autónoma of Barcelona. It is based on content analysis and, in particular, value system analysis. The Spanish team was directed by Lorenzo Vilches, together with Charo Lacalle, Rosa Alvarez Berciano and a university team.

2. 5. United Kingdom

British Film Institute (BFI)

British television drama has a long and well-documented history. The critical and commercial successes of the 1960s, from the BBC Wednesday Plays to ITC series like *The Avengers*, were complemented by the development of the British soap opera, quintessentially reflected in Granada's *Coronation Street*. British television drama has been enormously popular in the domestic market and some programmes have sold well on the international market.

It is a truism of television ratings that the domestic series or serial is always the most popular programme in any week in most countries. TV is national – TV drama reflects and mirrors the mores and ways of the nation, while its comedy fiction (the situation comedy) often reflects difficult areas in the collective

psyche. Film is the international medium (and is dominated by the Hollywood majors).

Now for the first time, with the EUROFICTION project, it will be possible to compare the TV fiction profiles of large European countries. For the BFI, which has long collected the basic data, there is the opportunity to explore basic cultural indicators against audience response. This allows the BFI to go beyond the over-simple ratings statistics, which act as the currency of the industry, towards an understanding of the complexity of the relationship between the audience and programmes. In this regard, it is interesting to consider the recent success on the BBC of Ealing-like comedies *Ballykissangel* and *Hamish Macbeth* – a strain of filmic British identity re-interpreted on 1990s TV.

The future is, of course, what concerns people in the industry most. What the overall project might show – apart from the quirkiness of each nation state within Europe and the difficulty of creating European television able to compete on an equal footing with the US majors – is that there are certain areas where co-operation and co-production might work without the creation of unwanted and unwatched 'Europuddings'. The BBC's soap opera *Eldorado* tried to inject Europe into the UK domestic scene and failed – maybe this sort of research will show why. This research will show how diverse Europe's fiction is, and may allow further insights into identity questions, suggesting possible strategies for success for European production companies.

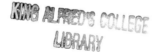